Praise for Birth of the Chess Queen

"An intriguing, insightful, and very learned feminist interpretation of the history of chess, focusing on the transition from "Vizier" to 'Queen.' I particularly like the way in which Yalom subtly integrates the development of chess with the social and cultural aspects of each era. I learned a lot from this book."

-Norman F. Cantor, author of In the Wake of the Plague

"A wide-ranging exploration of the origins of chess and of its most powerful piece.... Marilyn Yalom has rattled the vaults of Europe to shake out the missing-link chess pieces that show the game's evolution on the continent.... [Her] entertaining and credible contention is that the booting of the Vizier and the coronation of the Queen are linked to the rising status of women in medieval Europe." —New York Times Book Review

"An enticing portal into the past. . . . Yalom writes passionately and accessibly about this esoteric topic."

-Los Angeles Times Book Review

DØ189437

"Yalom makes a credible . . . case that [the chess queen's] rise reflects the power intermittently accorded to, or seized by, female European monarchs." —The New Yorker

"In this remarkable book we have the first full-fledged investigation of how the chess queen came to the game . . . [and] developed into the most powerful piece on the board."

-Chess Life

"Combining exhaustive research with a deep knowledge of women's history, Yalom presents an entertaining and enlightening survey that offers a new perspective on an ancient game." —Publishers Weekly "Marilyn Yalom has written the rare book that illuminates something that always has been dimly perceived but never articulated, in this case that the power of the chess queen reflects the evolution of female power in the Western world."

—San Francisco Chronicle

"A capable explanation of how the [chess] queen became the board's dominant aggressive piece, [and] an interesting depiction of chess as representing the culture of its time. The work is a sympathetic, nonpartisan explanation of the rise of the power of the female, especially in Europe." —Boston Globe

"A delightful tale.... Yalom mixes fascinating, if obscure, information about the game of chess with equally interesting stories of political matriarchs, celebrated and unknown alike.... Whether one's interest is the game of chess or the game of politics, the reader will come away simultaneously entertained and enlightened." — Washington Times

"A fascinating book." — Atlanta Journal-Constitution

"A well-researched and enjoyable book." — The Economist

"An interesting book for lovers of chess and, above all, lovers of strong women." —St. Louis Post-Dispatch

"Both chess fans and those unfamiliar with the game will enjoy this absorbing look at the evolution of chess." —*Booklist*

About the Author

MARILYN YALOM is a senior scholar at the Institute for Women and Gender at Stanford University. She is the author of A History of the Wife; A History of the Breast; Blood Sisters: The French Revolution in Women's Memory; and Maternity, Mortality, and the Literature of Madness. She lives in Palo Alto, California, with her husband, psychiatrist and writer Irvin Yalom.

Birth of the Chess Queen

ALSO BY MARILYN YALOM

A History of the Wife

A History of the Breast

Blood Sisters: The French Revolution in Women's Memory

Maternity, Mortality, and the Literature of Madness

Le Temps des Orages: Aristocrates, Bourgeoises, et Paysannes Racontent

A History

Perennial An Imprint of HarperCollinsPublishers

<u>MANANANANANANA</u>

Birth of the Chess Queen

Marilyn Yalom

Photographic credits follow page 272.

Grateful acknowledgment is made to Gary Glazner for the use of his poem "Waking Piece."

A hardcover edition of this book was published in 2004 by HarperCollins Publishers.

BIRTH OF THE CHESS QUEEN. Copyright © 2004 by Marilyn Yalom. All rights reserved. Printed in the United States of America. No part of this book may be used or reproduced in any manner whatsoever without written permission except in the case of brief quotations embodied in critical articles and reviews. For information address HarperCollins Publishers Inc., 10 East 53rd Street, New York, NY 10022.

HarperCollins books may be purchased for educational, business, or sales promotional use. For information please write: Special Markets Department, HarperCollins Publishers Inc., 10 East 53rd Street, New York, NY 10022.

First Perennial edition was published 2005.

Designed by Cassandra J. Pappas

The Library of Congress has catalogued the hardcover edition as follows:

Yalom, Marilyn. Birth of the chess queen : a history / Marilyn Yalom.

p. cm.

Includes bibliographical references (p.) and index.

ISBN 0-06-009064-2

1. Queen (Chess)-History. 2. Chess-History. 3. Queens-History.

I. Title.

GV1451.5.Q43Y35 2004

794.1'46-dc22

2003062456

ISBN 0-06-009065-0 (pbk.)

05 06 07 08 09 \$/RRD 10 9 8 7 6 5 4 3 2 1

For Irv, who introduced me to chess and other wonders

Waking Piece

The world dreams in chess Kibitzing like lovers

> Pawn's queened redemption L is a forked path only horses lead. Rook and King castling for safety Bishop boasting of crossways slide.

Echo of Orbit: starless squared sky. She alone moves where she chooses.

Protecting helpless monarch, her bidden skill. Attacking schemers, plotters, blundered all.

Game eternal.

War breaks.

She enters.

Check mate.

Hail Queen.

How we crave

Her majesty.

-GARY GLAZNER

Contents

Acknowledgments	xiii
Introduction	xvii
Selected Rulers of the Period	xxv

PART I . THE MYSTERY OF THE CHESS QUEEN'S BIRTH

One	Chess Before the Chess Queen	3
Two	Enter the Queen!	15
Three	The Chess Queen Shows Her Face	31

PART 2 . SPAIN, ITALY, AND GERMANY

Four	Chess and Queenship in Christian Spain	43
Five	Chess Moralities in Italy and Germany	67

PART 3 • FRANCE AND ENGLAND

Six Chess Goes to France and England	ix (Chess	Goes	to	France and	England	
--------------------------------------	------	-------	------	----	------------	---------	--

83

XII · CONTENTS

Seven	Chess and the Cult of the Virgin Mary	107
Eight	Chess and the Cult of Love	123

PART 4 • SCANDINAVIA AND RUSSIA

Nine	Nordic Queens, On and Off the Board	151
Ten	Chess and Women in Old Russia	173

PART 5 • POWER TO THE QUEEN

Eleven	New Chess and Isabella of Castile	191
Twelve	The Rise of "Queen's Chess"	213
Thirteen	The Decline of Women Players	227

Epilogue	•				237
Notes					243
Index					257

Color illustrations follow page 160.

Acknowledgments

This book would not have been possible without the vast philological, archaeological, literary, and art historical research of previous writers, most notably from Germany and England. With deference to my predecessors, many of whom were serious chess players and almost all of whom were men, I have called upon my long experience as a feminist scholar to cast a new light on the game and its most paradoxical figure.

Two libraries rich in chess materials and four knowledgeable librarians opened their resources to me. At the Cleveland Public Library, Steven Zietz and Jeffrey Martin helped me explore the amazing John White Chess Collection. Similarly, at the Royal Library in The Hague, Henk Chevret and Henriëtte Reerink shepherded me through their enormous chess holdings. My heartfelt thanks to these institutions and their courteous curators.

My home base at the Institute for Research on Women and Gender at Stanford University provided me with library resources and supportive colleagues. Above all, Institute Senior Scholar and historian Susan Groag Bell severely critiqued the manuscript from the first page to the last. Thanks also to Institute Affiliated Scholars, mathematician Alice Silverberg, and sociologist Ashraf Zahedi for useful comments on the epilogue.

I am indebted to many other individuals. Professor Kathleen Cohen from the Art History Department at San Jose State followed the progress of this book over the course of several years, enthusiastically sharing her knowledge of relevant artworks and providing one of the photos. Professor Leah Middlebrook of the University of Oregon was an astute critic of the Spanish chapter in its first version. Professor Brigitte Cazelles of Stanford University gave me early leads on medieval French material. Professor Danielle Trudeau from San Jose State also counseled me on pertinent French texts. For the Scandinavian section, I wish to thank the literary scholar Dr. Vera Føllesdahl and the historian of early North Atlantic exploration Kirsten Seaver, as well as Peter Carelli of the University of Lund and the Swedish/Finnish writer Stina Katchadourian. Professor David Goldfrank of Georgetown University was extremely helpful in reviewing my Russian chapter. Professor Hester Gelber from the Stanford Religious Studies Department gave me advice concerning the cult of the Virgin Mary. Professor David Riggs of the Stanford English Department helped elucidate a sixteenth-century poem on chess. Ira Lapidus, Emeritus Professor of History at the University of California/Berkeley, prevented me from making errors in matters of Muslim history. The British chess historian Victor Keats offered important information on Spanish Jewish contributions. Berkeley Professor of Comparative Literature Robert Alter commented judiciously on a Spanish Hebrew text. Medievalist Roswitha Woolev helped with translations from Middle High German. Biographer Peggy Liss shared relevant information from the reign of Queen Isabella of Castile. Ambassador Juan Duran Loríga facilitated research in the Spanish Royal Library. Christophe Reisner, who directs the Göttingen Literary Fair, arranged crucial contacts for me in Germany. Father P. Odo Lang, OSB, from the Library at the

Benedictine Abbey in Einsiedeln, Switzerland, provided essential information on the earliest known document mentioning the chess queen. Author David Shenk, who is writing another history of chess, added thoughtful comments on my final manuscript.

Sharlette Visaya, Stanford graduate student in the Modern Thought and Literature program, fulfilled the role of the perfect research assistant.

My son, Ben Yalom, worked on the developmental stages of the book, helping to provide a structure for its varied historical material, and carefully edited its final version for publication.

A very special thanks to my editor at HarperCollins, Julia Serebrinsky, who saw the merit of this quirky book from the start and never lost faith. Her guidance and editorial suggestions were of inestimable value. Similarly, my literary agent and good friend, Sandra Dijkstra, supported me in countless ways.

As always, my husband, Irvin Yalom, was my partner in this venture. When one has an enlightened king at one's side, it's easy to be a queen.

Introduction

Books are born in unexpected ways. This one grew out of a misconception. While preparing for a lecture at the Isabella Stewart Gardner Museum in Boston on my book *A History of the Breast*, I was shown a small ivory figure of a Madonna and Child by one of the curators, who referred to it as a "chess queen." This figure of Mary suckling the baby Jesus captured my imagination. How could a fourteenth-century nursing Madonna be a chess queen?

I discussed this so-called chess piece in my lecture on "Breasted Visions" at the Gardner in 1998, but with more questions than answers. Little did I know then that I would spend the next five years tracking down every surviving medieval chess queen to determine whether the Gardner figure did or did not belong on a chessboard. (See chapter 7 for my conclusions.)

During those years, I became fascinated with the chess queen as an icon of female power. How did she come to dominate the chessboard when, in real life, women are almost always in a position of secondary power? What is her relationship to the other chessmen? What can she tell us about the civilization that created her? Consider the chess queen as she exists today. She is an awe-

XVIII • INTRODUCTION

some warrior who can move in any direction—forward, backward, to the right, to the left, and diagonally—one space at a time or across the entire board. In a microcosm where all movement is strictly regulated, she defies the narrow constraints that bind the rest of her army.

Initially, she sits at the side of the king, as befits a royal spouse. During the game, she charges forth to protect her lord and destroy their enemies. If necessary, she may give her life in combat, for ultimately it is the king's survival that counts. This is the paradox of chess: he is the crucial figure, even if she is more potent.

But this scenario did not always exist. Before the birth of the chess queen, there was no queen at all on the chessboard. In India, Persia, and the Arab lands where the game was first played, all the human figures were male. These consisted of the king, his general or chief counselor called a vizier, and a line of foot soldiers. There were also, as in real Indian armies, chariots, horses, and elephants. It was only after the Arabs invaded Southern Europe in the eighth century and brought chess with them that the queen appeared on the board. Around the year 1000, she began to replace the vizier, and by 1200, she could be found all over Western Europe, from Italy to Norway.

This event, miniscule in the great order of things, raises major questions about the position of women during the Middle Ages. In what ways did her birth reflect the power of real-life queens and highborn ladies? In contrast to the Near East, where the vizier was the shah's second-in-command, the European queen was the king's other half, his trusted companion, his deputy when he was absent or incapacitated. The Christian monogamous ideal, which paired one husband and one wife, stood in contrast to the polygamous possibilities allowed Muslim men, and the pairing of king and queen on the chessboard symbolized a partnership more significant and more enduring than that of a king and his chief minister. It also reflected another difference between a European queen and the wife of an Eastern potentate: the European queen expected to share political power with her husband, especially if she had brought territorial holdings into the marriage. In countries like Spain and England that allowed for daughters to inherit thrones from their fathers in the absence of a male heir, some queens even ruled on their own, without the benefit of a spouse.

In India, where chess had originated in the fifth century, it would have made no sense to have a queen on the board. Chess was resolutely and exclusively a war game enacted between male fighters mounted on animals or marching on foot. This same pattern made its way into Persia and the Arabic lands, with only slight modifications. To this day, the Arabic game is played with a vizier and an elephant, having resisted the changes that took place in Europe a thousand years ago.

When the Arabs carried the game across the Mediterranean into Spain and Sicily, chess began to reflect Western feudal structures and took on a social dimension. The queen replaced the vizier, the horse was transformed into a knight, the chariot into a tower (today's castle or rook), the elephant into a bishop (though in France, it became a jester, and in Italy, a standard bearer). Only the king and the foot soldier (pawn) at the two ends of the hierarchy remained exactly the same.

The Indian game had been played with naturalistic chessmen intended to look like a miniature army. But in the Arab world, after the death of Muhammad in 632, Muslim players transformed these realistic pieces into abstract ones because the Koran, like the Hebrew Bible, prohibited the portrayal of living creatures. Then, following the Arab invasion of Southern Europe in the eighth century, as chess made its way up the Spanish and Italian peninsulas, it came in contact with artisans who had no inhibitions about depicting human beings and animals realistically as in the original Indian sets. A foot soldier could be shown standing on two sturdy feet with shield and sword in front of him.

XX • INTRODUCTION

The mounted knight was furnished with reins and stirrups. The elephant, unknown to Europeans, became a bishop with a twopronged miter or a jester wearing a cap with two bells—probable transformations of the elephant's tusks. The king and queen sat on thrones, wore crowns on their heads, and carried scepters or orbs in their hands. One could see on the chessboard the very same people who walked or rode through medieval streets, prayed in Romanesque churches, and presided over royal assemblies.

We know relatively little about the transmission of chess from the Muslim to the Christian world and even less about the invention of the first chess queen. Where did she first appear? Was there a living sovereign who inspired this innovation? What was the reaction of the chess carver when his patron commissioned a set with a queen instead of the traditional vizier? Did the fact that girls, as well as boys, commonly played chess have anything to do with the advent of the queen on the board? Did women—queens and other highstatus ladies—bring a new dimension to the game that would not have existed without them? These are some of the questions that obsessed me as I followed the traces of the medieval game from texts, images, and other artifacts, and tried to reconstruct the civilization that had borne and nurtured the chess queen.

But there is a second part to this puzzle. The chess queen did not start out as the mightiest piece on the board. In fact, like the vizier, she was initially the weakest member of her community, allowed to advance only one diagonal square at a time. Yet, by the end of the fifteenth century, she had acquired an unparalleled range of movements. In 1497, when Isabella of Castile reigned over Spain and even those parts of the New World discovered by Columbus, a Spanish book recognized that the chess queen had become the most potent piece on the board. This book, written by a certain Lucena and titled *The Art of Chess (Arte de axedres)*, was a watershed dividing "old" chess from "new" chess—the game we still play today. It is fitting that the chess queen reached the summit of her power under the rule of Isabella of Castile, the most renowned Spanish queen of all time. This convergence of queen and icon begs another set of questions: Was the evolution of the chess queen related to the increased prominence of queens during the late Middle Ages? What political and cultural events should be taken into account as one considers the five-hundred-year period between the chess queen's timid emergence and her elevation into the game's mightiest figure?

During the eleventh and twelfth centuries, when the chess queen was driving the vizier from the European board, there were numerous currents favorable to the idea of female power. The first was the reality of Christian queenship, which had taken its distinctive shape during the early Middle Ages. The queen was, first and foremost, the king's wife, his faithful partner, helpmate, and loyal subject. Like the Eastern vizier, she was also a giver of advice, especially on issues concerning kinship, but even in matters of diplomacy and warfare. Her official duties included intercession with the king on behalf of various petitioncrs, be they members of the nobility, clergy, or laity.

On a more intimate level, she was expected to preside over the royal household, with chief administrative responsibility for providing food, clothing, rest, and entertainment. Even more intimately, she was expected to produce children. This was her most important function, since only the king and queen's heirs could ensure dynastic stability.

Most queens, as well as duchesses and countesses, became rulers by virtue of marriage to a reigning sovereign and were then known as queens consort. If they were widowed, some were appointed queens regent until the heir apparent came of age. Precious few women were queens regnant, ruling by right of inheritance, like the Spanish queen Urraca of León and Castile, who received her kingdom directly from her father in 1109. At a

XXII • INTRODUCTION

somewhat lower level, many noblewomen with inherited titles assumed full responsibility for their fiefs. Even after marriage, they did not automatically turn over authority to their husbands. Such heiresses did homage to their superiors—kings, emperors, and popes—in formal ceremonies that acknowledged their feudal allegiance. Some became de facto rulers of their domains when their husbands went off to the Crusades, beginning with the First Crusade in 1095.

A second cultural current that coincided with the chess queen's birth and reinforced the institution of queenship was the cult of the Virgin Mary. From the eleventh century onward, the miraculous birth of Jesus became the subject of countless poems, hymns, narratives, and theological treatises. Hundreds of churches were dedicated to Our Lady, with mother and child represented in sculpture, wall paintings, and stained glass. In her privileged maternal position, Mary could be appealed to for intercession with the Lord, or she might produce miracles on her own. Mary in her various incarnations as the Mother of God, the Bride of Christ, and the Queen of Heaven became an object of unrivaled worship throughout medieval Christendom.

A third influence was the cult of romantic love. The adoration of a beautiful lady, often the wife of a king or powerful noble, was first celebrated by troubadours in the South of France and then exported to all the courts of Europe. Chess soon became associated with good breeding and "courtesy." The knight who wanted to be considered "courteous" was expected to be able to play chess well, with female as well as male adversaries. The game allowed the two sexes to meet on equal terms, and sometimes served as a cover for romance. Both Mariolatry and its secular opposite—the cult of romantic love—contributed to the rise of the chess queen.

We shall follow the spread of chess, region by region, from India, Persia, and the Arab lands to Spain, Italy, and Germany;

INTRODUCTION • XXIII

France and England; Scandinavia and Russia. Simultaneously, we shall encounter the significant queens, empresses, countesses, duchesses, and marchionesses reigning in each country. The interplay between symbolic queens on the chessboard and living queens at numerous royal courts provides the woof and warp of this book. While there were few women rulers before the fifteenth century whose names can be definitively linked to the game, the reality of female rule was undoubtedly entwined with the emergence and evolution of the chess queen. In time, the chess queen would become the quintessential metaphor for female power in the Western world.

Selected Rulers of the Period

Muslim Rulers

8

786-809	Reign of Caliph Harûn al-Rashîd in Baghdad
822-852	Reign of Caliph Abd al-Rahman II of Córdoba
913–961	Reign of Caliph Abd al-Rahman III of Córdoba
hristian	Spanish Rulers
95?—970	Toda Asnárez of Navarre, widow of Sancho Garcés, King of Pamplona (died 925)

975–1058 Ermessenda, countess of Barcelona, widow of Count Ramón Borrell (died 1017)

1172-1109	Reign of Alfonso VI, king of León-Castile
1109–1126	Reign of Urraca, queen of León-Castile
1252-1284	Reign of Alfonso X, king of León-Castile
1474-1504	Reign of Isabella of Castile and Ferdinand
· · · ·	of Aragón

German and Italian Rulers

931-999	Adelaide, German queen and Holy Roman
	Empress, widow of Otto I (died 973)
958?-991	Theophano, German queen and Holy Roman

Empress, widow of Otto II (died 983)

- 1046–1115 Matilda of Tuscany
- 1154–1198 Constance of Hauteville, queen of Sicily and Holy Roman Empress, widow of Henry IV of Hohenstaufen (died 1197)
- 1194–1250 Frederick II, king of Sicily and Holy Roman Emperor

French and English Rulers

1121?-1180	Louis VII, king of France
	(reigned 1137–1180)
1122-1204	Eleanor of Aquitaine, queen of France
	(1137–1152) and queen of England
	(1154–1189)

1133–1189	Henry II, king of England (reigned 1154–1189)
1165–1223	Philip Augustus, king of France (reigned 1180–1223)
1187–1226	Louis VIII, king of France (reigned 1223–1226)
1188—1252	Blanche of Castile, queen of France (1223–1226) and regent (1226 and 1248–1252)
1214–1270	Louis IX, king of France (reigned 1226–1270)

Scandinavian Rulers

969–1000	Olav Trygvason, king of Norway
1353-1412	Margaret of Denmark, regent in Denmark
	as of 1387, ruler in Norway as of 1388,
	ruler in Sweden as of 1389

Russian Rulers

1672-1725	Peter the Great, Russian emperor
	(reigned 1682–1725)
1729–1796	Catherine the Great, Russian empress
	(reigned 1762–1796)

PART I

The Mystery of the Chess Queen's Birth

ONE

Chess Before the Chess Queen

hough historians still debate the exact origins of chess, most agree that it emerged in India no later than the sixth century. In Sanskrit, the game was called *chaturanga*, meaning "four members,"

which referred to the four parts of the Indian army: chariots, elephants, cavalry, and infantry. This fourfold division, plus the king and his general, provided the basic pieces of the game, first in India and then throughout the world.

Chess in Persian Literature

The first definite literary reference to chess comes not from India but from Persia. In an ancient romance called *Kārnamāk*, written around 600 in Pahlavi (the writing system of Persia before the advent of Islam), chess already commanded the great esteem it would hold for centuries to come.¹ The Persians took from the Indians the essentials of the game—the six different figures, the board with sixty-four squares—and rebaptized the pieces with Persian names. This new nomenclature was to have enduring significance far beyond the East, for *shah*, the Persian word for "king," ultimately served as the name of the game in several European languages by way of the Latin *scacchus: scacchi* in Italian, *Schach* in German, *échecs* in French, and chess in English, among others.

The Persian epic Book of Kings (Shah-nameh), written by the great poet Firdausi (c. 935-1020), gives an amusing account of how chess made its way from India to Persia. As the story goes, in the sixth century the raja of India sent the shah a chess set made of ivory and teak, telling him only that the game was "an emblem of the art of war," and challenging the shah's wise men to figure out the moves of the individual pieces. Of course, to the credit of the Persians (this being a Persian story), one of them was able to complete this seemingly impossible assignment. The shah then bettered the raja by rapidly inventing the game of "nard" (a predecessor of backgammon), which he sent back to India with the same challenge. Despite its simplicity relative to chess, the intricacies of nard stumped the raja's men. This intellectual gambling proved to be extremely costly for the raja, who was obliged to pay a heavy toll: two thousand camels carrying "Gold, camphor, ambergris, and aloe-wood,/As well as raiment, silver, pearls, and gems,/With one year's tribute, and dispatched it all/From his court to the portal of the Shah."²

Another story in the *Shāh-nāmeh* tells how chess was originally invented. In this tale, an Indian queen was distraught over the enmity between her two sons, Talhand and Gav, half brothers with respective claims to the throne. When she heard that Talhand had died in warfare, she had every reason to think Gav had killed him. The sages of the kingdom, the tale has it, developed the chessboard to recreate the battle, and show the queen clearly that Talhand had died of battle fatigue, rather than at his brother's hands. The Persian term *shāh māt*, used in this episode, eventually came down to us as "check mate," which literally means "the king was dumbfounded" or "exhausted," though it is often translated as "the king died."

The *Shāb-nāmeh* version of the birth of chess vied with another popular legend in which a man named Sissa ibn Dahir invented the game for an Indian king, who admired it so much that he had chessboards placed in all the Hindu temples. Wishing to reward Sissa, the king told him to ask for anything he desired. Sissa replied, "Then I wish that one grain of wheat shall be put on the first square of the chessboard, two on the second, and that the number of grains shall be doubled until the last square is reached: whatever the quantity this might be, I desire to receive it." When the king realized that all the wheat in the world would not suffice he commended Sissa for formulating such a wish and pronounced it even more clever than his invention of chess.³

While no Indian or Persian chess pieces have survived from this early period, later pictures of Indian and Persian men playing chess give us an idea of what a match must have looked like. Usually, the chessboard is a white cloth divided by vertical and horizontal lines. The illustration included here, found in a fourteenth-century manuscript of the *Shāh-nāmeh*, depicts a Persian noble playing with an envoy of the Indian raja.

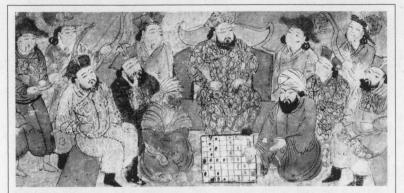

Leaf from *Book of Kings (Shāh-nāmeh*) written by Firdausi (circa 935–1020) showing a Hindu envoy and a Persian noble playing chess at the court of Khusrau I. Persian, early fourteenth century.

Chess in Muslim Theology

In 638, six years after the death of the prophet Muhammad, Arab conquerors under the leadership of Caliph Omari overran Persia to spread the gospel of Islam. (A caliph is the supreme ruler of the Muslim community in both religious and secular matters.) As they moved on, they brought chess with them, spreading the game to such far-flung destinations as Spain (conquered in 711) and Northern India (1026). Arabic became the dominant language in many of these conquered lands, and some of the chess pieces took on Arabic names (*al-fil* for elephant, *baidak* for pawn, and *firzan, firz*, or *ferz* for the general or vizier), while others retained their Persian labels (*shah* for king, *rukh* for rook, *asp* for horse).

While the Muslims were clearly enthralled with the game, chess sets with pieces resembling humans and animals appeared suspect to them, probably because of a passage in the Koran that reads: "Believers, wine and games of chance, idols and divining

CHESS BEFORE THE CHESS QUEEN • 7

arrows, are abominations devised by Satan. Avoid them, so that you may prosper."⁴ Sunni Muslim theologians took this ban on "idols" to include all representations of humans and animals, in forms as diverse as painting, sculpture, and chess pieces. In contrast, Shi'ite Muslims gave this a narrower interpretation, limiting the meaning to religious idols.

On the whole, the Sunni interpretation prevailed, and realisticlooking Indian and Persian chessmen were transformed into abstract pieces. Curiously, the prohibition against realistic representation has never been applied universally. Court culture often ignored it, as in numerous Persian works of art, even though symbolic figures became the norm on the chessboard.

In general, Muslims held that chess was permissible as long as it was played with nonrealistic pieces, did not interfere with the

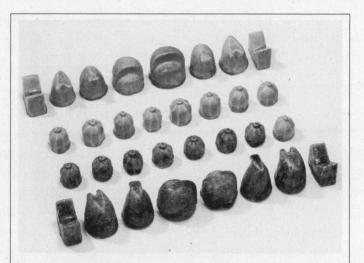

Abstract Islamic chessmen said to have been found at Nishapur. The king and vizier (ancestor of the queen) are represented by two identical abstract thrones placed in the center of the first row. The only difference between them is that the piece representing the vizier is smaller. Persian, twelfth century.

performance of religious duties, was not played for money, and did not lead to disputes or foul language. Mālik, an influential eighth-century jurist and head of a Muslim theological school, took a harsher view: he is reported to have said that "there was nothing good about chess" and pronounced it *haram*, an expression classifying it as forbidden and deserving punishment.⁵ From time to time during the following centuries, a strict caliph would issue a blanket prohibition of the game and order the destruction of all sets.⁶

This extreme position was found in the last decades of the twentieth century under the Ayatollah Khomeini in Iran, where chess was banned from 1979 to 1988, and the Taliban in Afghanistan, who lumped chess together with movies, television, alcohol, nail polish, kites, billiards, firecrackers, and secular music. Afghanis found enjoying these "unclean things" were subject to whipping and imprisonment. Not surprisingly, when Afghanistan was liberated from the Taliban, the first objects to be taken out of hiding were radios, musical instruments, and chess sets.

Chess Under the Caliphs

Despite such ultra-orthodox prohibitions of the game throughout its embattled history, chess has survived and prospered in Muslim circles. No less a figure than the famous Caliph Harûn al-Rashîd, who reigned in Baghdad from 786 to 809, is credited with popularizing the game. Along with backgammon, polo, archery, and racket games, chess became an exemplary court activity. If you wanted to shine in Harûn's presence, skill in chess was a sure way to catch the light. Unusual prowess, like being able to play blindfolded, could bring admittance to high society as well as great riches, even for those of humble origins. An analogy with the pawn promoted to the rank of vizier once it had crossed the board ("queened" in today's language) was appropriated for someone who rose from lowly beginnings to achieve worldly success.

Harûn's lavish gifts to those who won his favor have become legendary. Hundreds of gold pieces, prized slave girls, silk robes, and even thoroughbred horses were offered by Harûn or his beloved wife, Zubaidah, to lucky members of their entourage. A poet producing verses that touched Harûn's heart or a chess player unfolding a remarkable combination might become the recipient of a fabulous reward. One of the stories in *The Arabian Nights* tells how Harûn paid ten thousand dinars for a slave girl known to be a fine chess player. After he had lost to her three times in succession, he rewarded her by commuting the sentence of a certain Ahmad b. al-Amin, presumably her lover.⁷

Whether this story had any factual basis whatsoever, Harûn's interest in chess is a matter of historical record. In 802, when Emperor Nicephorus succeeded Empress Irene to the Byzantine throne, his greetings to Harûn used a chess metaphor to describe his discontent at their current relations: "... the Empress to whom I have succeeded estimated you as of the rank of the Rook, and estimated herself as of the rank of the Pawn, and paid a tribute to you, which you rightly should have paid to her. But this was because of a woman's weakness and folly."⁸ The new emperor felt that the former empress had underestimated herself vis-à-vis the caliph, and demanded that Harûn return the tribute. The matter was ultimately settled in battle, and Nicephorus, whose forces were soundly beaten, was compelled to continue the tribute that Irene had paid without bloodshed. Perhaps she was not a victim of weakness and folly, but a practitioner of sober Realpolitik.

Arabic Women Players

That Empress Irene spoke the language of chess was not unusual, as high-status Byzantine women and Muslim women from various social levels have played chess ever since the game was introduced into their homelands. For example, Ali ibn Husayn, a great-grandson of the prophet Muhammad, is reputed to have played with his wife. Caliph Ma'mûn, the brother of Caliph Amin of Baghdad (reigned 809–813), is reported to have bought a female slave for the lofty price of two thousand dinars, in no small part because of her great skill as a chess player. Stories of clever women had wide currency in the Arab world, especially those about well-educated slaves taught to recite poetry, play the lute, and excel at chess. Sometimes they even offered assistance to a prestigious male so he could beat his opponent, as in the competition between two famous scholars, Sûlî and Mâwardî, during the first decade of the tenth century.⁹

In addition to these semihistorical accounts, a wealth of chess stories featuring women formed part of medieval Islamic fiction. These stories often took the form of a contest between the sexes, with the possibility that the winner might be a woman intensifying the excitement. In one such tale, the beautiful maiden Zayn al-Maswâsif invites Masûr, a love-struck suitor, to play chess using a set made of ebony and ivory, and encrusted with pearls and rubies. They begin to play, but Masûr becomes so obsessed with her fingertips that he is unable to concentrate on the game, and is quickly defeated.

A similar story from *The Arabian Nights* pits the Muslim prince Sharkân against the Christian princess Abrîza. The princess is the leader of a group of beautiful young girls, who enjoy such unfeminine activities as wrestling. After the prince has secretly watched

CHESS BEFORE THE CHESS QUEEN • II

the princess defeat a series of female opponents, he makes himself known and challenges her to unarmed combat. Although he is her physical equal, he becomes so dazed by the touch of her body that he, too, loses—no fewer than three times! The princess then offers him hospitality, and, on one of the following nights, challenges him to a chess match. Again the prince is distracted, this time by looking at her beautiful face during the game. He is once again undone, and once again defeated. Predictably, the two fall in love, Abrîza is converted to Islam, and they depart for the court of the prince's father.¹⁰

We shall see in later chapters how the theme of chess matches between the sexes is taken over, but treated differently, by European authors. In those equally biased tales, it is usually the exotic Arab princess who becomes distracted by the beauty of the European male, and, if a conversion is made, it is invariably from Islam to Christianity.

Fictional tales like these, as well as the game itself, arrived in Spain with the Arab conquerors. Chess was introduced at the court of Córdöba, the seat of Spanish Islam, in 822 by an influential musician from Baghdad named Ziriab.11 He also brought the new modes of Arabic poetry and song practiced in Baghdad, all of which quickly took root in this new land. By the tenth century, Córdoba had become the acknowledged equal of Baghdad in wealth, splendor, and cultural achievements. The mighty caliph of Córdoba, Abd al-Rahman III (reigned 913-61), established a luxurious and sophisticated court that was admired by ambassadors from both East and West. Chess figured prominently in this cosmopolitan setting where Muslims, Christians, and Jews played the game together, the women as well as the men. Christians and Jews, it should be noted, were legally protected from persecution in Islamic Spain as long as they did not proselytize or make a public show of their faith. The period of rule by the Omayyid caliphs (756-1013) became known as a "golden age" for Muslims and Jews.

Queen Toda of Navarre

Caliph Abd al-Rahman III was the nephew of the legendary Christian queen Toda of Navarre. Like other visitors to his court, she would have encountered chess there, and then returned to her own kingdom familiar with the game. Queen Toda's story reveals so much about the interchange between Islamic and Christian Spain, as well as the status of queenship in this era, that I shall recount it at some length. Queen Toda Asnárez of Navarre was the major political figure of tenth-century Spain, overshadowing all the other Christian sovereigns, male or female. Those sovereigns ruled over small principalities in the North—Galicia, Asturias, León, Castile, Navarre, Aragón, Catalonia—each jockeying for power, and all mindful of the greater Muslim power that occupied the rest of the Iberian peninsula.

The success or failure of the Christian kingdoms was largely determined by the character of their rulers. A successful king had to be a fierce warrior, and a queen, too, could not shrink from the sight of blood. She was often expected to accompany her husband at the head of an army or, if need be, lead troops into battle on her own. Both kings and queens had to be skillful politicians, forming alliances with influential members of the nobility and clergy, and administering their realms with untiring vigilance.

For the most part, in Spain as elsewhere in Europe, daughters from noble or royal families became queens by marrying the inheritors of thrones. This was the case for Queen Toda when she married Sancho Garcés, king of Pamplona, around 912. She quickly became known as an intelligent coruler, but it was upon her husband's death in 925 that she transformed herself into an awe-inspiring regent. For many years, she wielded great power as the force behind the throne of her son, García Sánchez, who was only six when his father died. It is clear from both Christian and

CHESS BEFORE THE CHESS QUEEN • 13

Arab documents that she was seen in the Muslim world as the true ruler of the kingdom—the decisive voice in politics, diplomacy, and the military.¹² Even after García Sánchez married in 943, Queen Toda's name often appeared in royal documents rather than that of the new queen, her son's wife. Sometimes a charter read, "I, García Sánchez, King by the grace of God, together with my mother Queen Toda," and sometimes it read, "together with my wife Queen Teresa." There is good reason to believe that powerful dowager queens like Toda enjoyed a special status superior to that of their sons' wives.

Toda's children—four daughters and a son—were partially the key to her success. She married each one advantageously so as to create a network of influence throughout the Iberian peninsula. From her seat in Pamplona on the French border, she manipulated the long tendons of power that extended east to León and Castile, west to Aragón, and even south to Córdoba, the resplendent Muslim capital that outstripped all the other peninsular cities in size and wealth.

But Toda's dominance did not go uncontested. Her son-in-law Count Fernán González of Castile was equally ambitious. A bold warrior and astute politician, he had fought his way up from obscurity to become the greatest landowner in Castile and a dominant presence in the neighboring kingdom of León through the marriage of his daughter to the reigning monarch. However, with that king's early death, Queen Toda seized the chance to push her grandson Sáncho onto the Leónese throne.

As Fernán González was not one to give up control without a fight, it was necessary to war against him. Queen Toda and King Sáncho formed a coalition of military forces, including Toda's nephew Caliph Abd al-Rahman III of Córdoba. González was ultimately defeated and compelled to accept Sáncho as king of León.

Sáncho's problematic right to the throne was compounded by a major physical impediment. He was so obese that he could not mount a horse, which was an absolute prerequisite for a king.

Desperate to create a better image for her grandson, Toda asked Abd al-Rahman whether his personal physician, the internationally famous Jewish doctor and statesman Hasdai ibn Shaprut, would treat Sáncho. When Hasdai visited Toda and Sáncho in Pamplona, he insisted that the patient come for treatment to Córdoba, accompanied by his grandmother. Toda and Sáncho accordingly went off to Córdoba, where he endured a lengthy diet, and she had the satisfaction of seeing her slimmed-down grandson reinstalled on the throne of León in 959. (Sadly, despite his efforts, Sáncho has come down in history as "Sáncho the Fat.")

Queen Toda treated royal politics as a family affair. Daughters, sons, and their spouses, grandchildren, nieces, and nephews were all subject to her dominion. Toda was not limited by her sex; she simply found cunning ways of manipulating circumstances to her advantage. Though she became a queen through marriage and an even more powerful one through widowhood, she established a model of fierce matriarchal rule that would be used by numerous queens during the next centuries.

Abstract Chessmen in Spain

In tenth-century Spain, whether in Muslim or Christian territories, chess would have been played with abstract pieces representing the king, vizier (predecessor of the queen), elephant (predecessor of the bishop), horse (predecessor of the knight), rook, and pawns. Even after realistic pieces had been introduced, abstract chess sets continued to dominate the Spanish scene. And although the chess queen was known elsewhere in Europe by the year 1000, her definite presence in Spain can be traced back only to the twelfth century. Surprisingly, it was not south of the Pyrenees, but in the shadow of the Alps, that the chess queen made her first recorded appearance. Read on.

TWO

Enter the Queen!

o witness has left behind an announcement of the chess queen's birth. The first recorded sighting appears in the musty leaves of a Latin manuscript preserved in the Einsiedeln Monastery in

Switzerland for over a thousand years. In the late 990s, a German-speaking monk wrote a Latin poem of ninetyeight lines titled "Verses on Chess" ("*Versus de scachis*") that contains both the first European description of chess and the first evidence that the chess queen had been born.¹

Let us try to imagine the atmosphere within the monastery when this anonymous monk wrote what is now called the Einsiedeln Poem. As a Benedictine, he would

dendo demonstration of a dinferiora permitter. Disposioner and dun for fire mining police fuerot. loca uacuo interdutiforer notienariti pdif ferentia - gributto · qui minarem ditufore ueldunforer. admarore levabro. de hic no uenarius uccenere differences potensmi EN LEAE RATEDONE ין עלומאיז דרייסיים andida fifider fuerte fibr primarabella Noncolor aborrur. hine aliquanda copr. Hoc mer e pedrer siguando par mbostem. Ordinis adfinem cumo meare pores. Namfic concordant obliquo tramite defa. Utireana hic good d'illa quear. AA quor usernor dominis curuola notain. Transuer to curfu. At loca pauca persone. Primo diffirmate non aliquando pere portoria abula non aliquando pere Qu'a fir regine difformer ille maer ille " reterea cur fur equiter garola facettures Sun quib, oblique multiplicerq gradup Dumprima sede quiquis contempnit core. Difeolor aprima tereta carpie reer. Sicatemain tende mic illumg, colore. Gretiba urourno ene tabella quear .

Manuscript page from the Einsiedeln Poem, circa 997, containing the first recorded mention of the chess queen (*regina*) and preserved for more than a millennium at the Einsiedeln Monastery in Switzerland.

have spent hours reading the Bible and the writings of the Church Fathers, in addition to following the daily rituals of his order. Yet he found time to compose a nonreligious poem on a game that would prove controversial within the Church, and would even be prohibited by various ecclesiastical authorities. What did he have in mind when he set down the rules of the game with obvious enthusiasm and precise detail?

The Einsiedeln Poem began by praising chess as a unique game that required neither dice nor a stake. This was an obvious attempt to counter religious opposition to games of chance, especially those involving gambling. The poem then described everything one needed to know in order to play. As the following summary of the poem shows, the rules were somewhat different from today's, but beyond these differences, one could indeed create a chess set and play, given the information provided.

The board must have sixty-four squares and two colors, so as to make the moves easier to follow. (This contrasted with the Arabic board, which was unicolored and divided only by vertical and horizontal lincs.) The thirty two chessmen, sixteen on each side, have to be colored white and red. The pieces are named: *rex* (king), *regina* (queen), *comes* or *curvus* (count or aged one, today's bishop), *eques* (knight), *rochus* (rook), and *pedes* (pawn).

The game begins by moving a pawn to the square in front of it. Pawns capture another piece by taking it diagonally on an adjacent square of the same color. The king can move to any adjacent square, but the queen can move only to a diagonal adjacent square, always of the same color. (This made her the weakest piece on the board, after the pawn.) A pawn that reaches the eighth row can move afterward like the queen, provided the original queen is no longer on the board. The count or aged one moves diagonally to the third square of his original color. The knight moves to the third square of a different color—two steps straight ahead, then one step on the diagonal. The rook goes in a straight path as far as the player wishes. The knights and rooks are the chief fighting forces, and should be carefully guarded. The king can never be taken, but when he is under attack and surrounded so that he can no longer move, the game comes to an end.²

It is worth noting that this monk treated the presence of the chess queen on the board as no more remarkable than that of the other pieces. The transformation from vizier to queen was already a fait accompli, at least in the mind of this Einsiedeln monk. But the transformation from elephant to bishop had reached only a halfway stage: "counts" or "elders" were the German ancestors of

the future bishops. During the tenth, eleventh, and twelfth centuries, bishops wielded enormous power as administrators of church moneys, properties, and even armies of their own. Their traditional collaboration with royalty was eventually reproduced on the chessboard, where they took their place flanking kings and queens.

The prohibition on promoting a pawn to a queen while the original queen was still on the board was an attempt to preserve the uniqueness of the king's wife, his only permissible conjugal mate according to Christian doctrine. The Arabic game did not have to face that problem because a Muslim ruler could theoretically have as many viziers as he wanted. The idea of multiple queens on the chessboard proved so anxiety-making for Europeans that it remained a subject of contention for centuries to come.

All the pieces described in the Einsiedeln Poem had the same moves they already had in Persian and Arabic chess. The significant differences from today's game are the movements of the count/bishop (no more than two squares at a time, as opposed to today's limitless diagonal movement) and the queen (one diagonal space, as opposed to any number of squares in a straight or diagonal line).

Living Models for the Chess Queen

The monk's version of the game gives us some clues as to the state of chess during that era in Europe. The canton of Einsiedeln, like the rest of Switzerland at this point, was part of the Holy Roman Empire. Further, the monastery itself had close ties to the Germanic Ottonian emperors. From this we can safely deduce that chess was already being played with a queen in the German and Italian territories under imperial rule.³ But how did she make her way onto the board? Given what we know, we can speculate on the living sovereigns who might have served as models for the miniature queen. Empress Adelaide, the wife of Otto I, and Empress Theophano, the wife of Otto II, are the most probable candidates. This duo of mother-in-law and daughter-in-law were exceedingly prominent during the last decades of the tenth century—the period during which the chess queen must have been created, since she appeared in the "Verses on Chess," circa 997, not as a novelty, but as a piece whose existence was unremarkable.

First, consider the history of Adelaide of Burgundy, the most famous of the Romano-German empresses. She was betrothed to Lothar, son of the king of Italy, when she was six and he scarcely older. They married ten years later, in 947, and spent three unhappy years together before his early death. The young widow, praised for her character and appearance, was seized by Lothar's successor, the margrave Berengar, not for himself but for his son. When she refused the proposal, Berengar imprisoned her at Como, where she remained for four months. Her daring escape from prison and her flight disguised as a peasant, with Berengar in hot pursuit, caught the imagination of her contemporaries and attracted the attention of the widowed German king Otto I. Aware of her plight and her political usefulness as a conduit to the Italian throne, he proposed that he be her husband, and she accepted.

Adelaide and Otto celebrated their nuptials in Pavia in 952. This was the beginning of a union that, bolstered by Otto's armed invasions, gradually extended German sway over Northern Italy. In 962, Pope John XII crowned Otto and Adelaide in Rome as emperor and empress of the Holy Roman Empire.

Otto, it has been said, ruled over the German duchies, Switzerland, Italy, and even the papacy "like a second Charlemagne."⁴ And from the start of their marriage, Adelaide, too, played an important role in German and Italian affairs. On the political

level, she was influential in crushing the revolt of Liudolf, Otto's son from his first wife. Like most queens, she was anxious to eliminate rivals to her own children, only two of whom survived into adulthood—Mathilda, a future abbess of Quedlinburg, and Otto II, his father's successor.

On the cultural level, she helped turn Otto I's court into a center for the revival of classical learning and the promotion of literature and the arts. Through her connections to Burgundy and Lombardy, she led the Ottonian dynasty in a new cultural direction that was less Saxon and more broadly European. Otto and Adelaide also supported monasteries and convents lavishly, establishing connections that would have long-term consequences, including—among those unmentioned in textbooks—future ramifications for the game of chess.

Adelaide's refinements of court behavior extended even to table manners. For instance, at the time it was the custom for guests to stop eating as soon as the king and queen did so. In one instance, when Adelaide's appetite failed her, she graciously held her knife aloft in her hand for an extended period, pretending she would eat more, thus allowing her guests to continue with their meal.⁵

In addition, she exercised a controlling influence over her eldest son, who became emperor as Otto II after his father's death in 973. Even though Otto II had already married the Byzantine princess Theophano in 970, Adelaide continued to rule at her son's court, at least for the first year of her widowhood. She accompanied Otto II on his inaugural progress through his lands, and her name appeared in his charters. A battle for power between the two extraordinary women ensued, perhaps best summed up by one knowledgeable historian: "There was room for only one queen in the household; the functions and power of that position could belong to one woman only. When a young king took a wife and queen it was time for his mother to bow out gracefully."⁶ Before long, Theophano gained the upper hand, and Adelaide was forced into exile. Adelaide fell entirely out of favor, and remained that way for nearly a decade until, shortly before Otto II's untimely death in 983, mother and son were reconciled, and the animosity between daughter-in-law and mother-in-law was set aside. Again their accord was primarily political, fashioned so the two women could work in concert to defend the rights of Otto III, the son and grandson respectively. Many of the child king's male relatives joined the fray, struggling for control over the boy, until he was eventually handed over to the care of the two empresses. With his care secured, Theophano once again turned on her mother-in-law, managed to eject Adelaide from power, and became sole regent for her son.

Lest we judge her too severely, let us now look at this scenario from the vantage of the younger empress. As the niece of the reigning Byzantine emperor John Tzimiskes, as the wife of Otto II, and as the mother of Otto III, Theophano expected to command the same great authority in the Germanic lands that empresses wielded in Constantinople. Her marriage in 970, when Otto II was sixteen and she at least twelve, had been an eminently political act destined to unite the pinnacles of power from East and West. The dower given by the Ottonians recognized her exalted status: written in golden ink on purple parchment that has survived to this day, it granted her extensive estates in both Italy and Germany.7 Her own dowry, consisting of luxury items such as chess pieces, perfume bottles, textiles, and other treasures, became legendary in her own time and gave rise to the subsequent belief that she deserved major credit for spreading the culture of Byzantium directly to Saxony.⁸ She commissioned a group of painters, sculptors, poets, and Greek scholars from Constantinople to work at the Western imperial court, and introduced many refined practices such as taking baths and wearing silks.

In all probability, she promoted the game of chess, since chess

had been played at the Byzantine court from at least the turn of the ninth century. Remember the unfortunate letter from Emperor Nicephorus to Harûn al-Rashîd, informing him in 802 that the late Empress Irene had compared herself to a pawn and the caliph to a rook—the letter that led to warfare, and Nicephorus's eventual defeat. Chess, called *zatrikion* in the Greek spoken at the Byzantine court, was a highly regarded skill, and would have been expected of the princess. Like Queen Toda bringing chess from the court of Córdoba to Navarre, so, too, Theophano would most likely have transmitted the game from the Eastern Empire to the West.

During the thirteen years of her marriage to Otto II, Theophano had five children—four daughters (one who died at an early age) and one son, the future Otto III. She also played a significant role as counselor to her husband on matters of state to such an extent that Otto II was often criticized for following the advice of his Byzantine wife rather than that of his council. The German nobility were doubly hostile to Theophano because she was a woman and because she was a non-Western foreigner, "the Greek," as she was unceremoniously called behind her back.⁹

When her husband died in 983, she fiercely fought off the designs of enemy dukes and princes who were eager to place a claimant other than her son on the imperial throne. She held on to her power with a firm grasp, speaking for her son in all documents, those to foreign rulers and the Italian nobility alike. Within Italy she even issued charters in her own name, and in at least one of them, a diploma issued in Ravenna in 990, she went so far as to call herself *imperator augustus*, masculine words for the emperor, instead of the more common words used for the empress, *imperatrix augusta*. The chronicler Thietmar of Merseburg praised her for her "manly watchfulness."¹⁰ Ultimately commanding the kind of respect normally reserved only for men, Theophano incarnated the strongest authority possible for a dowager queen.

As queen regent, she ruled in Italy until her early death in 991,

when she was succeeded by none other than her long-lived mother-in-law, Adelaide! Adelaide ruled for her grandson Otto III until he achieved his majority in 994, and expelled her from court on the grounds that she had, out of spite, refused his mother a memorial service. So the feud continued even after Theophano had been laid to rest.

Adelaide's posthumous insult to her daughter-in-law did not, however, destroy Theophano's memory. Her glory lived on, most notably in the monastery of Saint Salvator Maggiore in Rieti,

where a fresco painted in 975 showed her and her husband with halos around their heads.¹¹ Other images of Otto and Theophano, enshrined in books, carved into ivory, and molded into medallions, conveyed their iconic significance as the supreme reigning couple of their day.¹²

Both Adelaide and Theophano had been designated as *consors regni* in documents issued by their husbands. This meant they had institutional power that they shared with their spouses while the men were alive, and then full power as queens regent after the husbands died and before the heirs apparent came of age. If a female consort was

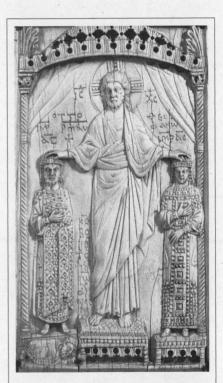

Ivory plaque, with both Greek and Latin letters, representing the coronation of the Holy Roman Emperor Otto II and Empress Theophano, 982–983.

fortunate enough to be long-lived and to have produced an heir, she might receive a bonus at the end of her life in the form of a regency, although not all would have considered widowhood a blessing and some undoubtedly were not equipped or inclined to rule. Only exceptional women like Adelaide and Theophano had sufficient confidence to take up the reins of power and govern in that interlude between male rulers.

Adelaide or Theophano?

Was it Adelaide or Theophano who served as the model for the chess queen in the Einsiedeln Poem? A circumstantial case can be made in favor of both. Both were connected to the Einsiedeln Monastery, as evidenced by charters issued in the names of Otto I and Otto III, which mentioned Adelaide three times and Theophano once. In the first charter, dated January 23, 965, Otto I "with our dear wife Adelaide" (*dilecta coniunx nostra Adalheide*) granted Einsiedeln certain properties in an exchange with another monastery. In a second, also concerning property matters, Otto I called her both "dear wife and august empress." And after Theophano had died and Adelaide was reinstated as regent, a charter granted by Otto III in 992 referred to his grandmother as "our dear Adelaide."¹³

The one reference to Theophano occurred on October 27, 984, in a text that established the monastery's freedom from paying tolls to the city of Zurich. Although issued under the name of her young son Otto III, the true donor was "our dear mother Theophano and august empress."

Theophano, like Adelaide before her, continued a tradition of strong support to monasteries, convents, and churches. We know that she frequently went in person to Gandersheim Abbey, home of the learned Benedictine nun Hrotsvitha. Contacts between Hrotsvitha and the imperial family can be inferred from her writings, and especially from her *Gesta Ottonis*, a long epic commissioned to celebrate Otto the Great.¹⁴

Theophano and Otto II sent one of their daughters, Sophia, to be educated at Gandersheim while Hrotsvitha was alive. Both Sophia and her sister Adelaide (named after her grandmother) eventually took the veil and became abbesses, Sophia at Gandersheim and Essen, and Adelaide at Quedlinburg and later at Gandersheim. Of Theophano's three daughters, only one— Mathilda—married.¹⁵

Mathilda's marriage to Ezzo, the count Palatine, is associated with a chess anecdote that is too good to be left in silence, even if its veracity is questionable. As the story goes, Mathilda was married to Ezzo, the count Palatine, after her youthful brother, Otto III, acting as her guardian, lost her to the elderly count over a chess match.¹⁶ It is impossible to determine whether this tale is true, but Otto III is known to have been a quixotic personality, so the decision to marry off his sister in this fashion is not entirely out of keeping with his character.¹⁷ We do not know the date of the event or even the age of the bride, but it probably occurred after the death of Theophano, when she was no longer in a position to influence the choice of a husband for her one marriageable daughter.

Both Theophano and Adelaide provide plausible sources for the birth of the chess queen. Both were famous during their lifetimes as consorts sharing power with their husbands and as queens regent successfully protecting their dynasty. Both were highly cultivated in the realm of art and literature, and had a working knowledge of Latin. Both have been credited with inspiring the Ottonian Renaissance at the imperial court. Both died in the 990s (Theophano in 991, Adelaide in 999), the decade during which the Einsiedeln Poem was composed. What more fitting tribute to a recently deceased empress, or one about to die, than a poem attesting to the existence of the chess queen?

Perhaps Theophano's strongest claim is rooted in the special

relationship she had to the game through her Byzantine connection, which would have familiarized her with chess at an early age. If she had been a carrier of chess from Byzantium to Western Europe, perhaps she herself suggested that the game be played with a queen. After all, a woman who had not hesitated to use the masculine title *imperator augustus* would not have feared a sex change in the other direction, from male to female, so as to represent herself on the chessboard.

Would that I could present even more convincing evidence for one or the other or both empresses! As I studied their lives and tried to determine which one should be granted the honor of having engendered the chess queen, it seemed to me as if they were still competing against each other from the grave.

In the years immediately preceding the composition of the Einsiedeln Poem, there were an unusual number of queens regent. Indeed, for a brief period in the 980s, the rule of queens regent was dominant in Western Europe. Not only were Adelaide and Theophano regents for Otto III, but Adelaide's daughter Emma was regent for the French king Louis V, the duchess Beatrice of Lorraine ruled for her minor son, and the youthful Aethelred II in England was under his mother's tutelage.¹⁸ With so many queens in positions of extraordinary prominence, it is perhaps not so surprising that the chess queen appeared exactly when she did.

A New Era in History

The appearance of the chess queen and the count/elder/ future bishop around the year 1000 corresponded to a new stage in European history, marked by the rising power of kingship, queenship, and the Church. In this new era, German kings and queens, metamorphosed into emperors and empresses, sought to manifest their authority in every possible way. Crowns, thrones, scepters, orbs, seals, banners, processions, public displays of largesse, and ceremonies of vassalage were all signs of ascendant royalty.

Feudal society encouraged an outward display of rank. The bishop's crosier and miter, the knight's horse and sword signified their respective positions in the social hierarchy. The king and queen were situated at the very top, like keystones that held everything in place from on high.

To represent themselves as superior, members of royalty had themselves portrayed in drawings, paintings, and carvings as bigger than the other human figures. So, too, on the chessboard, the king was always the tallest piece, with the queen usually second in size. The game of chess, adapted to European Christendom, provided the perfect representation of a social order in which everyone was expected to know his or her exact place.¹⁹

The Latin epic *Ruodlieb*, written by another German-speaking monk circa 1070, illustrates this sense of order, and tells us something about how chess was played by the nobility at regional courts. The epic was written at Tegernsee, a monastery that, like Einsiedeln, had close connections with the imperial family. Otto II had helped revive the ancient monastery, and his wife, Theophano, was probably responsible for stimulating the Byzantine contacts that occurred there during the tenth and eleventh centuries. The text of *Ruodlieb* reveals contacts with the Eastern Empire in such signs as Byzantine gold coins and precious objects.²⁰

Our major interest in this work lies in an episode centered around a court chess match. When the hero Ruodlieb is admitted to the court of the "little king" and invited to play against him, he at first declines—after all, having a king as one's adversary involved matters of etiquette that were awkward for a simple knight. Eventually, he is forced into playing, and while he tries to lose, Ruodlieb nonetheless beats the king three times, to the astonishment of the nobles watching the game.

At this point, the king magnanimously lays a wager against

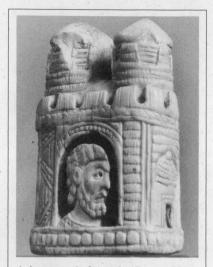

A bone rook from the Lower Rhine showing a bearded man's head enclosed in a crenelated structure, topped with two towers. Germany, second half of the eleventh century.

Ruodlieb, without allowing him to bet anything in return. The nobles, too, put forward their stakes on the king's side. While they kibitz, or comment on the match. Ruodlieb continues to win, again three times, after which he refuses to play anymore. He tries to turn down the money he has won, considering it sinful to enrich himself through gambling. "I am not in the habit of winning anything by playing games," he tells the nobles, to which they reply, "While you are amongst us, you live as we do! When you get back

home, then you can live as you like."²¹ What we learn from this scene is that chess was commonly played in German courts during the second half of the eleventh century, that kibitzing was allowed, and that betting on the game was a matter of local custom.

Church Opposition to Chess

Betting on chess became a subject of heated controversy during the eleventh century and was one of the main reasons that the Church opposed the game. Another reason was that dice were frequently used to determine which piece should move next, making it a game of chance rather than skill, and such games were frowned upon by Church authorities. For example, if the number six was thrown, the king had to move; if five was thrown, it was the queen's turn. Dice became popular because they made the notoriously slow game of chess move faster. While the Holy Roman Emperors were privileging chess, even with stakes and dice, at their German and Italian courts, the Church began to outlaw it, particularly for the clergy.

In 1061, the Italian bishop of Ostia, Petrus Damiani, wrote disapprovingly of chess in a letter to the pope-elect Alexander II. Damiani blushed with shame at the sight of priests engaged in "hunting, hawking, and specially the madness of dice or chess." He was particularly outraged by the bishop of Florence, seen contaminating his hands with "an impious sport." When this bishop tried to defend himself, Damiani insisted that canon law outlawing dice games was meant to include chess: "The decree does not mention *scachus* [chess] but includes the class of either game under the name of *alea* [games of chance]... each game is included under the one name, and condemned."²²

The story, as Damiani tells it, concluded with the bishop's promise never to play chess again and his request that a penance be imposed upon him. He was made to read the psalter three times and wash the feet of twelve poor men, with the payment of twelve pieces of money to each of them.

Damiani's letter led the way to a number of new ecclesiastical decrees banning chess for the clergy and the knightly orders. But these prohibitions did not limit the spread of the game among the laity, and many members of the clergy simply ignored them. By the end of the eleventh century, despite the Church's opposition, chess had established itself firmly in Italy, as well as Southern Germany and Spain. In the years to come, it would make its way north, west, and east from these lands to many others. In each country, the chess queen eventually showed her face, although rivalry with the vizier sometimes retarded her appearance for

decades and even centuries. The following chapters will show how the chess queen established her reign. They will also show how the lives of certain memorable queens intermingled with the chess queen's march across Europe and her ultimate transformation into the game's most potent piece.

THREE

(0)(0)(0)(0)(0)(0)(0)(0)(0)

The Chess Queen Shows Her Face

emarkably, two chess queens have survived from the eleventh century. Both were carved in Southern Italy, in the ivory workshops of Salerno or Amalfi between 1080 and 1100. In both, the

figures of the queen are enclosed in pavilions, with small female attendants on each side drawing back the curtains. They look very much like idols in a niche—the Virgin Mary attended by angels, or pre-Christian goddess figures, as were commonly found in Sicily and other parts of the Mediterranean world. One queen carries a globe,

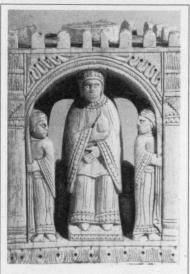

This chess queen carrying a globe is one of the two earliest queens with a face that have survived. southern Italy, 1080–1100.

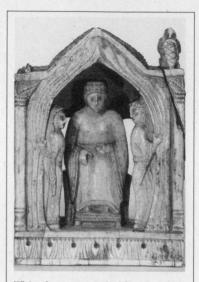

This chess queen holding her belt buckle is the other surviving queen from the ivory workshops of southern Italy, 1080–1100.

the other holds on to her belt buckle. Each wears a crown as a sign of queenship, but neither looks fully assured of her authority. These are the earliest queens with faces that have been preserved.

The two queens belong to a collection of Italian-made chessmen that are housed in the Cabinet of Coins, Medals, and Antiquities at the French National Library. The accompanying kings wear beards and crowns, carry scepters, and, like the queens, are placed inside pavilions with attendants on each side.

The single surviving pawn, which is truly a picturesque marvel, has been decisive in dating all the pieces. On the basis of his almond-shaped shield and helmet with a nose guard, the likes of which were worn by Norman foot soldiers circa 1075–1100, art historians have debunked the long-standing belief that the collection was originally owned by Charlemagne (742–814). A surpris-

THE CHESS QUEEN SHOWS HER FACE • 33

ing feature of the "Charlemagne chessmen," as they continue to be called, is their large size and great weight: the queen is 13.5 centimeters tall, and the king is 15.8 centimeters and weighs almost two pounds. Today it is believed that they were not meant to be played with, but rather to be treasured and displayed. In addition to their unwieldy size, this idea is also supported by the fact that these pieces were preserved for hundreds of years in the treasury of the Abbey of Saint-Denis in Paris, despite the Church's negative attitude toward the game. A distinction must have been made between playing chess and owning chessmen for their symbolic value.¹

How this collection got from the Italian ports of Salerno or Amalfi to Paris remains a mystery. They may have been carried back by one of the crusaders, either after the First Crusade, inau-

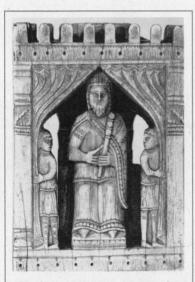

Chess king holding a scepter, encased in a pavilion like the queens. Southern Italy, 1080–1100.

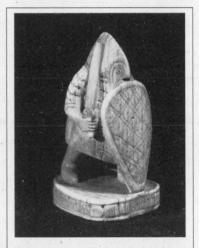

With his almond-shaped shield and distinctive helmet, this pawn has been decisive in dating the "Charlemagne chessmen" to the end of the eleventh century. Southern Italy,

gurated in 1095, or the Second, in 1146. If they were brought back during the Second Crusade, they may have been given directly to Abbot Suger of Saint-Denis, who built the abbey Treasury into the most valuable religious repository in France by the time of his death in 1151. For the abbot, such precious objects were an expression of the divine, and allowed earthlings to glimpse the glories of paradise. He sincerely believed that "the numbed mind of man rises toward external truth through material objects."² But all we know for sure is that the "Charlemagne" pieces entered the Saint-Denis treasury sometime in the Middle Ages and remained there until the church was looted during the French Revolution.

When these chessmen were made in the late eleventh century, the pawns were fabricated to look like Norman foot soldiers because Normans had recently invaded Sicily and Salerno. Salerno was captured in 1076 by the headstrong Norman conqueror Robert Guiscard, and then turned into his chief residence. His access to power was facilitated by his marriage to Princess Sikelgaita, the daughter of the prince of Salerno. Robert had no scruples disposing of his first wife to marry Sikelgaita and lay hands on Salerno, a city already famous for its medical school, its commerce, and its ivory workshops.

Sikelgaita is known to history as an effective propagandist for her husband, Robert, and their son, Roger. During the 1070s, she championed her husband's cause in her native Salerno. Then, after Robert's death in 1085, she became a backstage negotiator on behalf of her son, Roger, in pursuing his claim to rule over the southern kingdom. Successfully championing Roger over Robert's older son from his first marriage, Sikelgaita gained power less from her own position than from marriage and motherhood, which, as we've seen, was a familiar pattern of female rulership in the early and central Middle Ages.³

Matilda of Tuscany

Farther north in Tuscany, a mother-daughter dynasty, whose reigns overlapped with that of Sikelgaita in Salerno, became politically prominent by supporting the papacy in its struggles against the Holy Roman Empire. The mother, Beatrice, was the wife of the Marquis Boniface II of Tuscany. After his assassination in 1052, she remarried and ruled Tuscany with her second husband, Godfrey IV the Bearded of Lorraine. Upon his death in 1069, she reigned on her own.

The daughter, Matilda of Tuscany, was married to Godfrey V the Hunchback of Lorraine. When he was assassinated in 1076 and her mother died shortly thereafter, Matilda took over the rule of Tuscany and continued her mother's defense of the pope against the emperor. She rode at the head of her troops and became a one-woman symbol of papal resistance. Though she mediated a reconciliation between Emperor Henry IV and Pope Gregory VII, she eventually lost Tuscany to Henry's invading armies in 1081. Then for the next fifteen years, as an outsider to Tuscany, she still continued to be involved in papal politics.

In 1089, at the age of forty-three, she married the seventeenyear-old Welf V of Bavaria. It was a political union arranged at the behest of the new pope, Urban II, and one that continued to promote anti-imperial policies. Although it was not too unusual for a female potentate to "marry down" in age and status, a difference of twenty-six years was more than the marriage could bear. Matilda and Welf separated in 1095, and he went back to Germany. Then, with the aid of the pope and the newly crowned king of Italy, she became marchioness of Tuscany once again, for another twenty years.

Matilda is described in glowing terms in a lengthy account

written by an Italian cleric named Donizo, and in less than glowing terms by her German contemporaries. A composite reading of both sources leads to the picture of a politically savvy woman, pious to be sure, but also worldly and wise. She certainly had unusual abilities: fluency in three languages (French and German as well as Italian) and warrior skills that inspired fear among her enemies. All in all, she was a remarkable public figure at a time when most women, and even many female sovereigns, tended to have a low profile.

An ivory chess queen carved in Italy during the early twelfth century makes me think of Matilda. This imposing figure sits openly on a massive arch-backed throne that still bears traces of the original red paint. She wears huge disks on her ears and a hoop crown on her head. Her right hand is raised to her breast with its index finger extending upward, and her left hand falls downward into her lap. When I was lucky enough to have had a private audience with this queen in Berlin, I realized (once again) the colossal

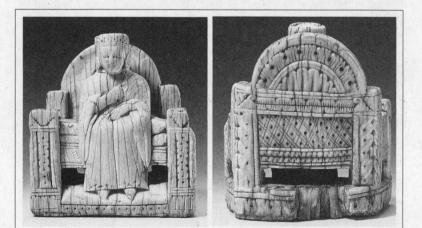

Majestic chess queen, who has replaced the vizier. Southern Italy, early twelfth century.

THE CHESS QUEEN SHOWS HER FACE • 37

difference between seeing the photo of a work of art and the original of that same work. In her presence, this amazing figure exudes an air of regal self-assurance, almost as palpable as the throne she sits on.

This particularly majestic chess queen was made in the twelfth century, and while queens had clearly entered the game in certain regions, their place was not yet entirely secure. The same southern Italian workshops that produced her were still producing viziers in other sets, though probably in decreas-

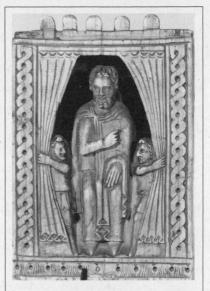

Is this vizier pointing to a king who was once at his side? Southern Italy, early twelfth century.

ing numbers. It is interesting to compare this queen with a vizier from roughly the same period, who is now housed in the same room as the "Charlemagne" chessmen. Although he sits in a pavilion with attendants pulling back the curtains like the "Charlemagne" kings and queens, this vizier was probably made ten or twenty years later. What links him to the later Italian queen are identical hand gestures. The hand on the right points to the left, the hand on the left drops downward. Two hundred years earlier, the ivory plaque commemorating the joint rule of Otto and Theophano (page 23) already represented the queen in this pose, with the sole difference that the hand on her heart was open; this ritual gesture was performed by both husband and wife during the coronation ceremony. Whatever their specific iconographic meaning, all these hands speak for indisputable authority.

All in all, I have found few chess queens with faces before 1200: three from Italy, one from Spain, and the eight Scandinavian queens from the Lewis collection (to be discussed in chapter 9). There are none from Germany, France, England, or Russia. Still, we can assume that many other queens were produced during this period in Europe, given the growing market for the game among the elite. A luxury chess set was considered a fine wedding gift. In 1083, for example, a Bohemian princess married to the German count Wipecht von Groitzsch in Thüringen was given an ivory and rock crystal chess set as a wedding present. Either she already knew how to play, or she would have been obliged to learn very quickly.⁴ Such gifts may have been helpful to the many young princesses who were married for political reasons and shipped off to foreign domains where they did not speak the language. There at least they could amuse themselves wordlessly, playing chess.

Constance of Hauteville

A century later, the Sicilian princess Constance of Hauteville was sent to her husband, the German king Henry of Hohenstaufen, with a magnificent dowry. One hundred and fifty mules were needed to carry all the gold, silver, furs, silks, and ivory objects. Nine years later, as Holy Roman Emperor and Empress, the couple traveled the same route in the opposite direction, bent on conquering Southern Italy and the kingdom of Sicily claimed by Constance as the Sicilian heiress. This time a smaller number of mules carried the empress's personal belongings: silk robes, woolen tunics, mirrors, missals, crosses, "and the ivory caskets and combs and chess pieces from the workshops of Amalfi and Palermo that she had brought with her nine years before."⁵

Mary Taylor Simeti, in her charming book *Travels with a Medieval Queen*, retraces this return trip to Sicily made by Henry and Constance in 1194 when she was pregnant with her first and only

THE CHESS QUEEN SHOWS HER FACE • 39

child. While her fierce husband was conquering Southern Italy and making his way across the waters to Sicily, she descended the peninsula more slowly. At the age of forty-one, she cautiously awaited the birth of an heir, which would secure her position as queen consort-otherwise she might be discarded for a second wife. Even though she herself was the legitimate heiress to the throne of Sicily, the Sicilian crown had to be conquered by her husband in her name and by right of his imperial claim. The day after Christmas, 1194, Constance gave birth to the future Emperor Frederick II in the town of Jesi in the region of Ancona. An illuminated codex in the Vatican Library shows her inside a sumptuous tent, handing her baby to the townswomen as witnesses. But she would not have left him in their hands for long, for contrary to the common practice of entrusting royal babies to wet nurses, she herself nursed the infant. During the forty days of her lying-in period, she may well have enjoyed the distraction of playing chess and checkers in bed. This maternal practice, common among the elite, eventually fostered the production of game boards intended specifically for new mothers. One especially beautiful one can be seen in the Fogg Museum at Harvard University: an Italian salver with a game board on one side and the painting of a woman propped up in bed after childbirth on the reverse.6

Constance was probably still nursing on the route to Tuscany, several months later, by which time her husband had defeated the Tuscan forces, and had himself crowned king of Sicily. On Easter Sunday, 1195, Constance was crowned queen of Sicily in the Italian city of Bari. By the time Henry joined her in Bari, he had ransacked the Sicilian royal palace and treasury, and sent many precious items back to Germany. All joy Constance would have had at returning must have been overshadowed by revulsion when she arrived in Palermo and saw that her childhood home had been utterly despoiled by the man who was her husband. She was, after all, a Norman Sicilian by birth, and must have felt divided loyalties

between her native Hauteville heritage and that of the Hohenstaufens acquired through marriage. This was often the situation of queens in the past, sent from their homelands to distant countries where they were always, to some extent, foreigners. Unlike most, Constance had the opportunity to return to her native land. A letter written to the pope some months later indicates that she considered her right to rule Sicily grounded in *paterna successione et imperialis adquisitione*—the right of paternal inheritance mentioned before that of imperial acquisition.⁷

Henry's corule of Sicily was so oppressive that the inhabitants rebelled, only to be ruthlessly put down and cruelly punished. Fortunately for the Sicilians, he caught a chill and died in September 1197, leaving Constance to rule as coregent with her son. She ruled for only one year, but it was long enough for her to institute significant change for the better in the political climate, as well as to see her son crowned king of Sicily at the age of three in a magnificent ceremony at Pentecost, May 1198. In November, exhausted by late childbirth, marital strife, extensive travel, and political upheaval, she died at the age of forty-four and was interred in the Cathedral of Palermo next to her husband and her father. Her son, Frederick, went on to become not only king of Sicily but also Holy Roman Emperor, king of Jerusalem, a sometime enemy of the papacy (which twice excommunicated him), an efficient administrator with new laws codified under his direction, an Italian poet in the troubadour tradition, the author of a Latin treatise on falconry, a patron of the arts and sciences, and an outstanding chess player.

Apparently, Frederick's love for chess was contagious. By the end of his reign, in 1250, players from Italy, especially those from Lombardy, were becoming famous throughout Europe. As we shall see in the next chapter, the only other European country that produced players of this caliber was Spain.

PART 2

Spain, Italy, and Germany

FOUR

Chess and Queenship in Christian Spain

he Iberian peninsula has a special claim to chess since it has been played there longer than anywhere else in Western Europe—among Spanish Muslims since the early eighth century, and among

Spanish Christians and Jews since at least the early tenth century. As chess spread into the Christian parts of Spain during the eleventh century, it developed a growing body of dedicated players and a distinctive style of chessmen. It

also produced a rich didactic literature during the twelfth and thirteenth centuries, culminating in King Alfonso X's famous *Book of Chess (Libro de Axedrez)* discussed later in this chapter. The Spanish world we are about to explore built upon the inheritance of Caliph Abd al-Rahman III of Córdoba and Queen Toda of Navarre in allowing Muslims, Christians, and Jews to coexist despite antagonisms and sporadic warfare. All three religions contributed to medieval culture and commerce, and all three must be credited with the extraordinary success of chess in Spain.

Catalonia

At the beginning of the eleventh century, the Catalonian count Ermengaud of Urgel possessed a valuable chess set. He thought so much of it that he ordered his executors to give his chessmen to the French convent of Saint Giles "for the work of the church."¹ Much of what we know about chess in Catalonia at this time comes from a number of similar sources: wills that specify the disposition of sets, and pieces that have survived to the present in churches.

For example, in 1033, King Sáncho II of Navarre donated three chess pieces—two pawns and a horse—to the sanctuary of San Millán de la Cogolla, to be encrusted within that saint's reliquary. In 1045, a clergyman from Urgel known as Siofredo willed his set to the convent of San Julian de Bar. That same year, a Catalonian Jew, Ramón Levita, left a bone chess set to his family. These pieces bequeathed by people from diverse social strata—a king, a clergyman, and a Jewish commoner—speak for the popularity of chess in Northeastern Spain and especially in Catalonia. The late chess historian Ricardo Calvo has identified the Christian town of Urgel in Catalonia and the Muslim city of Córdoba in Al-Andalus (Islamic Spain) as the foremost Spanish chess centers of the eleventh century.²

CHESS AND QUEENSHIP IN CHRISTIAN SPAIN • 45

One chess bequest is of special interest, as its donor was a notable woman—Countess Ermessenda, sister-in-law to Count Ermengaud, and widow of his elder brother, Ramón Borrell. During his lifetime, Ramón and Ermessenda ruled Catalonia as a powerful team; side by side they received their vassals, encouraged trade, and led military forces.³ When he died in 1017, Ramón willed his property and authority to her, rather than to their son, who was still a minor. Ermessenda held on to the reins of government for the next forty-one years, and oversaw her own affairs as well as those of her son and grandson.

In her testament of 1058, Ermessenda followed the lead of her brother-in-law by leaving her rock crystal chessmen to the church of Saint Giles, which had received Ermengaud's set fifty years earlier. So began the tradition of leaving chess sets to churches, either to be sold for the church's upkeep or to enter into the church treasury for permanent keeping. Rock crystal chess pieces like these were treasured not only for their value and aesthetic beauty, but also because they were believed to have salutary properties. The somewhat ironic result of this, given the Church's intermittent prohibitions on the game, is that these pieces were treated with quasi-religious veneration and used to adorn church altars, crosses, chalices, and reliquaries.

Why would Countess Ermessenda leave her chess pieces to the Church? Like many political figures of this era, Countess Ermessenda made substantial donations to the Church and, in turn, received its backing. These donations were an important measure of a medieval woman's worth, and a tool by which many queens, empresses, duchesses, and countesses heightened their public identities.

While we cannot be sure that the countess was an avid chess player, we do have a good idea of what her set would have looked like from a collection of rock crystal chessmen from this period found in the parish church of Ager, a village near Urgel in Catalonia. For a long time it was believed that these "Ager chessmen"

were donated to the church by a member of Ermessenda's family, but more recent research suggests they may have belonged to the legendary Catalonian nobleman Arnau Mir de Tost, famous for his fierce maintenance of the frontier between Christian and Islamic Spain. The inventory of the possessions of Arnau's wife, Arsenda, from the year 1068 and his own inventory from 1071 mention several rock crystal, ivory, and silver chess sets.

Nineteen pieces remain in the Ager set, which is now the pride of the small diocesan museum in Lerida (Lleida). Whether the pieces came from Countess Ermessenda's family or from the Mir de Tost clan, the collection provides us with both interesting insights and vexing questions. First, this set belonged to a Christian family, but was almost certainly made in Arabic-Spanish workshops. And while the chess queen was beginning to appear elsewhere in Christian Europe by the year 1000, she was nowhere to be

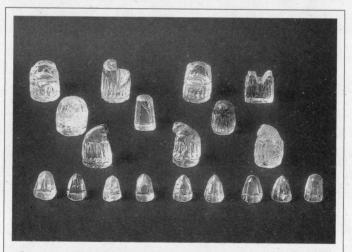

Spanish-Arabic chessmen found at the church of San Pere of Ager near Urgel, in Catalonia. The king resembles a throne, but the vizier looks like an obelisk. Rock crystal, end of the ninth to beginning of the eleventh century.

found on the Iberian peninsula at this time, even in the Christian North. Because of the persisting Moorish influence, the vizier rather than the queen continued to stand at the side of the king.

In nearly all Arabic and Persian sets from this period, the vizier was represented by a throne, just slightly smaller than the king's throne. For many years, this was thought to be the case in the Ager collection as well. After extensive research, however, the Lleida curators are now firmly convinced that the single obelisk-shaped picce is the vizier. If this abstract piece, reminiscent of the phallic shape of the "general" in some Indian sets, is indeed the vizier, it is something of an anomaly among Islamic chessmen (color plate 1).

Aside from the kings' thrones, the Ager chessmen made no concessions to realism. Firmly abstract in design, the pieces could be used by both Muslims and Christians. Indeed, Muslim-type abstract chess sets continued to dominate the Spanish scene, even after realistic pieces had been introduced.

Castile and León

Outside of the chess hotbeds of Catalonia, the game was making headway into other parts of Christian Spain. Alfonso VI, who reigned over the combined kingdom of Castile and León from 1072 to 1109, was a known chess devotee. At his court, he welcomed other chess aficionados regardless of their religion—Muslims and Jews as well as Christians.

Alfonso VI is perhaps best known, at least to literary folk, for his association with *The Poem of the Cid*, Spain's greatest epic. It was Alfonso VI who banished Rodrigo Díaz de Bivar—the Cid and sent him on his legendary adventures. One of the most colorful figures in the early annals of Spanish royalty, Alfonso combined the strength of the consummate warrior with the gifts of the wily statesman, bringing both together for the prize conquest of Toledo in 1085. He was also a fabled ladies' man, with no fewer than five legitimate wives, and two extra-legal partners. His union with the Muslim Zaida produced his only son, an illegitimate child, and therefore ineligible for succession, as well as an illegitimate daughter, Teresa. Ultimately, it was Alfonso's eldest legitimate daughter, Urraca, who became his successor and one of the strongest queens in Spanish history. Castile, like England and unlike France, never established laws that directly prohibited a king's daughter from inheriting the crown.

Doña Urraca

Doña Urraca's birth around 1080 coincided with the chess queen's youth, and the many battles she fought as a reigning queen were mirrored on the chessboard. She became queen at the tender age of fourteen, when her father gave her in marriage to Raymund of Burgundy and placed the young couple on the throne of Galicia in the northwestern corner of Spain.

After her marriage to Raymund, Urraca bore a first child, the infanta Sancha, probably around 1095, when she was fifteen. Ten years later, on March 1, 1105, she gave birth to the infans Alfonso—the future Alfonso VII of León and Castile. In the intervening decade, it seems likely that Urraca had numerous other conceptions that ended in miscarriages, stillbirths, or children who perished in infancy.⁴

Urraca initially played a secondary role in matters of state. Her name appears on the occasional grant or diploma, and she was undoubtedly called on to intercede with Raymund on behalf of various supplicants, but she was largely a spectator. When she succeeded her deceased husband as the sole ruler of Galicia in 1107, and especially after 1109, when she succeeded her father as the ruler of León-Castile, she became a powerful queen in her own right.

CHESS AND QUEENSHIP IN CHRISTIAN SPAIN • 49

Despite her considerable power, she could not escape a second marriage, which was arranged at her father's insistence shortly before his death. The new husband was Alfonso I, king of Aragón and Navarre, called "The Battler." The never-married groom was probably thirty-six and his bride twenty-nine. In the marriage agreement, he made significant concessions to his future wife in recognition of her superior holdings, most notably that if they didn't have a son, the young Alfonso Raimundez from her first marriage would inherit from both of them.

Unfortunately for Urraca, these initial concessions and kindnesses proved the exception in their relationship. Alfonso I, it turns out, truly merited his moniker "The Battler." A fierce warrior on the battlefield, he was equally unlovely in private. Urraca's fears of being bound to "the cruel, fantastic, and tyrannical king of Aragón" were quickly realized. His methods of dealing with his spouse when she disagreed with him were egregious: insult, humiliation, and physical abuse. He was probably no more brutal than many warrior-husbands from that era, and many wives would have been obliged to put up with their husbands' brutish ways. Not so Urraca, who had already ruled Galicia on her own, and had no need for a tyrannizing spouse. But getting out of this marriage-which had been duly arranged by her revered father and confirmed by powerful bishops and lords-was no simple matter. To do so, Urraca appealed to Rome. She asked for an annulment on the grounds that she and Alfonso had a common ancestor, and thus their marriage had infringed the laws of consanguinity established by the Church. (Never mind that she and her first, more pleasant, husband had also had a common ancestor!) The Church sided with Urraca, and granted a condemnation of the marriage in 1110.

In a battle that makes modern divorce proceedings pale by comparison, Urraca and Alfonso began open warfare with each other, both commanding troops and laying claim to properties they considered their own. This was the moment of truth for

Urraca. Would she be able to rule her father's realm on her own? Would she be able to ward off Alfonso's constant incursions? Would she be able to hold on to the territories held by her son Alfonso Raimundez, still only seven, and prepare him for the eventual rule of their combined kingdoms?

Spain is a huge peninsula, and Urraca's presumptive realm extended over hundreds of miles. Constantly on horseback, she conducted campaigns against Alfonso, administered affairs of state in León, and negotiated with various clergymen and lords, who helped devise strategies that would ultimately outmaneuver her former husband. By the end of 1115, she was able to celebrate her Christmas court in León, and at the beginning of 1116 she granted donations to several monasteries as a demonstration of her new strength. She also felt secure enough to parade her eleven-year-old son through some of her reconquered territories and to proclaim him as her coruler and heir. Having reclaimed most of Castile from Alfonso, Urraca concluded a truce with him in 1117.

She still had to deal with unrest on the Portuguese border. Her brother-in-law, Count Henry of Portugal, had taken advantage of the strife between Alfonso and Urraca to seize land, and although he died in battle in 1112, Portugual remained a thorn in Urraca's side for many years. She returned to Galicia in 1117 and attended a meeting with the powerful Bishop Gelmirez, only to be confronted with a band of rebellious townspeople. They forced Urraca and the bishop to take refuge in the cathedral tower and then fired upon it. In one of the most humiliating episodes of her reign, Urraca was driven from the tower, stripped, and stoned, before being rescued by calmer heads. Escaping from the city and rejoining her troops, she returned to exact substantial penalties. The rebels were exiled, their property was confiscated, and an indemnity was levied against the townspeople.

It is a measure of Urraca's strength of character that this humiliating incident did not break or weaken her. On the contrary,

CHESS AND QUEENSHIP IN CHRISTIAN SPAIN . 51

she continued as before—moving about the country to consolidate her authority; putting down the occasional uprising; parrying the plots of her widowed half sister Teresa of Portugal and her ex-husband, Alfonso; and confronting the Church in its efforts to restrict her power. The image of an embattled chess queen comes easily to mind.

In one crucial incident, when her half sister Teresa invaded southern Galicia and claimed certain territories for the Portuguese crown, Urraca marched to Galicia prepared for war, but managed to avert it through diplomacy. At this point of her life, Teresa was at the height of her glory. She had in her camp a second husband, Count Fernando Perez, as well as her son Alfonso Enriquez, and sufficient supporters among the nobility and clergy to stand up to her proud half sister. But Queen Urraca did not have to envy Teresa's fortune. She, too, had at her side a lover, Count Pedro González, though she did not bother to marry him. There were even two children born of that union, the infanta Elvira and a son. It is a sign of her extraordinary strength that she could publicly recognize this son, "Fernandus Petri minor filius," in November 1123-just as male monarchs recognized their "bastard" children. This may, in fact, be the only example of a major reigning queen who officially acknowledged her illegitimate offspring.

The following year, Urraca's elder son, Alfonso Raimundez, aged nineteen, was armed by Bishop Gelmirez at Santiago de Compostela. The ceremony bestowed upon her heir the vestments and gravitas of a Christian warrior. When Urraca died in 1126 at the age of forty-six, he inherited the kingdoms of León-Castile and Galicia.

Alfonso the Battler's Chess Connection

Urraca's divorced husband, Alfonso I of Aragón, may not have been a success in Castile, but he left behind an interesting legacy to chess. Under Alfonso's patronage, his court physician, Moses Cohen (also known as Moses Sefardi) converted to Christianity and was baptized as Petrus Alfonsi in 1106.⁵ Such conversions were common in Spain at that time for, as in Germany and the Austro-Hungarian Empire in the nineteenth century, Jews often found it necessary to convert to Christianity if they desired professional advancement.

As Petrus Alfonsi, the converted physician authored a book called the *Disciplina Clericalis*, which was essentially a collection of Arabic tales translated into Latin. These tales introduced a mode of Oriental storytelling and wisdom literature into Christendom that would become extremely popular. In the section called "The Mule and the Fox," concerning the true nature of nobility, Alfonsi listed seven accomplishments expected of a knight. "The skills that one must be acquainted with are as follows: Riding, swimming, archery, boxing, hawking, chess, and verse writing."⁶ So, by the beginning of the twelfth century, chess had become a mandatory skill for Spain's elite warriors.

The Chess Queen in Spain: Hebrew Evidence

During the twelfth century, the chess queen would make her first definite appearance in Spain. Her reception on the board was largely determined by local custom and religious belief. The Muslim world was uninviting: chess figures continued to be represented abstractly, and the vizier did not give way to the queen. European Christianity, in contrast, both allowed and actively encouraged the representation of humans, animals, and the divine, including easily identifiable queens. Jews found themselves somewhere in the middle. On the one hand they, too, were prohibited from making "graven images," but they were less rigid on the matter than Muslims. And while the queen never gained admittance to Muslim chess, she made her way into the hands of Jewish players, as evidenced by three Hebrew texts of Spanish origin.

First, in a poem written by the Spanish rabbi Abraham ibn Ezra (1092–1167), we see the Arab-style game played without a queen. Ibn Ezra was a renowned mathematician, astronomer, scriptural exegete, and poet, greatly respected by Jews, Muslims, and Christians alike. His "Verses on the Game of Chess" lovingly describe the moves of each piece, as summarized below.

The chariot (rook) moves across the board's whole length and breadth in a straight line. The horse (knight) moves three squares along a "crooked path"—two squares in a straight line and one at right angles. The elephant (bishop) moves diagonally three squares at a time. The vizier, called *paraz* in Hebrew (ibn Ezra's equivalent for the Arabic *firz*), moves diagonally one square at a time. The king steps to any contiguous square. The foot soldier (pawn) advances in a straight line, but to take a piece, he moves diagonally. If he advances to the eighth row, then he can return in any direction (like a "queened" pawn today).⁷

Comparing the lowly foot soldier with his modern counterpart, one sees that he has not made any progress over the centuries. Similarly, the king, the rook, and the knight already had the moves they have today. But the ancestor of the bishop—the elephant—could move no more than three squares at a time, instead of the whole length of the board as he does in modern chess. The vizier, though, bears little resemblance to today's queen since he could move only to the adjacent diagonal square, except

on his initial move when he could move three paces, including the square of departure.

A second Hebrew poem on chess that may also have been written by ibn Ezra, after he left his native Toledo, reveals the existence of the chess queen. Now the king has at his side the *Shegal* (Hebrew for "queen") instead of the vizier or general. Otherwise the pieces are the same.

> The king and the *Shegal* at his side And the elephants and horses next to them And [you also have] two chariots And [warriors] in front of them.... And the king [and likewise] the *Shegal* And their steps [are not very different].⁸

Presumably, in the course of his lifetime and travels, which took him to many parts of Spain, Western Europe, and the Near East as far as Persia, Rabbi ibn Ezra played with both Muslim and European-styled chess pieces. What did he think when he first saw a chess queen? I like to imagine that, after his initial surprise, he welcomed her to the game. In spite of the misogyny that permeated medieval Judaism, there were enough powerful women in the Old Testament, including the judge and war leader Deborah, to warrant the rabbi's respect. "What! A woman on the chessboard? Well, why not!"

A third Spanish Hebrew text, attributed to Bonsenior ibn Yehia, possibly twelfth century, possibly later, lines up the chess pieces like mighty armies with "the king in his glory" and "the queen [*Shegal*] at his right hand":

She sits at the top of the high places above the city. She is restless and determined. She girds her loins with strength. Her feet stay not in her house. She moves in every direction and into every corner. Her evolutions are wonderful, her spirit untiring. How comely are her footsteps as she moves diagonally, one step after another, from square to square!

And the King, dressed in black robes, stands on the fourth square, which is white. His queen stands on the square next to him, which is black. He draws near to the pitch darkness; his eye is upon her, for he has taken an Ethiopian woman [as his consort]. There is no difference between them as they come towards you. They set out towards you along the same path, at the same pace and by the same route. When the one dies, so does the other.⁹

This passage, recalling Proverbs 31 and the Song of Songs in the Bible, is an amazing tribute to the chess queen and to women in general, bringing together the Jewish wifely virtues of beauty and energy with a warrior's strength. And it presents the king and queen as loving equals, who cannot live without each other.

A Romanesque Chess Queen

Ibn Ezra's writings prove that the chess queen was known to some twelfth-century Spaniards, even if she was not universally established throughout the Iberian peninsula. Further evidence for her existence in Spain at this time comes from a tangible source: a captivating ivory figure belonging to the Walters Art Gallery in Baltimore. She is, to my knowledge, the only indisputable medieval chess queen in the United States and the earliest Spanish queen "with a face" that has survived. She sits totally encased within an oval structure suggesting a throne, with only her head showing. It is as if she had been ripening slowly from inside an earlier enclosure and now peeks out to see if the time has come for her appearance. Fancifully, I sometimes think of her as a jack-

in-the-box whose serious demeanor belies the board tricks she has in store. She wears a headdress in the style worn by Spanish queens and ladies at this time—a tight hood surrounding the face, held in place by a headband.

During a recent trip to the Walters, where this queen reigns in solitary splendor, the medieval curator told me visiting school children think she is sitting in a bumper car.¹⁰ Looking at her now I can see how the piece would bring to mind an amusement park ride to a contemporary child. To an ancient Roman (or even a modern' Italian) she might have evoked the Colosseum, and to a twelfth-century Spanish youth, the Romanesque arches from his local church. But whatever the associations evoked by her setting, this queen is timeless. She represents the constricted power of queenship, an ultimate female status, but one that is played out in chess as in life on a predominantly masculine playing field. The

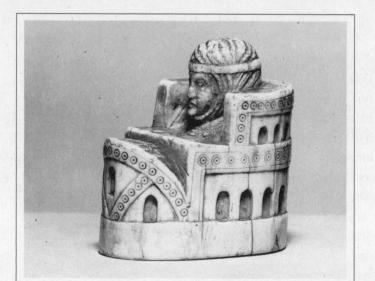

The earliest Spanish queen with a face, and the only medieval queen in the United States. Twelfth century.

chess queen, like other ladies of her rank, does well to keep a constant eye on her enemies and, depending on their moves, to be ready to retreat to a protected space.

Such a piece would have been uncommon in medieval Spain, where abstract chessmen of the Muslim type outnumbered representational chessmen, even among Christians. Its large size and fine carving would have precluded possession by any but royalty or affluent members of the nobility. But it would have been handled by women as well as men. One reason for the popularity of chess among women was that it could be played indoors. Even if one had to be confined to the home for reasons of childbirth or illness, women could play chess sitting up in their beds.¹¹

Alfonso X's Book of Chess, Dice, and Backgammon

The celebrated manuscript commissioned by King Alfonso X of León and Castile, titled *The Book of the Games of Chess, Dice, and Boards (Libro de los Juegos de Axedrez, Dados, y Tablas)* and dated 1283, tells us a great deal about how the game was played and viewed at this time, as well as the gender roles surrounding it. Indeed, it stated explicitly that board games were especially suited to women. "Women, who do not ride and remain in the house, can enjoy them," as well as elderly and weak men, prisoners, slaves, and sailors.¹² These games played in a sitting position were contrasted to those requiring footwork, such as running, jumping, fighting, throwing balls and spears, that were the purview of able-bodied men.

Alfonso's game book is both a landmark in chess history and an artistic masterpicec. The original manuscript, with its one hundred and fifty exquisite illustrations, is jealously guarded at the Es-

corial Monastery Library outside Madrid. Its first five leaves present an introduction ostensibly issuing from the mouth of King Alfonso, known as Alfonso the Wise (reigned 1252–84). The reader learns the game's philosophy and rules, as well as the shape, moves, and relative value of each piece. The heart of the book is found in one hundred and three chess problems, which were based primarily on Arabic models. Each problem in the manuscript is accompanied by a stunning miniature, which shows the board as if one were looking down on it from above with players on each side. It is easy to identify the pieces in their stylized Arabic forms, except perhaps for the "queened pawn" which carried an extra knob on top. If you can imagine a priceless coffee table book with everything you want to know about medieval Spanish chess, this is it.

In sixty of the one hundred and fifty illustrations, a vast array

The Spanish king Alfonso X shown playing against an unidentified woman. Alfonso's *Book of Chess*, 1283.

of men and women are seated around chessboards—kings, queens, courtiers, foreign visitors, Christians, Muslims, Jews. The players are often accompanied by friends or servants, some giving advice, some playing instruments. Female players are evident throughout the manuscript, appearing in twenty of the sixty illustrated chess miniatures.

Several miniatures show elegant European women with extremely high hats, signs of their elevated status. Another all-ladies scene serves up a bevy of Spanish beauties—blond, unmarried, and enshrined under a series of Gothic arches. Ladies wearing crowns, transparent veils, nun's wimples, and all manner of headgear face each other across oversized boards. Queens are shown teaching their children to play (color plate 3). An older nun instructs a young novitiate. Moorish women also appear playing

Nuns were allowed to play chess in Spain during the reign of Alfonso X, despite Church prohibitions elsewhere. Alfonso's *Book of Chess*, 1283.

against each other—in one instance, accompanied by a female guitarist. In another, they wear turbans and mouth coverings that leave little of the face to be seen except for the eyes and upper half of the nose. Other miniatures show mixed-sex matches, for example, that of a dark-haired, barefoot Moorish woman with hennaed fingers playing against a fair-haired youth, or a Christian woman with a transparent veil holding up the piece she has just taken from her male opponent. The variety of head covers worn by the women and the elegance of their clothing offer an ongoing fashion show. These women were clearly conscious of their apparel, even as they concentrated on the game at hand!

One problem, especially interesting for the social relations it portrays, shows King Alfonso himself, sitting on a red cushion and playing against a woman who has no sign of high rank or riches. He wears a cap bearing the royal arms and an ample tunic, while she sits in Moorish fashion, wearing a simple headdress bound under her chin and completely concealing her throat.

CHESS AND QUEENSHIP IN CHRISTIAN SPAIN . 61

One of the miniatures has recently been identified as that of Edward I of England (1239–1307) playing chess with his fiancée Eleanor of Castile, Alfonso's half sister. Edward is wearing a crown, and she, too, bears a regal coif. His identity was determined by two assiduous chess scholars, Ricardo Calvo and Mike Pennell, on the basis of his drooping left eyelid, a condition known as *ptosis palpebralis*.¹³ King Edward was a passionate chess player, whose legend includes the story of his narrow escape from death during a match when a huge stone crashed down from the roof. He was also a strong military man, credited with ongoing efforts to extend English rule to all of Britain—most notably Wales and Scotland. When Eleanor became his wife, she oversaw the making of a French version of Vegetuis's *Art of War* to be given as a gift to her husband. He later gave her a chess set—an eminently suitable gift for the sister of Alfonso the Wise.¹⁴

Alfonso's game book occasionally contains nontechnical insertions praising monarchy and other subjects dear to the king's

Edward I of England and his fiancée, Eleanor of Castile. Alfonso's *Book* of *Chess*, Spain, 1283.

heart, but the main text focuses on chess, dice, and backgammon, offering a clear description of how each game was played at his court. We are informed that chess required a board with eight squares to the row, and was deemed better than games played on boards with ten squares (deemed too lengthy and too tedious) or six squares (deemed too hurried). Half of the sixty-four squares on the board were to be in one color, and the other half in another, following the European rather than the Arabic mode.

So, too, the thirty-two chess figures had to be divided into sixteen of one color and sixteen of another. Of the sixteen figures on one side of the board, eight were called "inferiors" representing the "humble people" and eight dubbed "superiors." The king as "commander-in-chief" stood appropriately in one of the two middle squares of the first row, with his *alfferza* beside him. Fortunately for us, the author went into great detail explaining what the

Chess was a common pastime for Moorish women in Spain, as it was for their sisters throughout the Muslim world. Note the fingers covered with henna. Alfonso's *Book of Chess*, 1283.

CHESS AND QUEENSHIP IN CHRISTIAN SPAIN . 63

Beautiful young ladies playing chess. Alfonso's Book of Chess, Spain, 1283.

alfferza was. Derived from the Arabic al-firzan, or vizier, the alfferza was conceptualized as a standard-bearer, but the masculine word for standard-bearer, alfferez, had been transformed into the femininc alfferza. The text grudgingly acknowledged this gender confusion: "Some people, who do not know the right name, call it 'alfferza.'" Today we can speculate that the word had taken on the feminine gender because, by 1283 when this work was written, the queen had been on certain Western chessboards for around three hundred years and had supplanted the vizier in most European countries. In Spain, where Arabic pieces coexisted for centuries alongside the upstart European figures, confusion about the gender of the alfferza was inevitable. The queen would have been obvious in figurative sets, as in the Walters piece reproduced above, but at Alfonso's court, the Arabic abstract model still prevailed, as can be seen from the chessmen in the miniatures.

As for the rules of engagement, they were similar to those outlined by Rabbi ibn Ezra a century earlier. For the next two hun dred years, until the dramatic changes in the rules that occurred during the reign of Queen Isabella, Alfonso's compilation offered the final Spanish word on chess.

Other Works Commissioned by Alfonso X

Among the many works commissioned by Alfonso, one had special meaning for women: the Seven Divisions (Siete Partidas), an encyclopedic legal work intended to provide a model of good government. As envisioned here, the king was no less than God's viceroy on earth, and the queen, while secondary in status, had a consecrated place at his side. Ideally, she should come from a distinguished lineage and possess good manners, beauty, and wealth. And since a king, like any other Christian, was allowed but one wife and should not be parted from her until death, the queen should be his closest companion, sharing his pleasures, sorrows, and cares. Their most pressing concern should be to provide for their progeny.

But even so serious a work as the *Seven Divisions* made room for recreation. Following the biblical admonition that there is a time for every season, Alfonso recommended listening to songs and instrumental music, playing chess and similar games, and reading history books and romances, so as to escape from worry and experience pleasure.

Alfonso's wife, Violante of Aragón, seems to have measured up quite nicely to the high standards established for queens in the *Seven Divisions*. Descending from royalty and richly dowered, she enjoyed a long-lived union with Alfonso, producing ten children. Her role as the mother of future monarchs was indispensable to whatever power she exercised. In fact, she almost lost her chance at lifelong queenship because she failed to conceive for the first three years of their marriage, a circumstance that propelled Alfonso to send to Norway for another bride. Fortunately, by the time his new bride-to-be arrived, Violante was pregnant, and the Scandinavian princess was conveniently married off to Alfonso's brother.¹⁵

Violante was also a visible participant in Castilian politics and foreign affairs. As a queen consort, she put her name to documents, took a leading role in diplomacy, acted as her husband's deputy, and interceded with the king on behalf of towns and individuals in issues such as taxation. Sometimes she even opposed her husband on matters of state. One example, particularly crucial for her personally, was that she championed her younger sons' rights to succession, even though Alfonso preferred to pass the throne to the children of their deceased eldest son. More than a squabble over favorite offspring, this discussion held the key to Violante's future. If her younger sons became kings, she would have power in the event of Alfonso's death. If not, she would have had to relinquish it to her French-born daughter-in-law, the mother of Alfonso and Violante's grandson.¹⁶

The reign of Alfonso X of Castile and Violante of Aragón left its mark on European civilization through the numerous translations of ancient texts they commissioned from Arabic sources. Thanks to the Muslim world, many pre-Christian works from antiquity had been preserved, and thanks to Alfonso and Violante, these works were made available to the West through Spanish and Latin translations-a task that was often performed by Jewish scholars. Although from a Christian perspective, Jews were theoretically in league with the Devil (since they refused to accept Christ as their savior), Alfonso and his immediate predecessors and successors did not actively persecute them. Instead, Alfonso and Violante drew on all three religious communities to create a composite intellectual culture. Their promotion of everything scientific and artistic-from astronomy and botany to philosophy and literature-made their court a desired destination for scientists, mathematicians, writers, translators, and artisans. In this

highly cosmopolitan setting, chess occupied an honored position as the favorite pastime of kings and courtiers. It was considered the only proper board game for royalty, the nobility, and the clergy, with dice games left for soldiers and servants.

Alfonso's contribution to the history of chess lies primarily in the unique manuscript he left behind—perhaps the most beautiful work on chess ever created. Yet his book, however beautiful, did not turn out to be the most influential chess manual composed during his era. The Italians and Germans were simultaneously writing poems and treatises on the game, one of which would ultimately rival even the Bible in popularity.

FIVE

Chess Moralities in Italy and Germany

n Italy and Germany, the story of medieval chess reads something like a morality play. First the Holy Roman Emperors and the Roman Catholic Church lined up against each other, ar-

guing on the one hand that chess was an edifying recreation and, on the other, the path to perdition. Then, when the Church had softened its position on chess, certain clerics coopted the game as a symbolic model for the social

order. Jacobus de Cessolis's *Book of Chess*, written along these lines in late thirteenth-century Italy, became one of the most famous books of its day. Taken as a companion piece to Alfonso X's 1283 manuscript, it gives us a composite picture of European chess in the High Middle Ages.

Italy

Jacobus de Cessolis was a Dominican friar who used chess as the basis for a series of sermons delivered sometime between 1275 and 1300. In his era, chess was no longer solely a war game. Unwarlike figures, namely the queen and the bishop, had joined the king, knights, rooks, and pawns, which made it possible to think of chess as an allegory of society. Imagine the audience in church listening with rapt attention as Cessolis evoked an ideal state in terms of the miniature figures of the chessboard. His fundamentally conservative message supported the status quo: the king belonged at the top of the social pyramid and the peasants at the bottom. The lower classes were by no means dismissed as an indistinguishable mass. Cessolis clearly pointed out that pawns represented many different métiers, from farmers and artisans to doctors and apothecaries. Any number of parishioners would have been honored to hear their trades and professions respectfully named in such a holy place. At Sunday Mass they could look around with satisfaction as they recognized others, like themselves, who had an appointed place in society.

In The Book of the Customs of Men and the Duties of Nobles (Liber de moribus hominum et officiis nobilium) or The Book of Chess (De ludo scachorum) derived from these sermons, Cessolis portrayed each station in life, with its particular forms, manners, and duties, starting with the royal pair. "The King shall sit on a golden chair or a golden throne, a crown upon his head, a scepter in his right hand

CHESS MORALITIES IN ITALY AND GERMANY . 69

and an orb in his left. He shall wear a purple cloak and whatever else befits a King.... The Queen shall sit on a golden throne and wear a colored cloak, and whatever else befits a Queen."¹

The virtues appropriate to the king and queen were, of course, colored by a distinctly Catholic view of morality, emphasizing the control of sexuality. Thus the king "must observe absolute continence. That is symbolized by a single Queen." Here was the Church trying to enforce monogamy through the example of the chess king. Not surprisingly, the queen's sexuality was even more heavily scrutinized: "The Queen must be chaste, docile, descended from a good family, and attentive to the upbringing of her sons." The words "chaste" and "chastity" were repeated several times to remind the audience where a woman's greatest virtue

lay. Sexual fidelity was particularly crucial for a queen, so as to ensure that her offspring were unequivocally descended from the king. Cessolis ignored the political significance of female sovereigns and presented them exclusively as wives and mothers. This attempt to undercut the queen's political importance may have been due to anxieties about female power in general, and especially about the authority of ruling queens.²

In Cessolis's sermons, the chess pieces flanking the king and queen were likened to judges. Their virtue lay in firmness, incorruptibility, intelligence, and wisdom. Here as elsewhere, Europeans didn't quite know what to do with this piece derived from the Indian elephant, an animal they had never seen. Called *al-fil* in Arabic and Spanish, *aufin* in French and English, and *alfiere* in Italian, the elephant would eventually become a bishop in Northern Europe and England, a fool in France, and a standardbearer in Italy.

The knight was described as sitting on a horse and "clad in all the usual knightly accoutrements, including gauntlets and greaves, helmet and shield." Knights were enjoined to be brave, compassionate, generous, and wise.

The rook, anthropomorphized from a turret into a man, was to be dressed in a fur coat and a fur-lined hat. "In his right hand he shall hold a staff to show that he is on the King's business." Rooks were "the vicars or envoys of the King" and expected to demonstrate "justice, piety, humility, patience, voluntary poverty, and generosity."

One of the reasons for Cessolis's success as a preacher and writer was that he focused heavily on the common people during a period when chess was beginning to spread beyond the court and clergy into the greater populace. The entire third section of his book is devoted to pawns, depicted as recognizable human beings rather than mere ciphers. "The first pawn shall be a peasant and a wine grower, with a hoe in his right hand and a switch in his left and

in his belt a pruning knife." "The second pawn shall be a smith, carpenter and mason. In his right hand he shall hold a hammer, in his left an axe and in his belt shall be a trowel." The third pawn represents the notary and the weaver, holding "a pair of scissors in his right hand and a knife in his left. At his belt shall be writing utensils and a pen behind his right ear." The fourth pawn represents merchants and money changers. He "shall have scales in his right hand and an ell in his left. And on his belt a purse full of pennies." Of physicians and apothecaries Cessolis noted, "[T]he fifth pawn shall look like a physician. He shall sit on a chair, a book in his right hand and a jar of medicine in his left." Of innkeepers and hostellers, "[T]he sixth pawn shall be like an innkeeper. He shall hold a jug in his right hand and make an inviting gesture with his left." Of city guards and customs collectors, "[T]he seventh pawn shall have a large key in his right hand, an ell in his left and at his belt an open bag." Even rogues, vagabonds and gamblers have their place in this compendium of callings. "The eighth pawn shall be a curly-haired fellow, holding a few pennies in his right hand and three dice in his left." In all likelihood, Cessolis's copious attention to the common folk resulted from, and further contributed to, the transformation of chess from a royal game to a popular one.

One less commendable aspect of *The Book of Chess* is its confusing description of the moves allowed each piece. Even so, one can discern a few differences from Alfonso's manuscript, the most notable of which concerned the king. He was allowed to move two, three, or four squares on his first move, either in a straight line or diagonally or in a combination of the two. Interestingly, he could take the queen with him on his first and only three-square jump. This was but one of many symbolic attempts to remind the queen that she belonged to the king and was under his jurisdiction. It was up to the king to determine their "conjugal" first move.

The popularity and influence of The Book of Chess was remark-

able, and it became the equivalent of a late Middle Age best-seller. It was translated into French, Italian, German, Catalan, Dutch, Swedish, and Czech, and then, with the advent of the printing press in 1456, it spread even further. The great English printer Caxton published it immediately after the Bible. Every princely library during the late fifteenth century would have owned one or more copies, and even today some two hundred manuscripts have survived, not to mention the many printed editions. Of all the manuscripts and published books circulating around 1500, only the Bible existed in greater numbers.

Another important if considerably less famous work illustrates the state of the game in late thirteenth-century Italy. *Good Companion (Bonus Socius)* contained over a hundred chess problems with accompanying sketches. Although the pieces moved roughly as they had in the Einsiedeln Poem, there were a few notable variations.

Chess king and queen from a late medieval German translation of Cessolis's *Book of Chess*, as printed in H. F. Massmann's *Geschichte des mittelalterlichen Deutschen Schachspieles*, 1839.

Chess king and queen from *Game and playe of the chesse*, translated into English from a French version of Jacobus de Cessolis and printed by William Caxton. London, circa 1480.

The queen could, at the onset of the game, move two squares, vaulting over the first square if it was occupied. The bishop could also vault over a piece in his first move. A pawn that had managed to reach the far side of the board and been "queened" had the right to jump over the first square on its return trip. This fascinating manuscript, now in the National Library of Florence, presented a challenge even to specialists when it was found, since it was written in a kind of abridged Latin, not unlike shorthand.³

Other written works on chess continued to appear throughout Europe, many based to some extent on Cessolis's book. The highly popular fourteenth-century *Deeds of the Romans (Gesta Romanorum)* contained several sections on chess, some borrowed directly from Cessolis. One passage provided a Christian gloss on the chess queen, comparing her to the soul. Here, as in earlier and later reli-

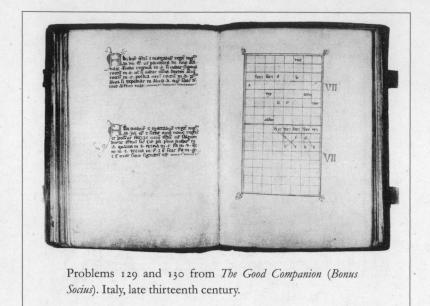

gious allegories, she was clothed in virtues considered appropriate for women, such as nonviolence, passivity, and lack of curiosity.

The queen is our soul, which can never learn to wage war abroad, but is driven to do good works from within the body. For our soul, that is reason, should direct our body, like the rider his horse, towards virtue, and teach the body not to go beyond the bounds of the church's teachings. It must proceed from the square of one virtue to that of another. So too must the queen go forwards on the chess board for a long period and not jump, but remain within the bounds fixed for it. Dyna, the daughter of Jacob, preserved her maidenhood so long as she kept quietly within her brother's house, but as soon as she, driven by curiosity, took herself off to foreign parts, she was dishonoured herself.⁴

From her first appearance, the chess queen made some men very anxious, and they felt the need to remind her that, regardless of her regal status, she was only a woman. For some writers, as we shall see in subsequent chapters, gentle allusions to proper feminine behavior were not enough. They became openly hostile to the chess queen and would have removed her from the board, had that been possible. Whenever a man chose to use chess as an allegorical mirror of society, he was forced to confront the reality of female power—a bitter pill for many to swallow. Sadly, this afforded some men the opportunity to chastise all women for the few who dared to act independently, aggressively, or deceitfully. In such allegories covering the whole spectrum of human society, authors could vent their sex and class prejudices, and many did.

Germany

In Germany, as we have seen, chess acquired a devoted population quite early. It moved quickly from the German Empire to regional courts, where no self-respecting lady or gentleman would have appeared without knowing how to play. The famous Manesse manuscript (1320), which contains both pictures and poems, shows the margrave Otto IV of Brandenburg playing chess with a fine lady. In his hand he holds a knight and she a bishop or jester—pieces that have just been removed from the board. Beneath them, miniature musicians play on bagpipes, drums, and trumpets, suggesting the festive atmosphere at his court (color plate 5).

Yet not everyone shared the courtly enthusiasm for chess. Around 1200, the celebrated German poet Walther von der Vogelweide lamented:

> Guests and trouble rarely come in peace So deliver me from guests That God may deliver you from chess.

Around 1300, the poet Hugo von Trimborg complained in one of his epigrams:

There is another game Men cherish, from which much Sin and shame come easily; Chess is the game I mean.

And a hundred years later, another poet bluntly warned his readers: "You should flee from chess!"⁵

These few outbursts aside, chess did not take long in Germany to spill beyond courtly and clerical circles. Burghers, students, even peasants in some locales, took up the game. An early-thirteenthcentury collection of anonymous Latin and German songs included descriptions of backgammon and chess accompanied by delightful illustrations. Some of the verses in this varied collection were clearly student drinking songs, some were love poems, while others were didactic texts with a strong moralizing flavor. Many

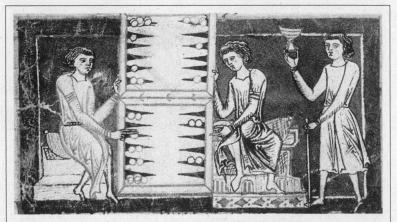

Backgammon players pictured in the *Carmina Burana*. Germany, early thirteenth century.

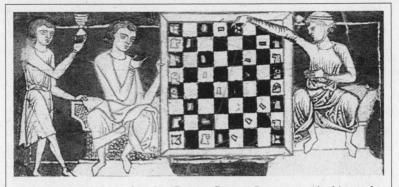

Chess players pictured in the Carmina Burana. Germany, early thirteenth century.

were accompanied by musical notation. These songs are the celebrated *Carmina Burana*, best known in modern times from the musical version composed by Carl Orff.

The *Carmina Burana* guide to chess, written in rhymed Latin couplets, can be summarized as follows:

If anyone wants to learn about the famous game of chess, let him attend to this poem. In the first square is placed the Rook (rochus), in the second the Knight (eques), in the third the Bishop (alficus), in the fourth the King (rex), in the fifth the Queen (femina)... The Pawn (pedes) advances and takes to the right and the left. When he reaches the limit of the board, he takes the Queen's (regina) move, and changing sex wields royal power.

The Rook goes the whole length of the board... The Knight runs rapidly... The Bishop, with his horned head, is to be dreaded for he misleads the opponent. Pawns take pieces and pieces Pawns, and both perish in the mêlée. But the King is not yet taken. When he loses his wife (*conjunx*) there is nothing of any value left on the board. Often he is mated and everyone shouts Mate! Mate! Mate!⁶

Certainly it would be difficult to play chess if all one knew

about the game came from this confusing guide! For our purposes, it contains some very interesting observations that have more to do with social attitudes than with chess per se. Both the knight and the bishop are styled as "deceivers," and the queen is allotted extraordinary power. Although her moves are not described, she is clearly the most important piece, because when she is gone, "there is nothing of any value left on the board." How can we interpret this statement? Should we assume that the queen had already taken on some of the movements she would acquire, officially, in the late fifteenth century? Possibly. What is more likely is that this privileging of the queen is a reflection of her prestige in society rather than her strength on the board.

What's more, she and the king are described as dearly attached to each other. She is called *femina* in her first incarnation, then *regina* after a pawn has been queened, and finally *conjunx*, wife, when it is a matter of her death on the board. The loss of the chess queen might not have been fatal to the game, but it was presumed to administer such grief to her spouse that he was unable to continue without her. Clearly, the author of this poem had more positive feelings about the chess queen, and wives in general, than those found in some of the other medieval works on chess.

A Chess-Playing Village

The village of Ströbeck in the Harz Mountains of central Germany claims that its peasants have been playing chess since 1011. As the story goes, Henry II of Germany kept the Wendish count of Gungelin in solitary confinement in the town tower, where he passed the lonely hours playing chess on the dungeon floor. In due time the Ströbeck peasants, who took turns guarding his cell, learned to play the game and taught it to their children. A more credible version of the game's origin in Ströbeck goes back only to the end of the fifteenth century, when a clergyman from Halberstadt was exiled there. He received such hospitality from the villagers that, after he had been freed and elevated to the rank of bishop, he founded a school in Ströbeck with the provision that the schoolmasters instruct the local children in his favorite game. For centuries, Ströbeck carried on this legacy.

H. F. Massmann, one of the earliest serious chess historians, noted in 1839 that all the inhabitants of Ströbeck more or less played chess, and that it was a required part of school instruction. The students, girls as well as boys, were divided into pairs to play against each other, and three annual prizes were given to the most successful players.⁷

A century after Massmann's observations, a 1931 issue of *National Geographic* reported on the continued chess program in the Ströbeck school. Children learned the game during the last three months of the academic year—January, February, and March—and made up for the time taken away from the regular curriculum by attending school during the summer, from seven A.M. to noon. No distinction was made between boys and girls, as can be seen from the pictures accompanying the article.⁸ Even today, children in Ströbeck study chess in school, and Germany, with a sizable contingent of players and scholars, has remained loyal to its long chess heritage.

PART 3

France and England

SIX

Chess Goes to France and England

o far we have concentrated on Spain, Italy, and Germany, countries where chess gained its first following in Europe and where the chess queen left early traces. Now we turn to France and

England, where she is more difficult to track. While a few medieval Italian and Spanish queens still exist, there are no comparable French or English survivors. What we have instead is a rich chess literature in Latin, Provençal, and Old French, and the stories of two remarkable historical queens: Eleanor of Aquitaine and Blanche of Castile.

Chess in Early French History and Literature

Chess came to France from Spain at the beginning of the second millennium. Its early presence on French soil can be verified not only by Count Ermengaud's Catalonian will of 1008, leaving his chess set to the church of Saint Giles in Nîmes, but also by a Latin narrative recounting the life of Saint Foy. Saint Foy was one of the most revered female martyrs in French Christendom, and *The Book of the Miracles of Saint Foy (Liber miraculorum sancte Fidis*) was intended to spread her glory among the faithful. One of its episodes concerned a noble youth miraculously liberated from prison, who was obliged to carry a chessboard all the way to the distant mountain sanctuary at Conques dedicated to her, as a mark of his gratitude. Early medieval chessboards, often quite large and made of precious materials like ivory and ebony, were considered a worthy offering for the church where Saint Foy's relics were preserved.¹

Religious fervor in Western Europe, marked by fierce hostility toward non-Christians, intensified during the eleventh century. Spanish Christians were wresting land violently from the Moors, and French Christians embarked on the first of several Crusades to conquer the Holy Land. An anonymous French poet captured the mood of the times in the robust epic *The Song of Roland (La Chanson de Roland)*, circa 1100. Although this charter work of French literature was ostensibly derived from Charlemagne's expedition to Spain in 778, the First Crusade (1095–99) was its true catalyst. Alongside tales of heroism and bloodshed, the poem also reflected less weighty contemporary realities, such as the newly fashionable game of chess. While some knights in *The Song of Roland* spent their leisure playing tables (a term used for a variety of games played with dice, such as backgammon), and others practiced fencing, "the wisest and the oldest" played chess. Here and elsewhere, skill in chess was seen as a sign of wisdom.²

Yet in the hands of the young and foolish, chess could be very dangerous. There are numerous stories of furious, violent acts that resulted from hard-fought games, such as the French tale *Ogier the Dane (Ogier le Danois)*. Here, after losing a close match, Charlemagne's son brutally murders Ogier's son, with the chessboard itself as his murder weapon.

Although this particular story had absolutely no basis in history, there were enough similar ones, in French and other languages, to suggest that medieval chess could sometimes be as hazardous as jousting.³ Chess duels became a common trope in medieval literature. Sometimes the stakes described were outrageous: a kingdom wagered by Charlemagne in *Garin of Montglane*, a Saracen princess in *Huon of Bordeaux*, each pitted against the hero's life.

Chess matches often figured in French and Celtic tales linked to the mythical King Arthur. Frequently, these tales involve female figures, who not only recall the memory of powerful pre-Christian deities, but also reflect the new importance of women in medieval society.⁴ A fanciful episode in Chrétien de Troyes's *Perceval* (1180–90) tells how Arthur's nephew Gauvain, besieged in a tower, defended himself and a helpful young lady by using the chessboard as a shield and the chessmen as projectiles. "They were carved of ivory, ten times heavier and harder than usual."⁵

In one Welsh version of the Arthurian legend centered around the quest for the Holy Grail, Perceval played chess against an invisible opponent and, frustrated at his defeat, ended up throwing the board into a lake. At that moment, a young girl appeared and reproached him for having lost the match. In another version, Perceval pursued a fabled white deer and, after many adventures, brought back the deer's head to a character called the Lady of the Chess Château to make up for his previous defeat.

Roland, Ogier, Perceval, and numerous other tales confirm the special place that chess—a war game between miniature armies—commanded in French and English feudal society. War of one kind or another was a given in medieval life, though it tended to be seasonal. Autumn was considered the best time for battle, after the harvest had been stored and before winter set in. During the long winter nights, isolated in their castles, knights-at-arms and their ladies were pleased to pass the time playing a strategic game that evoked military heroics without the bloodshed. The "game of kings and the king of games" shored up their privileged sense of self because it made visible the three major divisions of society. At the top were members of the nobility who ruled by virtue of birth and the sword, followed by the ecclesiastics who prayed, and then the great mass of peasants, serfs, artisans, merchants, and everyone else who labored.

Epic tales glorifying war came from the North of France where Old French was spoken. But the South of France, where Provençal prevailed, gave birth to a very different kind of literature: the lyric love poem. Instead of battles and bloodshed, Duke William IX of Aquitaine celebrated the *domna*, or beloved woman. Turning his back on the masculine glorification of war, he focused on love between the sexes, and especially on the passion that a beautiful woman could inspire in a sensual, articulate, and musically gifted man, such as himself. William IX was the first known troubadour and the grandfather of Eleanor of Aquitaine (1122–1204).

Eleanor of Aquitaine

Eleanor of Aquitaine—her name alone evokes images of castles and crowns, Crusades and convents, marriage and divorce, and political intrigue on both sides of the Channel. Eleanor, duchess of Aquitaine, countess of Poitou, duchess of Gascony, queen of France, queen of England—these are only some of the titles she wore as easily as the rich textures that adorned her body. It was a body prized by two powerful kings—Louis VII of France and Henry II of England—for three distinct reasons. First, it carried with it all the territories from the Loire to the Pyrenees, lands larger and richer than those possessed by the king of France. Second, Eleanor's body was expected to produce progeny for the crown, which it eventually did in great numbers: two children for Louis, no less than eight for Henry. Third, and this was thrown in for good measure since the first attribute alone would have sufficed, Eleanor of Aquitaine was, by all accounts, exceptionally good-looking.

Eleanor's history was interwoven at many levels with the spread of chess in France and England, and with the expansion of the chess queen's empire. During Eleanor's lifetime, the queen continued to replace the vizier throughout Europe, so that by the end of her reign there was hardly a sign of the vizier on the European board, except for Spain, where Arabic chessmen coexisted with European pieces into the late Middle Ages. It is tempting to assume that Eleanor's prestige played some role in the popularity of her miniature counterpart. At the least, she epitomized the trappings of queenship that worked their way into the symbolic system on the chessboard.

As a young princess at the court of her father, William X of Aquitaine, Eleanor would have learned to play chess, backgammon, and other dice games. Visiting troubadours were frequent guests in Aquitaine, and brought with them a culture of music, poetry, and games unfamiliar in most European courts of the era. Both chess sets and musical instruments (such as a portable harp) were essential parts of their traveling gear, and because the troubadours often served as gaming partners for noble children, Eleanor would have encountered chess at an early age, not to

mention the new romantic poetry brought into vogue by her grandfather and the younger generation of troubadours. She would have been captivated by their praise of desirable ladies beautiful, mysterious, and usually married—and by the sweet sighs of gentlemen transformed by the experience of love. (See chapter 8 for more on troubadour poetry and chess.)

In 1137, the young, elegant princess married Louis VII, when they were fifteen and sixteen years old, respectively. She left the sunny court of Aquitaine for the murky skies of Paris. There her lively mind, nourished on lyrical poetry, came in contact with the more earnest theological debates favored by her monkish husband. There is no doubt that Louis, deeply in love with his stunning young wife, was initially more influenced by her than she by him. She did her best to recreate in Paris the brilliant court life that had flourished in Aquitaine, replete with troubadours, storytellers, jugglers, and entertainment of every sort, including games of chance and chess.⁶ For the first eight years of their marriage, Eleanor and Louis had no children. The lack of an heir threatened the stability of the kingdom, and as the wife was always held responsible for not becoming pregnant, Eleanor had reason to fear for the future. Fortunately, in 1145 she gave birth to her first child, Marie. The following year, when the Church called for a Second Crusade to the Holy Land, Louis and Eleanor together decided to take up the cross. They were sent off with the blessings of the Abbot Suger after a moving ceremony at the basilica of Saint-Denis, leaving both their infant daughter and the French kingdom in the abbot's able hands. They were to be gone for nearly two and a half years.

Sometime after the Crusade of 1147–49, an anonymous poet wrote *The Pilgrimage of Charlemagne*, a mock-heroic narrative that poked fun at Louis and Eleanor, safely disguised as Charlemagne and his wife. The poem also offered a fantasy of imperial splendor at the court of Constantinople, which the royal couple visited en route to Jerusalem. There the crusaders found twenty thousand knights "dressed in silk and white ermine with great marten skins reaching down to their feet, playing games of chess and backgammon."⁷ While this description may have been exaggerated, courtly life in Constantinople was known for its ostentatious riches and various forms of entertainment, including chess. Setting the tone was the Byzantine emperor Alexis Comnenus, a passionate chess player, as described in the biographical work written by his daughter, Princess Anna Comnena (1083–1148). In Book 12 of her *Alexiad*, she tells how the emperor was in the habit of playing chess with his kinsmen when he awoke in the early afternoon: "it sweetened the bitterness of his many worries."⁸ There was precedent for this passion, of course, as the emperor had inherited a chess tradition that went back at least as far as the Byzantine empress Irene around the year 800.

On their actual journey to Byzantium, Eleanor and her caravan of noble ladies most probably brought chess sets with them, along with clothes, furs, household plates, goblets, jewelry, soap, food, and countless other amenities. Theirs were not Spartan traveling conditions, rather a great caravan of coaches, many of which had to be abandoned on the way.

While Eleanor was criticized as frivolous for the luxuries she carried with her, she was simultaneously lauded for her courage and perseverance. The journey from Paris to Constantinople and from there to Antioch and Jerusalem was both grueling and dangerous, yet Eleanor proved herself up to the ordeal. Whether or not Eleanor and her ladies ever took part in the fighting, the legend of a fierce queen leading Amazons into battle began to circulate soon after the Crusade. Can we see some relationship between this legend and the chess queen who had recently established herself on European boards? At the least, Eleanor's political authority and personal bravery reinforced the cultural image of a queen standing beside her husband in combat and facing the enemy *a deux*.

But Eleanor's union with Louis was not to endure. During

their brief stay in Antioch, where Eleanor was reunited with her uncle Raymond of Poitiers, chief of the eastern outpost, Eleanor announced to Louis that she wanted an annulment of their marriage. The grounds, as almost always among royalty, was consanguinity, that is, a blood connection deemed too close by the Church. Though reluctant to grant his wife's wish, even after the birth of a second daughter conceived during their return journey from Jerusalem, Louis was ultimately persuaded, in part by the need for a male heir. So far Eleanor had produced "only" females. The real reasons for their rupture have been subject to endless speculation for more than eight hundred years. Already in her lifetime Eleanor was accused of having betrayed her husband with several lovers, including her uncle Raymond.

What is certain is that in 1152, only eight weeks after her divorce from Louis, Eleanor was remarried, this time to Henry, duke of Normandy. With this marriage Henry added Aquitaine and Poitou to his lands, and, two years later, he also became king of England. At the time of their marriage, Eleanor was almost thirty and Henry but eighteen. She left behind at the court of France her two daughters, Marie and Alix, aged seven and eighteen months. Soon, however, she was producing progeny for the Duchy of Normandy and the English crown: her first son named Guillaume (William) was born in 1153, and was soon followed by four more sons and three daughters.

From sunny Poitou to chilly Normandy and then on to gloomy England, Eleanor was at Henry's side when he was crowned king under the arches of Westminster Abbey. Although they were often on the move, crossing the Channel and traversing France from Normandy to Bordeaux and back, Eleanor exercised the prerogatives of a ruling queen. She does not seem to have been backed up substantially by her husband, who would in time abandon her for a younger woman, or by her husband's closest adviser, Thomas à Becket, archbishop of Canterbury and later chancellor of England, who saw her as a rival for the king's ear. Nonetheless, whenever Henry was obliged to leave England for the continent, he delegated authority to his wife.

In one respect, Eleanor reigned supreme: she still presided over courts in England and Poitiers that promoted music, poetry, storytelling, games, riddles, and numerous other forms of entertainment. After dinner on festive occasions Anglo-Norman ladies and gentlemen danced, sang carols, enjoyed "wine, apples, ginger; some played backgammon and chess, others went to snare falcons," according to a description from *The Castellan of Concy* (*Roman du Castellan de Couci*).⁹

Chess may have come to England from Normandy with William the Conqueror in 1066, but there are no existing references to the game in England from that period. An early twelfthcentury Latin poem of English authorship preserved at the Bodleian Library at Oxford-the Winchester Poem-laid out the chessmen and their moves in thirty-six lines. As in the earlier Einsiedeln Poem, the king, queen, knight, rook, and pawns were called rex, regina, eques, rochus, and pedes, but the bishop was termed calvus, meaning "bald-headed," instead of comes or curvus ("count" or "aged one"). Calvus may have referred to the tonsured clergy, those who have shaved their heads, in which case the piece represents a step closer to the future bishop. Here and elsewhere the ancestor of the bishop was treated with contempt: "he lies in ambush like a thief." The queens were "allotted to the Kings as a guard," in keeping with the general view that a queen, in chess as in life, should stick close to her husband. A "queened pawn" was called ferzia instead of regina, which was a way of distinguishing between the true queen and an upstart queen. Judging from the Winchester Poem, the chess queen was already on the board when the game came to England, and there seems to have been little, if any, difference between the French and English game.¹⁰

In addition to chess and other forms of entertainment en-

joyed at the Anglo-Norman court, there were also the legendary "love courts" at which questions of love were debated and rules for romantic conduct established. How should a lover behave in the presence of his beloved? Does a young man renowned for his beauty and daring make a better lover than an older, virtuous man? How should a lady reward a faithful lover? Eleanor was, after all, the granddaughter of the first troubadour, William IX, so perhaps this discourse was in her blood. It was continued and deepened by Eleanor's daughter Marie de Champagne, carrying the troubadour tradition to her own court in Troyes.

Chrétien de Troyes

Marie was the patron of the brilliant writer Chrétien de Troyes, whose works reveal much about aristocratic life in France and England. His Arthurian romances, inspired by British models, follow the adventures of gallant knights such as Lancelot and Perceval pitted against despicable villains, cunning dwarfs, and awesome giants. Woven throughout are lithesome maidens and elegant queens to be rescued, wooed, and won.

In his first known work, *Eric and Enide*, probably written around 1170, Chrétien shows considerable knowledge of the court of Henry II and Eleanor of Aquitaine. In the guise of King Arthur and Queen Guinevere, they ride out to the hunt, preside over sumptuous banquets, and bestow honors according to twelfth-century chivalric codes. Incidentally, this story provides anecdotal evidence for the popularity of chess: when the protagonist Erec enters the courtyard of a neighboring castle, he sees maidens feeding their falcons and sparrow hawks, "while other town inhabitants/played dice and other games of chance; some chess, some at backgammon tables."¹¹ Like players today in New York's Washington Square and Paris's Luxembourg Gardens, medieval chess enthusiasts took the game outdoors when the weather permitted.

Another early romance, *Cligès*, probably written by Chrétien around 1176, presents further information about the England of Eleanor and Henry II, including scenes set at Windsor castle, disguised as the court of Arthur and Guinevere. In this tale Alexander, the elder son of the emperor of Constantinople, travels to King Arthur's court to be knighted, and falls in love with the proud and beautiful Soredamors. With Guinevere's intervention, he succeeds in winning Soredamors's heart and her hand in marriage. At their wedding celebration, a chess analogy is made, as Alexander's new consort is compared to the "queen/upon the board where he was king" ("*S'amie fu fierce/De l'eschaquier don il fu rois*"). It is a positive allusion meant to honor Alexander's bride.

But at virtually the same historical moment, in Gautier d'Arras's *Eracle*, analogy with the chess queen has a decidedly negative connotation. When the queen in this work commits adultery, the king is described as having been checkmated by his own wife ("*Li rois ert mates par se fierge*"). These passages from Chrétien de Troyes and Gautier d'Arras suggest the ambiguity of the queen's person, with Eleanor supplying the quintessential example in real life. In her role as consort, she could be a political asset to her husband, his right hand, a protecting "chess queen." Or, if she took a lover and endangered the line of succession with illegitimate heirs, she could become his worst enemy. By the time of Eleanor's reign in England, the chess queen had clearly entered the literary imagination as a metaphor for wifely behavior at the highest level. For better and worse, these double-edged visions of queens' behavior reflect medieval attitudes toward women in general.¹²

Marie de France

We get another sense of Anglo-Norman court life under Henry II and Eleanor of Aquitaine from the poetry of Marie de France, a mysterious woman living in England during their reign. Writing in Old French, the language of the English court since the time of William the Conquerer, she expressed the recent prominence of women both as subjects of literature and as active participants in the new society the nobility was creating.

Her story "Philomena" described the ideal noblewoman who was as "wise as she was fair," excellent at falconry, able to stitch on silk and brocade, proficient in writing both verse and prose, competent on the psaltery and lyre, and articulate without the promptings of a book. And, of course, "She knew all sorts/Of entertaining games and sports/... Both chess and backgammon she could play."¹³

In another story, "Eliduc," Marie brings us right into the bedroom of a young princess where a chess match was taking place.

> The king was having a game of chess After dinner in her [his daughter's] apartment. He played with a foreign knight and meant To have him teach his daughter the game.¹⁴

Ostensibly, the game was played in the young woman's chambers so that she could observe the match and benefit from the performance of a foreign knight brought to the castle to tutor her. The boys, we know from the epic poem *Gui of Nanteuil* (1198), started learning to play as early as the age of six, at the same time they were receiving their first lessons in horseback riding. They also played dice, tables (backgammon), and marbles, but chess was seen by parents and educators as more than a child's game since it provided an early exposure to military strategy.

Young men training for knighthood were often sent at a very early age for apprenticeship in a different household. There, before they were old enough to practice martial arts, the boys performed all sorts of useful jobs—they acted as messengers, waited on tables, assisted in falconry and hunting, and were enlisted as chess partners. Noble girls were not usually sent away from home, but they, too, had an apprenticeship in useful activities, such as sewing and household management, as well as lessons in singing, dancing, and playing chess. Oddly enough, despite myriad misogynistic distinctions between the sexes that went as far back as the Greeks and the Bible, chess was one arena in which the "natural inferiority" of women was never brought up. By the end of the twelfth century, in both England and France, an ability to play the game had become an accomplishment expected of a well-born lady, as playing the piano would be in the nineteenth century.

Naming the Chess Queen

As we have seen, Latin manuscripts from this period referred to the chess queen as *regina*. In Italian, *regina* was adapted into the vernacular as *reina*, in Spanish as *reyna*, and in French as *reine*—all words for "queen." But another word commonly used for the chess queen was *fers*—a term adapted from the Arabic *firz* and *firzan* (royal adviser or counselor), recalling the vizier whom the queen replaced. In Spanish, *fers* became *alfferza* or *alferza*; in Catalan, *alfersa*; in Italian, *farzia* or *fercia*; in French, *fierce* and *firege*. These were clearly feminine words that signified the transformation from male to female, but when the word *fers* was used without modification, there was confusion about its gender.¹⁵

What word did Eleanor use when she spoke of her chess counterpart? She probably used the Arabic-rooted term *fers*, or its Old French adaptations *fierce* and *fierge*. *Fierge* was still in use as late as the end of the fourteenth century in France, and *fers* was common in England well into the fifteenth century. Chaucer used it in his *Book of the Duchess*, written in 1369, when a knight mourning his dead wife compared his conjugal loss to the loss of a chess queen in a game against Fortune:

> At the ches with me she [Fortune] gan to pleye; With hir false draughts [pieces] dyvers She staal on me, and took my fers. And whan I saw my fers awaye, Allas! I kouthe no lenger playe.¹⁶

If one loses one's fers, he is saying, the game is virtually lost.

During the fourteenth century, *reine* (spelled *roine* or *royne* at that time) gradually replaced *fers*, *fierce*, and *fierge* in French usage, and during the fifteenth century, the word *dame* also began to take over. These linguistic changes heralded major advances for the chess queen in the late fifteenth century, which we shall consider later.

In Eleanor's lifetime, the names of the chessmen varied not only from one language to the next, but also within Latin. For example, Alexander Neckam, the renowned English author of *De Naturis Rerum* (circa 1180), which contained a short chapter on chess, used the word *senex* (old man) for the bishop rather than *comes, curvus,* or *calvus.*¹⁷ Incidentally, Neckam had a personal connection to the British queen through his mother, Hodierna, who had been the wet-nurse of Eleanor's favorite son, Richard I, in 1157. Since that was the same year as Neckam's birth, it would have made the two men what the French call "milk brothers." But getting back to the chess bishop, he was generally not held in high esteem. Neckam referred to him as a "spy," and the Winchester Poem called him a "thief." The very word *aufin* commonly used in French and English for this piece became a term of scorn or reproach in both languages.¹⁸

On the whole, Neckam seems to have had a low opinion of chess. Like his Italian predecessor, Bishop Petrus Damiani, he considered it a waste of time, and, worse, something that often led to heated brawls. This judgmental attitude colored what he wrote about the pieces themselves. There was, for example, something unseemly in the pawn's "changing his sex" when he crossed the board and became a queen. On the other hand, Neckam's high regard for kingship led him to tell an illustrative story about the French king Louis VI: in 1110, when Louis was nearly captured in a skirmish and an English knight shouted that the king was taken, he is reputed to have said, "Begone! Ignorant and impudent knight, not even in chess can a King be taken."¹⁹

The medieval chess player seems to have valued the pieces not only on the basis of their true strength on the board, but also in terms of the position they held in society. Thus the knight was treated as the equal of the rook, although the latter piece was the only one able to advance the full length of the board in one move, and was therefore more valuable. Several textual references seem to show an exaggerated opinion of the value of the queen, even if she was, in terms of her movements, one of the weakest pieces. Perhaps the glory of the illustrious Eleanor added to the inflation of the chess queen's value.

But Eleanor's glory days were about to be interrupted for fifteen years. In 1173, her sons began a revolt against their father, Henry II. Siding with them rather than her husband, Eleanor provided considerable military assistance to their revolt. To her chagrin, Henry was victorious, and, as punishment for backing the rebels, Eleanor was thrown into the tower of Chinon in 1174. From there she was whisked back to England and placed in isolation in a series of depressing locales, all under the eye of watchful

jailers. For more than nine years, she was allowed few visitors, and had to draw upon the resources she had acquired as a girl: reading, stitching, playing musical instruments, and chess. A precedent for granting a chess partner to a royal prisoner had been established earlier in the century by Henry I, the youngest son of William the Conqueror, and Queen Matilda, during the lengthy captivity of Henry's older brother, Robert, the duke of Normandy. Robert, who had lost Normandy to Henry in battle, remained a prisoner in England for the rest of his life, but not without the amenities considered appropriate to his rank.

Playing chess seems to have been a given for royal prisoners in England throughout the Middle Ages. One is not surprised to find a chess set included among the many lavish expenditures of King Jean II of France during his four-year imprisonment, after he was captured by the English at the Battle of Poitiers (1356). While waiting to be ransomed, Jean was not deprived of games, musical instruments, fancy clothes, dogs, and even imported venison and whale meat, as long as he could pay for them.

Eleanor's incarceration was considerably more spartan, at least for the first decade. Then, for the next five years, she was only a semiprisoner. When Henry II died in 1189, she not only regained her complete freedom, but became the major force in English governance. The new king, her favorite son Richard the Lion-Hearted, was interested primarily in joining the Third Crusade, and left many affairs of state to his mother. (Both Richard and his brother, the future King John of Magna Carta fame, were known to have been dedicated chess players.) At sixty-seven, Eleanor took on the mantle of leadership in England, Normandy, and Aquitaine. Her political experience, wide kinship network, and continued vitality served her and her dominion well.

One of Eleanor's last acts was to select from her considerable progeny a wife for the future king of France. She turned to her daughter, also named Eleanor, who had become queen of Castile,

CHESS GOES TO FRANCE AND ENGLAND • 99

to provide one of her children for this prestigious union. Thus, in the year 1200, as queen mother of England, Eleanor traveled across the Pyrenees to Castile to collect her granddaughter Blanche and bring her to France, where she would become the influential wife of Louis VIII and mother of Louis IX, better known today as Saint Louis. Looking back on that event from the vantage point of the twentieth century, one of France's leading historians began her biography of Blanche of Castile by asserting: "At the turn of the thirteenth century, in the year 1200, it was women who made history."²⁰ There is much truth to that statement. Eleanor of Aquitaine and Blanche of Castile became in their long lifetimes the equals of their husbands and sons, the living models of female strength and grandeur symbolically incarnated in the chess queen.

Unfortunately, no French or English chess queens from this period have survived, though a number of other pieces are still intact. A twelfth-century French king sits on a throne holding a large cross in his hands (Florence, National Museum). A twelfthcentury French rook has two knights jousting against each other on one side, and Adam and Eve on the other (Paris, Louvre). A thirteenth-century English knight encased in a coat of mail and a rectangular helmet sits astride a beautiful horse (Oxford, Ashmolean). A king with a crusader's cross, knights on horseback brandishing swords—both were appropriate symbols of the royal world from which Eleanor peacefully took leave in 1204 at the age of eighty-two (color plate 6).

Blanche of Castile

Eleanor's granddaughter Blanche of Castile added another impressive chapter to the history of queenship. Married to the future Louis VIII when she and he were both twelve, they

spent their adolescent years together in and around Paris before consummating the marriage five years later. During this time, they seem to have established a loving friendship that was to endure for the rest of their marriage. They shared an education in Scripture, Latin, and French, and were enthusiasts of dancing and hunting. Presumably, they also played chess, an assumption backed up by records that Blanche once offered Louis the gift of a chess set.²¹ Though we have no further information about this set, or another she offered to an unnamed recipient, they were probably elaborate, garnished with silver or decorated with fine inlaid woods, like those mentioned in several medieval inventories.²²

During most of their marriage, Louis's father, Philip Augustus, was still alive, and the young couple was not obliged to bear full regal responsibilities. Blanche was busy enough producing babies—twelve in all, eight of whom survived. But in 1223 when Philip Augustus died, Louis VIII and Blanche were crowned together in the cathedral of Reims, when both were thirty-five years old. During the tour of the kingdom that followed their coronation, the couple was showered with expressions of loyalty and affection.

Blanche was at the height of her happiness. Beloved by her subjects, husband, and children, she radiated elegance, piety, and generosity. But her good fortune was not to endure for long. Three years after their coronation, Louis succumbed to the rigors of a long military siege in the South and died on the journey back to Paris. France had lost an excellent king and Blanche an exemplary husband. Unlike his father and most French kings, Louis had always been faithful to his wife. Considering the traditional prerogatives of kings, it is astonishing that he never had a sexual partner other than Blanche. In his testament, Louis stipulated that, in the event of his death, his wife would rule the kingdom until their son Louis came of age. Blanche, overwhelmed with despair, had to find the strength not only to go on living as a grieving widow, but also to secure the kingdom for her twelve-year-old son. It is a measure of her determination and efficiency that she organized his coronation at the cathedral of Reims exactly three weeks after his father's death, despite opposition from the barons who felt it was not suitable for a woman to "govern so great a thing as the kingdom of France."²³

Blanche's role as queen mother gave her more power than she had ever had before, and she wielded that power for the rest of her life. Louis, predisposed to the pious acts that would later be recognized as the hallmarks of a saint, rarely took a position without consulting his mother first. Blanche, for her part, loved this son beyond measure and saw him develop into a young man who fulfilled her greatest hopes. It was a mother-son relationship made in heaven (color plate 7).

Even when Louis married Marguerite of Provence, he at the age of twenty and she but thirteen, deference to his mother often took precedence over his conjugal responsibilities. This triangle inevitably produced problems for the young couple, who were much in love and remained so for the rest of their lives.

Blanche was involved in everything: from the making of royal marriages to the administration of the realm, from political alliances to strategies for war and peace, from gifts to the poor to the building of churches. In the latter respect, her son was not only at her side, but often took the lead—for example, in the construction of the Sainte Chapelle, intended to house relics of the "true cross" and the crown of thorns. From 1243 to 1248, Paris experienced a virtual architectural renaissance, including major construction on the cathedral of Notre Dame.

Caught up in the fervor surrounding the Virgin Mary, Blanche made a pilgrimage to Rocamadour, site of the oldest sanctuary in France devoted to the Virgin. With her four sons, their wives, and a large entourage, Blanche paid homage to the celestial queen and also expressed gratitude for the recent birth of Marguerite's son,

Louis. In addition to the two daughters Marguerite had previously borne, there was now an heir to the throne. (In all, Marguerite would give birth to eleven children.)

This pilgrimage within France was, however, not sufficient for Louis IX. Against the advice and supplications of his mother, he was determined to take up the cross and travel to the Holy Land. In 1247, a hundred years after the Crusade led by his greatgrandparents, Louis VII and Eleanor of Aquitaine, Louis set off by sea with his wife, three of his four brothers, and a vast assembly of nobles and clergymen. He left his three children in the care of his mother, and, even more importantly, he entrusted her with governance of the kingdom. Disconsolate as she was, Queen Blanche was once again obliged to rule on her own.

While Louis and Marguerite experienced the adventures and perils of travel to and from Jerusalem, which included battles, imprisonment, ransom, sickness, near-death, the birth of three babies, the loss of loved ones, the cruelty of foreign rulers and their unexpected kindness, Blanche remained at home and carried on. Many of her last acts reflected her generosity and piety, for example, the freeing of her serfs in 1252. But her dearest wish, to see her beloved son return from the Near East, was never realized. At the age of sixty-four, in November 1252, she took to her bed and died. Her body was carried to the Abbey of Saint-Denis, resting place for the kings and queens of France. By then, the "Charlemagne" chess pieces were probably already a part of the rich treasury of Saint-Denis, so the first chess queens and the most influential queen of medieval France were preserved unmarred in the same sanctuary until the time of the French Revolution (1789-93).

Blanche's son Louis was not a friend of chess. Unlike other thirteenth-century monarchs—the emperor Frederick II of Palermo, Alphonso X of Castile, and Edward I of England, who were enthusiastic players—Louis had an aversion to all games, and especially those with dice and stakes. According to his chronicler Jean de Joinville, when Louis saw one of his brothers playing chess while at sea during the Crusade, he dumped the board and all its pieces into the Mediterranean.²⁴ Later, during the campaign at Saint Jean d'Acre, he probably just held his tongue when "The Old Man of the Mountain," the head of an Islamic sect, offered him a luxurious chess set in crystal, amber, and gold. But upon his return to France, Louis did what he could to eliminate game playing altogether. I lis royal ordinances of 1254 and 1256 prohibited the playing of chess and dice, and forced the closure of gambling houses.²⁵

In many circles, chess had a bad reputation because of the violence it provoked. London legal documents between 1251 and 1276 include two chess homicides. In the first case, when a quarrel arose between two gentlemen of Essex over a chess match, one of them struck the other "in the stomach with a knife so that he died." In the second case, "David de Bristoll and Juliana wife of Richard le Cordwaner were playing chess together in Richard's house. . . . A quarrel arising between them, David struck Juliana in the thigh with a sword, so that she died forthwith. He at once fled."²⁶ Here a woman was the chess victim, but usually both the killers and their victims were men, and the homicide took place more commonly in a tavern than in a gentleman's home.

English attempts to ban chess were largely limited to the clergy. In 1274, a decree issued at Abingdon forbade the monks to play chess anywhere within the bounds of the monastery. In 1291, the Archbishop Peckham condemned the prior and canons of Coxford Priory, Norfolk, for "being led astray by an evilly-disposed person...who had actually taught them to play chess, which heinous vice was to be banished, even if it came to three days and nights on bread and water."²⁷ These harsh prohibitions were to no avail, and chess thrived in English monasteries, as it did among continental clergymen.

Christianity was not the only religion that tried to get rid of chess. Jewish theologians differed in their pronouncements, but one of the greatest—the rabbi, physician, and philosopher known as Maimonides (1135–1204)—expressed unambiguous disapproval of the game when it was played for money, and he even declared that professional chess players were not to be trusted in courts of law. Throughout Europe, rabbis issued bans against games of all sorts in times of trouble, as a means of placating God's wrath. Usually chess was spared, and if there were no stakes involved, chess could be played even on the Sabbath.²⁸

Early Arabic theologians, as we have seen, eyed the game with suspicion. They stressed the neglect of prayer and the exchange of money frequently involved. Even if chess was not mentioned in the Koran, ultra-orthodox Muslims periodically proscribed the game right into the twenty-first century. The recent Taliban ban on chess in Afganistan is a case in point, but it, too, ultimately proved no more successful than Saint Louis's prohibitions in the thirteenth century.

Perhaps because chess is such a complicated game, it has always been taken seriously. Indeed, it has provided matter for reflection on the most mystifying aspects of human existence war, love, society, religion, even death. The Persian poet Omar Khayyam (died 1123) established an oft-repeated analogy between the chessboard and the course of human life: "We are in truth but pieces on this chess board of life, which in the end we leave, only to drop one by one into the grave of nothingness."²⁹.

More than a century after Khayyam's death, John of Wales, an English Franciscan monk who studied and taught at Oxford and later in Paris, rephrased that analogy in Christian terms. When he wrote "All the world's a chess board" sometime between 1250 and 1260, he added a sobering religious dimension, making the chessboard not only a symbol of life and death, but also a metaphoric space for sin and redemption. He reminded his audience that whatever their station in life, all members of society, including the king, would be thrown pell-mell into the same sack once the game was over. Death being the great equalizer, a king could fall to the bottom of the sack and go to hell, while even a poor peasant might ascend to heaven.

Like others before and after him, John of Wales was not exempt from coating chess pieces with his own prejudices. He, too, held bishops (aufins) in contempt and accused them of cupidity, perhaps because his Franciscan order prized poverty and humility over the worldly qualities that bishops often displayed. He was also clearly misogynistic, accusing queens of being greedy, like all women, and known to take through rapine and injustice. He made much of the fact that both the bishop and the queen moved on the diagonal, representing unjust qualities, whereas the king and rook moved in just, straight lines. (Here John conveniently forgot that the king could also move diagonally.) The knight has both possibilities: his straight moves are associated with his legal power in collecting rents and his oblique moves with extortion and wrongdoings. Pawns, too, have these dual attributes: they generally are straight, but when they take anything, they take it obliquely. John interprets the promotion of the pawn to a fers and his subsequent diagonal moves as a clear example of how hard it is for a poor man raised above his station to act justly. More than anything, perhaps, John of Wales's analogies show us how versatile the chessboard is as a metaphor for social life.³⁰

Elsewhere the chess queen profited from the splendor of real queens like Eleanor of Aquitaine and Blanche of Castile. Their illustrious reigns coincided with the spread of chess in France and England, and enhanced the prestige of the queen on the board.

Eleanor, associated with troubadour poetry and a romantic vision of regal women, brought chess into her court, where it became an accomplice to courtly love. Her granddaughter Blanche of Castile had other interests: she contributed to the reli-

gious expansion of her age and to a heightened veneration of the Virgin Mary. The cultural currents for which these two queens are remembered—the cult of the Virgin Mary promoted by Blanche and the cult of love promoted by Eleanor—had surprising consequences for chess, as will be seen in the next two chapters.

SEVEN

Chess and the Cult of the Virgin Mary

n ivory statuette of the Virgin Mary, only three and a quarter inches high, must be held responsible for this book. This little Madonna, housed in the Isabella Stewart Gardner Museum in Boston, triggered

my interest in the chess queen and led to my eventual discovery of a hidden relationship between Mariolatry (worship of the Virgin Mary) and the game of chess.

Carved during the fourteenth century in Scandinavia, she sits squarely on a throne, wears a floriated crown over a veil, and looks out serenely through carefully drilled eyes.

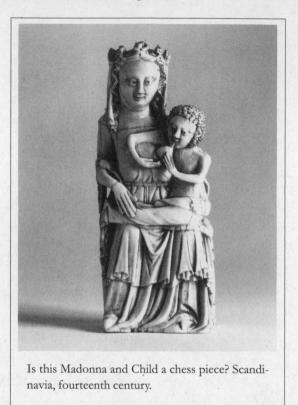

Her long-sleeved robe belted at the waist falls in sumptuous pleats to her feet, covered by pointed shoes. As befits the Holy Mother, she holds a nursing Jesus, whose legs stretch across her lap. His skinny arms reach out to grasp her breast, which, in the style of the times, does not appear to be truly connected to her body.

I first saw her on a tour of the Gardner after I had published A History of the Breast. My assignment was to choose something from the museum's collection related to my book that would provide material for a subsequent lecture. At one point the curator who took me around said he wanted me to see "the chess queen," whereupon he opened a cabinet and took out this remarkable Mother and Child. Although I had seen many other nursing Madonnas, I had never seen one quite like this and was prepared to believe she was a chess piece. In my hand she felt like one, and certainly the exquisite detail carved into the back of the throne was a feature common to many chessmen.¹

Soon I was in hot pursuit of Mary on the chessboard, but while I found several medieval Scandinavian pieces that were clearly chess queens (see chapter 9), none of these looked anything like the heavenly Virgin. Eventually I came to the conclusion that a Madonna—and a nursing Madonna at that—could not have been a chess queen. After all, I asked myself, what would the other pieces have looked like? God the Father? Jesus? Saints and angels? Having, however, become hooked on the subject of the chess queen, I continued my research, forgetting any possible connection between the queen on the board and the queen of the heavens. That is, until one day when I came across evidence that such a connection could, and did, exist.

There is a short poem in the Bodleian Library in Oxford that answered my question about what the other pieces might have looked like. In forty-eight verses written in Anglo-Norman French, an anonymous thirteenth-century author imagined the following scenario. The world seemed to him to resemble a chessboard with its kings, aufins, rooks, and knights. The black pieces belong to the Devil, the white ones to God. Our first ancestor, called Adam, was like a great king on the board. He played against the Devil, who defeated him in three moves. When God saw that Adam had been checkmated, he started the game over again, this time with Jesus as the white king, and the Virgin Mary at his side in the place of the queen. The rooks were apostles sent out to preach in groups of four. The aufins were the "confessors" (bishops), and we humans are the pawns. This fable of the fall of man and redemption through the birth of Jesus was spelled out in terms of chess. Well then, at least in the imagination of this author, there was a set of chessmen that included the Virgin Mary,

IIO · BIRTH OF THE CHESS QUEEN

as well as Jesus and the apostles. If nothing else, this poem pointed to a poetic association between the chess queen and the Holy Mother.

Unfortunately, the manuscript does not follow the progress of the transformed pieces once they have been set in place by the hand of God. Instead, it continues in the vein of other moralities from this period, chastising men for acting like children and throwing away eternal happiness for trivial pleasures. It stops abruptly with the sexually loaded admonition: "They [men] love to sow, but they hate to harvest."²

With this poem in mind, I searched assiduously for similar analogies and soon found another in the *Deeds of the Romans* (*Gesta Romanorum*), a Latin collection of anecdotes, parables, and tales that were extremely popular during the later Middle Ages. A chapter on chess describes the game as a Christian morality play. The supreme king is identified as Jesus Christ and the queen as the Virgin Mary, as in the following passage.

But that beloved King is our Lord Jesus Christ, who is King of Kings in Heaven as on Earth, which may be seen from the way he moves and advances. For when He advances all the choirs of the holy Angels go with Him. Rooks and *Aufins* and the other chess pieces protect Him. . . . He takes with him also the Queen, who is the mother of all compassion and also our Lady Mary. For her sake He takes the step of mercy to the square of the pawn, which means to all men on earth.³

This Marian chess queen is seen primarily in her role as a merciful intercessor with God, and not as a combatant on the board. *Deeds of the Romans* and various versions of Jacobus de Cessolis's *Book of Chess* spread this concoction of chess and religion throughout Christendom.

Gautier de Coinci's Miracles of Our Lady

None of these texts, however, focused primarily on the Virgin Mary. It wasn't until I encountered *The Miracles of Our Lady (Les Miracles de Nostre Dame)* by Gautier de Coinci that I found what I was looking for: a lengthy composition featuring Mary as the star of a chess drama. Gautier's life (circa 1177–1236) coincided with the rise of the cult of the Virgin and overlapped, in his adult years, with the reign of Blanche of Castile, Mary's great advocate in France.

Three separate passages in Gautier's *Miracles* present the Virgin Mary in the guise of a chess queen.⁴ In the lengthy prologue to Book I, combat for possession of a man's soul takes the form of a match between God and the Devil, with Mary identified as the chess queen on God's side. Mary and the Devil are pitted against each other in an ultimate battle, the outcome of which will determine whether an individual is to spend eternity in heaven or in hell.

> Whoever serves her (Mary) well . . . Has such an advantage in all games That the devil . . .

Cannot beguile him.

.....

He (the devil) knows so many tricks and plays That in no time he will have us in a corner Where we will be taken and mated.

While Mary has an advantage over the Devil, he is not to be underestimated. Remember what he did to Adam and Eve! To

save us from their fate, "God made such a Virgin Queen/That he (the devil) was mated and undonc." On one level, the poem offers the traditional theological vision of Mary as the "New Eve," who helped redeem mankind from original sin. But on another, the poem is specific to the game of chess, to God's intervention in a particular match, and to His use of the Virgin Mary as a substitute chess queen.

> He planned a brilliant move long in advance Which the devil in no way foresaw. He covered his side with his queen. The devil, who works much evil, When God had advanced His queen, Lost his wits and his power. This queen moves in such a way That she checks the adversary in all directions. The traitor who knows many moves Soon takes fright when she moves: He cannot fathom even one of hers. Then she gives him a perfect check So ingenious and so well done That he immediately loses his game completely. God, what a queen! God, what a chess queen!

In this last verse, the words *roine* (*reine* in modern French) and *fierce* distinguish between "queen" in general and "chess queen." *Fierce* or *fierge* were common French terms for the chess queen when Gautier de Coinci was alive. They were so close in spelling and sound to the word *vierge* ("virgin") that they may have sug-

gested the supreme Virgin to Gautier, and to anyone else with an ear sensitive to homonyms.

What is remarkable about this section is the extraordinary power granted the chess queen at a time when she was still the weakest piece on the board. Of course, these are miracle tales meant to honor the Holy Mother, so we should not be surprised by her supernatural moves. Gautier endowed the Virgin queen with an ability to move rapidly in all directions and across long distances.

> Other queens move but one square, But this one moves so fast . . . That before the devil has taken one of hers, She has him so bound and bewildered That he doesn't know which way to move.

Such strength would not be officially assigned to the chess queen until the late fifteenth century—that is, two hundred and fifty years after Gautier's death. Should we see this as intuition or prophecy on his part? It is more likely that the veneration of the heavenly queen spilled over onto all queens and even to the symbol of queenship on the chessboard. In all probability, the cult of the Virgin Mary provided a context that not only valorized the chess queen, but eventually helped to elevate her above all the other pieces.

Before leaving the story of the Virgin's miraculous checkmate, Gautier burst into a poetic paean for his Lady:

> This queen mates him [the Devil] head-on. This queen mates him in the angle. This queen quiets his jangle, This queen deprives him of his prey, This queen torments him every day.

This queen goads him everywhere This queen [drives him] from square to square.

This *fierce* deserves no less than the poems sung by troubadours to their idealized mistresses. But instead of comparing the Madonna to Venus or Flora (highly inappropriate similes for the Virgin Mother), Gautier sings her praise by conflating her with the chess queen. Both women enjoyed the "queen bee" privilege of being the only female on the playing field.

A second passage in Gautier's *Miracles*, the song "Mother of God, Wise Virgin," picks up the chess queen analogy. A supplicant begs Mary to save him from being trapped by the Devil in the corner of the chessboard. Being pinned in the corner is equivalent to falling into "the pit of Hell." Only through Mary's intercession can the player be saved from checkmate and eternal damnation. Thus he throws himself upon her mercy and acknowledges:

We cannot move without you. [We are] your pawns, Teach us to play, God's Chess Queen, And take such care of us That to the great King We may all arrive.

Here Mary is designated as "God's Chess Queen" (*Fierce Dieu*), and recognized as absolutely essential in defeating Satan. Only through her protection can we, the pawns of this earth, hope to be united with the great King. The song ends with an ascent from the chessboard to the heavenly realm inhabited by Jesus and Mary.

Finally, the introduction to Gautier's "Cleric's Tale" reminds the listener that "The one, whoever he be, man or woman,/Who does not sincerely love our Lady,/Cannot Win the game." God will say "Check! Check! And Mate in the angle" to all those who have not served the "great celestial Chess Queen."

The Celestial Queen and Secular Queens

Gautier was writing his *Miracles* during the first quarter of the thirteenth century, a time when the French monarchy was developing a level of intimate devotion to the Virgin. Blanche of Castile, as we have seen, identified herself with the cult of the Virgin and promoted it throughout her kingdom. The equation of the chess queen with the Virgin, and behind her, the French queen, would have made sense to the aristocratic readers and listeners for whom Gautier's work was primarily intended.

The cult of the Virgin Mary was everywhere in Christendom. Statues of the Mother and Child sculpted into wood or stone invited silent worship within the church, while outside on the façade she sat in majesty next to Jesus and the saints—for example, on the Saint Anne portal of Notre Dame in Paris. Her benevolent image shone down from stained glass windows, glistening mosaics, and painted frescoes, or radiated upward from manuscript illuminations.

Just as Mary's image offered a feast for the eyes, so, too, songs and prayers in her honor delighted the ear. Both Latin and vernacular prayers often began with an invocation to the Virgin: "Mary, holy mother of Jesus, I confer my soul, my body, and my spirit into your hands and those of your blessed son, today and forevermore." One typical fervent eleventh-century prayer included the following: "Virgin Mary, holy and immaculate bearer of God, most kind, most merciful and most holy, glorious mother of my Lord and illustrious beyond the stars . . . come to the aid of a miserable sinner."

Hymns exalted the Virgin as the Mother of God, the Bride of

Christ, the Mistress of Angels. The mournful "Salve Regina" that first appeared around 1100 became the most popular Catholic hymn of all time. The Four Hundred Songs of Holy Mary (Cántigas de María) written or collected by none other than Alfonso X of Castile, sang her praise and celebrated her miracles in Spain.

Mary was adored by the poor and the rich, by the inhabitants of hovels and castles, by nuns and mothers, by wives and widows. Pregnant women implored her protection in childbirth, and new mothers begged for a good supply of milk. Some left ex-voto symbols of their breasts or other body parts near her image in church to thank her for good health or to ask for a miraculous cure. The Virgin could do anything if she heard your prayers, and she was particularly receptive to the voices of women, who constituted a large proportion of her devotees.

Christianity had officially approved the term "God bearer" (*Theotokos*) for Mary at the Council of Ephesus in 431 and enhanced her reputation by proclaiming that she had conceived without sexual intercourse—that is, without the taint of original sin. The earliest representations of Mary almost always showed her in her maternal role with the Baby Jesus. Somewhat later, the image of Mary as Queen (Maria Regina) was added to the image of Mary as Mother. During the sixth and seventh centuries Maria Regina appeared in several Italian church frescoes in the guise of a Byzantine empress, probably modeled on representations of the famous sixth-century Empress Theodora.⁵

In the twelfth century, the theme of the coronation of the Virgin entered into Western iconography, first in the apse mosaic of S. Maria in Trastevere in Rome, and then on the façades of numerous French cathedrals newly dedicated to the Virgin.⁶ The coronation motif, which presented the Virgin as a consort seated in heaven next to Jesus, was modeled on the joint coronations of living kings and queens. In a mystical sense, Mary was considered the Bride of Christ, as well as his mother. Before long,

the Virgin would reach her apotheosis in the paintings of the Italian masters—Cimabue, Giotto, Duccio, Simone Martini, and Fra Angelico—who portrayed her seated on a throne in the heavens surrounded by adoring saints and angels.

In Italy, the Virgin was not only understood as a queen, but became a "surrogate monarch" in civic life. Cities such as Siena, Pisa, Parma, Spoleto, Orvieto, and Cremona adopted her as their patron and sometimes included her portrait in their official seals. Mary's four principal feasts (the Assumption, the Annunciation, the Nativity, and the Purification) became public holidays with city-sponsored processions. Conscious of the Virgin's authority in matters of judgment, confraternities arose in her honor and prayed collectively that she would "intercede for us with her son and promote and preserve the good state of our city." Over and over, they implored the "gracious queen," the "sovereign queen," "the queen of mercy," the "resplendent queen above the angels," the "great queen, who sways every kingdom," the "most powerful queen exalted above the heavens" to come to the aid of their communes. Mary in the court of heaven exercised her power of intercession with the greater male power, her son and mystical husband, just as real queens pleaded with their kings on behalf of imploring subjects.7

The idea of Mary as a cosmic queen, originally modeled on secular queens, ultimately reversed its course and redounded to the credit of flesh-and-blood monarchs. If the Holy Virgin could reign over the heavens, why shouldn't queens reign on earth? If the Holy Mother could be entrusted with the souls of men, could not women rulers be entrusted with the protection of their living subjects? It was an analogy female sovereigns used to shore up their authority.

Anything that honored the celestial queen honored them as well. They became patrons of churches dedicated to Our Lady. They endowed convents and monasteries, with special attention

to the well-being of chaste and obedient nuns choosing to emulate the Virgin. They commissioned Books of Hours containing prayers called the Little Office of the Blessed Virgin Mary (or simply the Hours of the Virgin) to be read at different times of the day.

Some queens even had themselves painted looking like the Virgin Mary. As early as the beginning of the eleventh century, a picture of Queen Emma (married to the Saxon king Aethelred in 1002 and the Danish king Canute in 1017) represented her like a Marian icon. She was portrayed sitting stiffly on a throne, with an

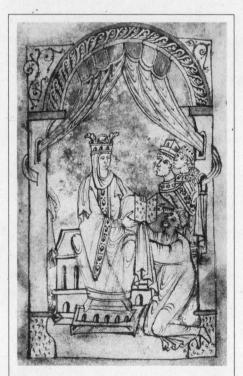

Portrait of Queen Emma of Denmark and England, and her sons. England, early eleventh century.

extravagant crown on her head and her two sons marginalized like supplicants at her side. One of these sons went on to become the English king Edward the Confessor.⁸

In the following century, a sumptuous painting of Blanche of Castile and her son, the future saint Louis was modeled on the celestial coronation scenes that were already visible on cathedral portals. No one seeing such a painting would have missed the intended association between the queen of France and the Virgin Mary (color plate 7). Mariolatry waxed steadily from the early eleventh century till its high point in the fifteenth century. This timetable was roughly the same for the history of the chess queen and for the cult of romantic love. The miraculous Virgin, the chess queen, and the beloved lady grew up together and reinforced one another. Collectively and individually, they represented womanhood positively in contrast to more traditional misogynistic pictures of women. Over time, these three cultural phenomena helped valorize the feminine, especially at the highest social levels. Mary herself was not only a woman but a courtly "lady"—Our Lady, Nostra Domina, Notre Dame.

And it is here that an interesting crossover occurred between the Virgin, the lady, and the chess queen. In the fourteenth century, *reine*, the French word for "queen," gradually replaced *fierce* and *fierge* for the chess queen; and during the fifteenth century, *dame*, the French word for "lady," began to appear. Both *reine* and *dame* were and are traditionally attached to the Virgin, as in Reine du Ciel (Queen of Heaven) and Notre Dame, and both are used in French today for the chess queen. In fact, in many European languages, the word for "lady," carrying strong associations to the Virgin, is used synonymously or exclusively for the chess queen for example, *dama* in Spanish, Czech, Bulgarian, and Serbian.

When the great chess reform took place at the end of the fifteenth century, Catholic countries continued to use the vulgar equivalents of *domina—dama* in Spain, *donna* in Italy, and *dame* in France—that evoked "Our Lady." But Germany and England, transformed by the Protestant Reformation, refused derivatives of *domina* that might suggest any link with the suspect cult of the Virgin. Instead, they used the secular terms *Königin* and "queen."

This differentiation in terminology between Catholic and Protestant countries is one of the reasons the chess queen should be understood as a symbol of the Holy Mother, according to the German chess historian Joachim Petzold. He argues that the

chess queen was born in a Catholic world, that she grew in stature along with devotion to the Virgin Mary, and that she became, ultimately, the only woman before whom even the king must bow.⁹ It's a good argument, even if it does not tell the whole story.

With all these connections between the Virgin Mary and the chess queen before me, could I definitively dismiss the possibility that the Gardner statuette was a chess piece? Perhaps not one hundred percent. There is a minuscule possibility that she sat on a chessboard surrounded by other religious figures, all of whom have been lost. More likely, some Scandinavian chess carver of the fourteenth century was commissioned to make a devotional statue in the form of a nursing Madonna. He shaped her like a

CHESS AND THE CULT OF THE VIRGIN MARY . 121

chess piece because that is what he knew how to do. She sits on an ornamented throne with finials across the back similar to ones he had used for chess kings and queens. One can think of this piece as a representation of Mary on a common throne shared by earthly and heavenly queens. To have taken the size and form of a chess queen did not dishonor Mary and probably shed honor on the little chess figure she resembled from on high.

EIGHT

Chess and the Cult of Love

ow did chess in the Middle Ages become associated with love? How did a war game enter into the ritual of courtship? Today, when we think of chess, we think of intense contests between competi-

tive adversaries, usually male and rarely well groomed. Courtesy, gallantry, the tender words of lovers are the last things that come to mind. And yet, for a period of four to five hundred years, this game of war was the metaphor of choice for the etiquette of lovers. Soon after the chess

queen brought a feminine presence to the game, chess came to be regarded as a field for romantic, as well as military, conquests. In considering this strange conjunction of opposites, we must look beyond the narrow confines of the board to those social and artistic movements that made it possible for chess to assume a romantic dimension. At the turn of the twelfth century, a fledgling cult of love was the decisive cultural phenomenon.

At first promoted by the troubadours in Southern France and somewhat later by the trouvères in Northern France and the minnesingers in Germany, courtly love brought something utterly new into the Western world. It reversed traditional masculine and feminine roles, granting the woman power over the man. She became the focal point of his aspirations, the source of "joy." In the words of the troubadour Bernard de Ventadour (1147–70), who sang the praises of Eleanor of Aquitaine and accompanied her to England, "Joy, myself. Joy, my lady above all else." ¹

The conventions decreed that he serve her and prove his devotion through any number of trials. A public joust, a grueling journey, hunger, injury, separation, humiliation—nothing was considered too demanding for the knight hoping to win his lady's smile and a first kiss. In some versions of courtly love, the first kiss was also the last, since the lady was usually married and her husband tolerated the adulterous affair only so long as it remained purely symbolic.

In other versions, adultery took to the bedroom and had no limits. The troubadour Jaufre Rudel (1125–48) expressed his preference bluntly: "Me, I prefer loving and trembling for the one/Who does not refuse her reward."² But whatever the final outcome, the arbiter of "joy" was supposed to be the woman.

Undoubtedly, this vision of female power was more poetry than reality. Since upper-class women were married for social, economic, and political reasons rather than for love, they often found themselves under the thumb (if not the boot) of uncaring

CHESS AND THE CULT OF LOVE • 125

and even brutal husbands. The husband predominated by force of law and custom, regardless of the wife's status. Small wonder that married women welcomed the adoration of a honey-tongued troubadour to provide a counter-reality to their daily lives. Though the troubadour was not necessarily rich or noble, he was by no means poor and uneducated. A successful troubadour had to be sophisticated, witty, skilled as a poet, singer, musician, and let us not forget—chess player.

Not surprisingly, some of the vocabulary of chess entered into troubadour verse. Bernard de Ventadour, complaining of the indifference of the beloved, compared himself to the loser in a chess match. Conon de Bethune recognized that he was perfectly capable of teaching the rules of the game to others, but incapable of protecting himself from a checkmate because the game of love made him lose his head.³ The two "games" paralleled each other, could not be played without a woman at the center, and were destined to end in a checkmate— $m\bar{a}t$ in Arabic meaning "dead." In courtly parlance, it was appropriate for the man to be $m\bar{a}t$ —to suffer, to submit, to become as if dead under the stunning effects of his lady.

It is noteworthy that the troubadour was sometimes a woman! Of the approximately eight hundred troubadours whose names have come down to us from the period between 1110 and 1300, several were known to be *trobairitz*—women troubadours. They, too, dedicated passionate verse to their lovers. The Comtesse de Die, writing between 1150 and 1160, spoke frankly of the understanding she expected to have with the recipient of her favors.

> My good friend, so pleasing, so handsome, When I hold you in my power, Sleeping with you at night, And give you a kiss of love, Know that my great desire

Is to take you instead of my husband, But only if you will promise To do everything according to my will.⁴

Whatever the gender of the speaker, convention decreed that the final authority, the ultimate arbiter of "joy," the mistress of the game of love, in bed as at court, should be female.

At the court of Marie de Champagne (Eleanor of Aquitaine's first daughter by Louis VII), Andreas Capellanus wrote *The Art of Courtly Love*. Its rules were cited endlessly as a guide to the cult that swept through Europe from the twelfth century onward. One can easily imagine a long-faced man reminding his lady of rule number twelve: "A true lover does not desire to embrace in love anyone except his beloved." She might have responded with rule number thirty-one: "Nothing forbids one woman being loved by two men, or one man by two women." Both of them might wistfully have agreed with rule number nineteen: "If love diminishes, it quickly fails and rarely revives."⁵

Chess as a Courting Ritual

The chess queen and the cult of love grew up together and formed a symbiotic relationship, each feeding on the other. Once the queen appeared, she legitimized the presence of women on a previously all-male playing field and further encouraged female participation in the game. Girls from good families could anticipate mixed-gender matches, with all the romantic possibilities such encounters afforded. Chess provided an excuse for lovers to meet in the intimacy of gardens and boudoirs, where they could spar with their feelings as well as their chessmen. And unlike dice, which was associated with license and disorder, chess had to be played with cautious ceremony. It was a perfect metaphor for love among the upper classes, who saw in chess a symbol of their own hierarchical values.

Evidence for the overlap between chess and love during the Middle Ages is extremely rich and varied. In literature, there are numerous allusions in troubadour verse, then incidents in epic poetry and chivalric romance, then whole treatises that explore the analogy between the two "games." The plastic arts, too, depicted chess as a ritual of love, beginning with manuscript illustrations and then extending to ivory carvings, stained glass windows, tapestries, and pieces of sculpture.

First, consider the literary examples. When troubadour verse established the analogy between chess and love, it propagated two enduring ideas: that love was a combat between two noble adversaries, and that it was also a ritual played according to rigorous, complex rules.⁶ Initially, the mere use of a single word—"checkmated" (*matz* in Provençal)—signaled the relationship between the poet/lover and the chess player. Later, the analogy became more elaborate. Bernart d'Auriac, a thirteenth-century troubadour, insisted he was ready to cede the chess match to his female partner—to be "vanquished and checkmated" if that was her pleasure.

The chess match metaphor worked not only as a contest between the poet and his lady, but also between the poet and a rival lover. Thus Peire Bremon Ricas Noval insisted he was a better player than another troubadour because Noval knew how to defend and preserve his queen. As a superior player and suitor, he was constant in the face of obstacles and attentive to the code of love. His rival, lacking in intelligence and refinement, allowed bad fortune, indifference, and scandalmongers to separate him from his lady. It is significant that the good lover's steadfast devotion to his lady was intertwined with his protection of the chess queen.

If troubadour poetry initiated the concept of eroticized chess, chivalric romances made it popular. Ideal French knights, like the heroes of *Gui of Nanteuil*, *The Lay of the Shadow, Raoul of Cambrai*,

and *Galeran of Brittany*, had to be outstanding chess players as well as fearsome warriors, able hunters, and courteous lovers. To cite but one of the earliest examples from around 1100, Alexander the Great was depicted as having learned "to speak to ladies courteously of love" alongside the instruction he received in chess and other board games.⁷ And the ladies, too, if they expected to be courted in such a manner, had to be "skilled in chess," as well as singing, playing the harp, and embroidering.⁸ Excellence in chess added distinction to the personal qualities one presented as a nubile man or woman.

Tristan and Iseut

Some of the most famous medieval romances placed legendary lovers on opposite sides of the chessboard. In the Tristan saga, the hero was sent to Ireland by King Mark to fetch

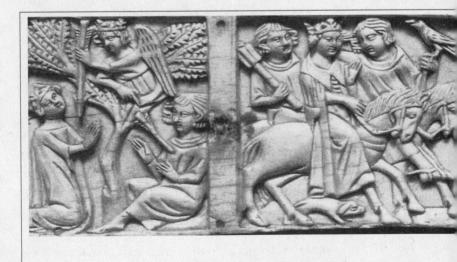

CHESS AND THE CULT OF LOVE • 129

Mark's bride, Iseut. On the return voyage, Tristan and Iseut accidentally drank the love potion intended for Iseut and Mark, which had such disastrous consequences. In some versions of the story, Tristan and Iseut play chess on the journey—a fitting accompaniment to their erotic awakening. Artists delighted in showing Tristan and Iseut playing chess as a metaphor for their love affair, as in the plate below and color plate 8.

Around 1300, in Heinrich von Freiberg's German version of *Tristan*, the chess pieces themselves have become romanticized, most notably "the king and the queen who sit lovingly next to one another."⁹

As the one female figure on the board, the chess queen became a magnet for erotic associations. While she was sometimes identified with the Virgin Mary, she was just as likely to be seen as the Goddess of Love. A thirteenth-century Latin poem of around six thousand lines, subsequently translated into French, presented her as something of a sexpot.

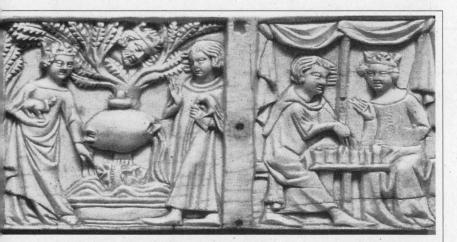

An ivory panel telling the story of Tristan and Iseut includes a chessplaying tryst. France, fourteenth century.

The queen whom we call *fierge* Takes after Venus, who is no virgin [*vierge*] She is likable and loving [*amoureuse*] Debonair and hardly proud [*orgueilleuse*].¹⁰

The anonymous author of this poem (titled *Vetula* in Latin and *La Vieille* in French) pretended it was written by Ovid, a ruse that allowed him to spice up the work with amatory exploits. Of the chess pieces, only the queen was eroticized: the king was compared to the sun, the rook to the moon, the knight to Mars, the bishop to Jupiter, and the pawn to Saturn. Presumably the queen sent out vibrations that were responsible for sexualizing the playing field.

Lancelot and Guinevere

Another pair of legendary lovers, Guinevere and Lancelot, were also linked together by a chessboard. In one of the episodes of *The Romance of Lancelot of the Lake*, Lancelot played on a magic chessboard where the pieces moved of their own volition. He won the game, was given the board, and sent it as a present to Queen Guinevere (color plate 9).

The queen, be she Iseut or Guinevere, was the necessary figure in medieval romance. She controlled the central position at the apex of a triangle shared with her husband and her lover. Already in the oral versions of these tales that preceded the earliest texts, mythical queens reflected the growing power of regal women. Even when they were not ideal wives and mothers, they commanded respect, and even if she took a lover, the queen could not always be disposed of by her husband. The lover might turn out to have political force in his own right, especially if he was well-born and influential among the nobility. No matter how suspicious or vengeful a king like Mark or Arthur might have been, in the end he took his wife back. She was, after all, the queen. This vision of a king's wife was far removed from that of *The Arabian Nights* (first written down in the Middle Ages), where Arabian kings and other powerful men habitually slayed their wives if they were caught in adultery.

Arab Women Champions in Western Literature

Yet Arab women were by no means powerless or irrelevant to the history of chess. As mentioned earlier, they played chess before their European counterparts, and, unlike Western players who came exclusively from the upper classes, Arab players included the rich and the poor, the educated and the uneducated, the young and the old. Several European tales captured the mystique of the Arabian woman as chess champion. She was invariably depicted as skilled in the game but vulnerable in love, especially when the man was a foreign knight. Maugalie, a character in a little-known, late twelfth-century French narrative called *Floovant*, was probably the earliest example of this type in Western literature.

The most famous work featuring a sensational chess match between a knight and a Muslim princess was *Huon of Bordeaux*, written in French around 1230. It tells the story of the young knight Huon, sent on an impossible mission as penance for unwittingly killing one of Charlemagne's sons. He is ordered to travel to the court of the Babylonian emir Gaudisse, kill the first Saracen he meets, and take away the emir's mustache and four of his molars. Given this wild plot, Huon's undertakings often partake of the fantastic. He gets away not only with the mustache and

the molars, but also with the emir's daughter, whom he beds, baptizes, and marries. All of this, I should add, with the aid of the fairy king Auberon, the ancestor of Shakespeare's Oberon in *A Midsummer Night's Dream*.

But before Huon's many adventures are over, he has to disguise himself as the servant of a wandering minstrel at the court of another emir named Yvorin. And it is here that the extraordinary chess match between Huon and Yvorin's daughter takes place. The terms of the match are established between Huon and Yvorin in the following manner.

"Seigneur... my abilities are very numerous. I know how to skin a sparrow hawk, hunt deer and wild boar.... I serve nicely at table during the course of a meal, and I am expert in the games of draughts and chess, to the extent that I haven't yet seen my equal."

"Stop right there," the emir said, "because I'm going to test you in the game of chess. . . . I have a daughter who is very beautiful but also very skilled in chess. Up till now, no one has been able to beat her. You will confront her under the following conditions: if she defeats you, your head will be cut off immediately, but if you beat her, I shall have a bed set up in my room, you will sleep with my daughter all night long, and the young lady will belong entirely to you."

When the emir's daughter is informed of the game in the presence of her father and Huon, she thinks that it wouldn't be too bad if she lost the match and was obliged to belong to such a noble knight. So they sit down to play with golden pieces on a silver chessboard.

Huon asks, "How do you want to play? By moving the pieces ourselves, or with dice?" She answers, "Only with the pieces." Preferring a game of skill to a game of chance, the princess rejects the use of dice to determine the moves of the pieces—a medieval option that was looked down upon by seasoned players.

Initially, the young man loses a number of his pieces, and the young woman begins worrying about his fate. "She does not stop looking at Huon, because Love has bitten her and burned her with its flame; she is so fascinated by the hero's great beauty that her inattention costs her the game."

The emir becomes furious. "My daughter, stand up. Cursed be the hour when I engendered you!" Huon, however, refuses the initial conditions of the match and suggests that the emir's daughter simply return to the ladies' quarters. The emir willingly accepts, compensating Huon with a large sum of money. Only the daughter is dissatisfied. She goes off saying to herself: "If I had guessed your intentions, I would have beaten you!"¹¹

This wild fantasy makes for a captivating story. Yes, Arabic women did play chess, but certainly not under these circumstances. That an emir would wager his daughter to a French knight and that she would fall immediately in love with him could have issued only from the unbridled imagination of a Western male. In Islamic literature, as noted earlier, the female player unsettles the male player by her beauty, but if she is a Christian, she ultimately converts to the religion of her Muslim opponent. Winner or loser, the woman is always the one expected to convert, which says something about gender realities in both Islam and Christianity.

The theme of the erotic chess match between a Saracen woman and a European knight found its way into German literature by way of the character of William of Orange. William of Orange, also known as William of Toulouse and William of Aquitaine, was a historical figure who fought with Charlemagne in defense of Southern France against the Moors. Then he devoted his life to spiritual pursuits and was venerated as a saint from the time of his death (812 or 813), though he was not officially canon-

ized until 1066. His legend was written down in Latin and French, and then carried to Germany in the early thirteenth century. The great German poet Wolfram von Eschenbach used William as the subject for his Willehalm cycle.

As the story goes, Willehalm was captured by the pagan king Tybalt and transported to his palace, where he was kept in captivity for several years. At one point, when Tybalt left for a military campaign, he entrusted Willehalm to the care of his wife, Queen Arabal. During the king's absence, Arabal taught Willehalm to play chess and Willehalm introduced Arabal to his religion. Ultimately, he convinced her to escape with him back to France. The two were married after she had predictably converted to Christianity.

In an early manuscript of this work commissioned by Heinrich II, the landgrave of Hesse, three exquisite miniatures show Willehalm and Arabal facing each other across a chessboard. In one, he instructs her in Christianity. In another, she instructs him in chess. The manuscript, made in 1334, was intended to reflect the opulence of Heinrich II's court, where chess was a prized activity (color plates 10 and 11).¹²

Chess, Sex, and Incest

By the early fourteenth century, the metaphor of chess for the ritual of love had become commonplace. In the plastic arts, a chess scene between a man and a woman signified romance. Imagine putting such a scene on a Valentine today instead of hearts or cupids! Mixed-sex matches were carved into the panels of ivory caskets or on the backs of mirrors intended for the personal use of upper-class ladies.

Sometimes the love analogy was spelled out in graphic detail. An elegant ivory mirror case at the Louvre shows a man and woman playing chess inside a tent. Two onlookers carry signs that

CHESS AND THE CULT OF LOVE • 135

leave no doubt as to the game's sexual meaning. On the man's side, the onlooker grasps a long-legged, long-necked bird. On the woman's side, the onlooker holds a sturdy ring, large enough for the bird to poke its head through. Similar ivories (at the Cleveland Museum of Art, the Walters Museum in Baltimore, the Victoria and Albert Museum in London, and the Kunsthistorisches Museum in Vienna) repeat this scene minus the onlookers, but with the same pleated indentation in the woman's lap suggesting her genitals.

An amusing parody of amorous, upper-class players is found on an ivory casket depicting the tale of the Prodigal Son. On one of the panels, the hero is seen playing chess with a prostitute, obviously for a stake, since he is stripped down to his underwear. While most depictions of erotic chess clothe the players with extravagant attire, this image deconstructs the traditional scenario so as to lay bare the lustful male body.¹³

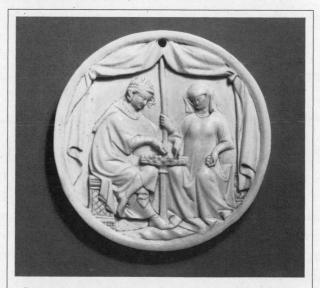

Ivory mirror case with couple playing chess. France, second quarter of fourteenth century.

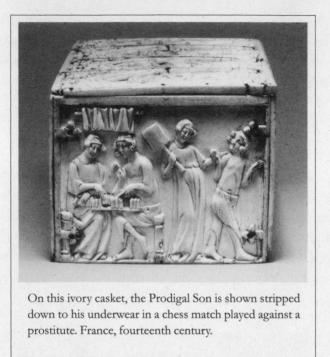

Playing chess as a courting ritual, however refined the symbols or euphemistic the language, was likely to have carnal consequences. Did mothers warn their daughters to protect their virtue before playing chess with a man? Since the chessboard qualified as a sexual space, it was reputed to hold special dangers for women.

One of the most chilling stories in this regard is "The Romance of the Count of Anjou," finished in 1316. The widowed count had a very beautiful daughter, who knew all the "rules, techniques, and tricks" of chess. Her father could never checkmate her, unless she let herself be beaten.¹⁴

One day he called his daughter to a match. "He had a chess board brought in, which was incrusted all over with jet and ivory. All the pieces . . . were artistically fashioned, each one represent-

CHESS AND THE CULT OF LOVE • 137

ing a sculpted personage." His daughter sat down across from him and they began to play. Unfortunately, the father began to lose most of his pieces, and soon he had only a castle and a jester (bishop). On her side, the girl had a knight, a jester, a castle, the queen, and two pawns. As she was about to take his castle, he raised his eyes toward her face, whose exceptional beauty struck him full force.

It was then that he had a horrible thought!... He experienced in the depth of his heart an irresistible desire to draw her into vice... He could not defend himself against such a reprehensible temptation and soon lost interest in the game. Alas! It would have been better for him to have been put in irons or nailed to a cross rather than to have played chess.

The father became prey to a perverse obsession: he wanted to sleep with his daughter. Without hesitation, he communicated this desire to her in the refined language of his class.

"Your beauty struck me with such force that I am abandoning myself to you, entirely conquered, bound hand and foot...I must obtain your consent to satisfy all my desires...A daughter who can bring a little comfort to the torment that is crushing her father should not let him suffer too long."

The innocent daughter was not sure of his meaning, which he then expressed in no uncertain terms. "Daughter...I am struck by such cruel suffering that it is eating me alive ... to the point of having to sleep with you and to experience with you that natural pleasure of the senses which lovers declare to be exquisite Joy."

Realizing her father's intent, the daughter now began to resist with all her might.

"Have pity on me! You have darkened my heart and filled it with sadness and anger in asking me, in an insane manner, to accomplish such a shameful and despicable act.... Certainly it is the Devil who is pushing you! My dear, tender father, in the name of Saint Denis, think about what you are asking of me and as soon as you are conscious of the ugliness and villainy of what you are demanding, you will give up the idea. Go to confession and repent because you are in the grip of sin."

Despite the daughter's fierce opposition, the father refused to abandon his idée fixe. He chided her for lacking in obedience, and insisted she would be obliged to perform under duress what he had asked her to do through love. Rarely has the subject of fatherdaughter incest been presented so bluntly, and all because of a chess game! Of course, the daughter managed to escape from her father's designs, and embarked upon a period of wandering, poverty, and suffering that continued through most of the tale.

While this story is clearly a work of the imagination, it does point to certain realities, including the oft-hidden problem of daughter sexual abuse. For our purposes, it captures the link between chess and desire that had worked its way into the French mentality by the beginning of the fourteenth century. Even the sacred father/daughter bond could be undone by the erotic valence of chess.

The negative association between chess and sex crops up in surprising places, such as an Italian painting on the wall of a matrimonial bedchamber. The fresco is based on *The Chatelaine of Vergy* (*La Chastelaine de Vergy*) in which the wife of a duke attempts to seduce an honorable knight. One half of the fresco shows the wife and the knight playing chess although there is no chess scene in the original French story; the other half shows her trying to kiss him, while he raises his hand to object. Since the painting was commissioned on the occasion of the 1395 marriage of Tommaso Davizzi to Caterina degli Alberti, it was presumably intended as a cautionary tale. This stunning fresco can still be seen in the Palazzo Davanzati in Florence, or failing that, in Chiara Frugoni's rewarding book, *Books, Banks, and Buttons.*¹⁵

The Edifying Book of Erotic Chess

The most remarkable manifestation of the overlap between chess and love is found in a treatise with the intriguing title *Le Livre des Echecs Amoureux Moralisés*, loosely translated as *The Edifying Book of Erotic Chess.* There are several things one must know before tackling this extraordinary work. It was written around 1400 by Evrart de Conty, a physician associated with the University of Paris and with the court of the French king Charles VI. Conty did not invent the titillating combination of words *Echecs Amoureux*. That belonged to an earlier writer who had composed an allegorical poem with this title around 1370. Whereas the earlier poet did not become sufficiently famous for his name to have endured, Evrart de Conty's prose commentary on the poem became an instant success and has survived in several manuscripts.

First we must take a look at the earlier work to understand the second. The following synopsis is based on the Dresden manuscript, which was tragically destroyed during the fire bombings at the end of World War II.¹⁶ It tells how the narrator as a young man was sent by Venus on a mission to find a lady worthy of his love. The lady was to be found in the garden of Venus's son, Deduit—a garden already famous from the late medieval French allegory *The Romance of the Rose*.

When the narrator found the maiden in Deduit's garden, they played against each other using pieces bearing insignias that evoked stages in the course of love—for example, turtledoves, lambs, and rings, or, conversely, panthers and serpents. The lady's

pieces were made of precious stones, such as diamonds, emeralds, and sapphires, with rubies for the queen (*fierge*). The narrator's chessmen were made of gold. To make a long story short, the narrator was so enraptured by his female opponent that he lost the game. He was subsequently comforted by the God of Love, who lauded his courage and gave him instruction for future conduct. The rest of this very long poem is both a manual for lovers and a compendium of knowledge concerning everything from health and education to politics, religion, knighthood, music, marriage, wet nursing, and Parisian living. As such, it constitutes a precious repository of late fourteenth-century popular wisdom.

Conty took up *Les Echecs Amoureux* with the stated intention of rendering it clearer in prose. But he went far beyond his initial goal, with additions that made his "commentary" a formidable allegorical work in and of itself. His enthusiasm for the project is evident from the start when he says of chess that it is, of all games, "the most beautiful, the most marvelous, and the one that offers the most affinities with love." ¹⁷

In the sixth part of this exceptionally long work, the part that is devoted exclusively to "The Chess Board and the Chess Match," Conty argues that chess can be compared to love because both are predicated on a series of battles. The battles, as one astute critic has recently observed, take place not only between the lover and the maiden, but also between various divisions of the lover's psyche; his attempt to reconcile romantic impulses with reason underlies the entire adventure.¹⁸

In keeping with the allegorical tradition, almost everything has symbolic value. For example: "The square form of the chess board signifies the equality, justice and loyalty that must reside in love... Two people who love each other should be as one person, that is, they should have only one heart and one will and be equal in love, without domination or submission." Such a credo would certainly appeal to egalitarian couples today.

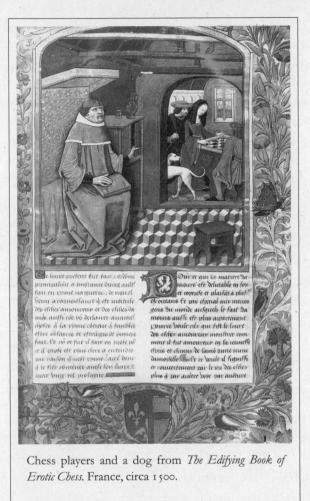

Medieval chess players who read *The Book of Erotic Chess* would have followed the match between the narrator and the lady with an understanding that each move on the board represented a decisive moment in the game of love. Today it is difficult to follow the moves, since the line-up of pieces was highly fanciful, even for the Middle Ages: the pawns were placed on the third row, the castles and knights on the second, and the king and jesters on

the first. Where was the queen in all this? She shared a square with one of the pawns! The queen could still move only one square at a time, diagonally, though this limitation would disappear in less than a hundred years. But even without knowing exactly how the pieces moved on the board, one can enjoy the following description of the match as a virtuoso variation on the theme of love.

The first move of the young lady, who began the game on the order of the God of Love, was that of the pawn, who carried on his shield a rose, the emblem of Beauty... Beauty, of all the erotic charms a woman can possess, is the most apt to move hearts and draw them to love, and the one that is normally the first to attract one's gaze and attention. To defend himself against the young lady, the Actor then moved his pawn with the sign of the key, that is Gaze, which he opposed to the great beauty that had struck him....

The narrative continues, move by move. The lady advanced the pawn with the sign of the lamb, signifying simplicity, and the actor moved his pawn with the sign of the tiger, signifying sweet thoughts. Several moves later, the lady advanced her knight of the unicorn, signifying shame, and took the pawn who menaced her queen. "The lover, who was plunged into contemplation of the pawn, would have forgotten to play if Love had not reminded him. When he recovered his senses, he moved the pawn with the Swan, that is to say, Good Appearance."

Then the lady moved in for the kill and captured the jester with her knight, announcing "Check to the king!" On the following move, she took the lover's left castle with her knight, and the actor moved his king to avoid a checkmate. But he was still not spared by the lady, who, on her seventh move, took his castle. To reinforce his other castle, the actor then moved his knight of the lion, boldness. On her eighth move, the young lady took her ad-

CHESS AND THE CULT OF LOVE • 143

versary's second castle. As soon as this happened, he took her knight, shame, with his knight, boldness. She then made her ninth move with her knight of the hare, and he countered with his pawn of the leopard.

When the Actor saw that he was on the point of being mated, he felt himself shudder and shiver. His body and his heart were so shaken that he lost his speech and his senses. It is true that lovers are sometimes, in their naiveté, so captivated by love that they do not know what is happening to them....

After the checkmate, the God of Love, who had observed the match, made himself known, and the young lover dedicated himself, body and soul, to Love.

This "love battle" provides an amazing example of the overlap between chess and love in the late Middle Ages. Previous literature, be it poetry or romance, had been content with short analogies. Here an elaborate allegory spelled out the correspondence between the moves of the game and the rites of courtship. European ladies and gentlemen—French, English, Italian, German welcomed this lengthy play of words conveying two things at the same time: how to play chess and how to conduct oneself in matters of the heart.

As a manual of seduction, *The Book of Erotic Chess* allowed women to play an active role as well as men. Indeed, it was the woman who made the first move of the match, not only because she played with the white pieces, but presumably because she initiated the course of love through her most strategic weapon beauty. The man was portrayed as defensive from the start and ultimately defeated by his partner's greater skill in chess and emotional maturity. At the game's end, he still has much to learn.

The Chess = Love Equation in Fifteenth-Century France

Sometimes, even when there was no reference to chess in the text, a book would include a picture of a mixed-sex match to indicate the amorous nature of the subject matter. Thus on the opening folio of Alain Chartier's *Poems*, written in France around 1460–70, one finds a miniature painting depicting a chess scene. Although there is nary a board game in the following pages, the image of the chess match was considered sufficient to tell prospective readers that the poems would be about love.¹⁹

In the fifteenth century, chess still occupied a privileged place among the nobility. As a required subject in the apprenticeship of fine ladies and gentlemen, it attested to one's breeding, intelligence, and character. No less a prince than Louis d'Orléans, brother to Charles VI of France, was known for his chess expertise. In fact, chess was a passionate pastime for Louis's entire family, including his wife, Valentine Visconti; his son, the poet Charles d'Orléans (1394–1465); and Charles's wife, Marie de Clèves.

Charles, in particular, has come down as the best-known French player of his age because of the many references to the game found in his poems. Among them, one youthful ballad is an allegory of chess and love. Its thrice-repeated refrain—"If I don't find [make, get] another lady" (*Se je ne fais une dame nouvelle*) expressed both his need to replace a lost chess queen with a promoted pawn, *and* his desire to have a new ladylove in his life.²⁰

After the introduction of printing, the erotic chess match moved from the pages of manuscripts into books that were widely disseminated. It also expanded from ivory boxes and mirror cases to the larger surfaces of tapestries, walls, and windows. Like cupids today, amorous chess players conferred love's blessings on the multitude.

A match between two gorgeous lovers was the subject of a stained glass window in the French residence known as the Hôtel de la Bessée in Villefranche. A richly dressed man and woman, crowned by extravagant headdresses, are arrested at a decisive moment of the game. He holds in his hand a white queen, indicating the advantage he now has over his adversary. She raises her right hand in a gesture of defense, but at the same time caresses his arm with her left hand. The dual meanings in this scene would have been apparent to any contemporary viewer. The apparent victory of the man suggests his romantic intent, and the woman's balanced gestures reveal her acceptance. Although he is the chess victor, she has control over the game

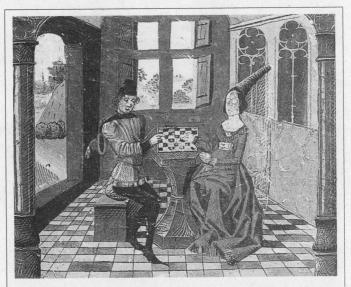

Alain Chartier's *Poèmes* begins with a picture of a mixed-sex chess match, although the poems themselves contain no reference to the game. France, circa 1460–70.

of love—a scenario that conformed to conventions for the two genders (color plate 12).²¹

At roughly the same time, at the palatial residence of Jacques Coeur in Bourges, a bas-relief showing a man and woman playing chess was placed above a fireplace. Considerably more stolid than the fanciful tapestry and stained glass figures, this wealthy bourgeois couple (possibly Jacques Coeur and his wife) presented a pleasing picture of married life. Flanking the chess players, two other couples were portrayed happily eating fruit. During the next century, scenes of domestic chess matches like this one would slowly edge out the heavily erotic ones.

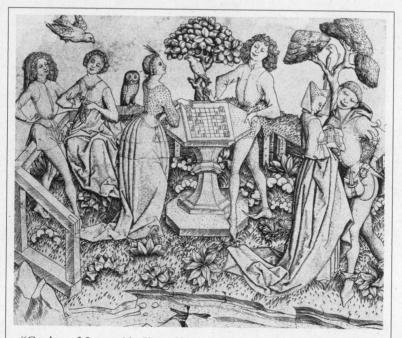

"Garden of Love with Chess Players." This German engraving shows three couples in a garden, the central position devoted to a chess match between a lady and gentleman. By Meister E. S., 1440 to 1446.

CHESS AND THE CULT OF LOVE • 147

Chess, you might say, had matured. It was suitable not only for lovers in the early throes of attraction, but also for spouses settled into conjugal happiness. By the late fifteenth century, when the chess queen's supreme powers were officially codified, the game itself was at the height of its popularity, with a special meaning for couples. They could look to chess as a privileged space for the interchange of intellect, feeling, and sexual desire. Both before and after marriage, chess offered a playing field where men and women could confront each other as equals.

PART 4

Scandinavia and Russia

NINE

Nordic Queens, On and Off the Board¹

he Isle of Lewis in the outer Hebrides off the coast of Scotland is an unlikely place for chess history to have been made, yet it is here that a unique treasure trove of medieval chessmen was discov-

ered. In 1831, a laborer digging in a sandbank chanced upon a previously hidden underground structure resembling a baking oven. Imagine his astonishment after he broke inside and found an assembly of miniature people—kings, queens, bishops, men on horseback or standing with shields.

Perhaps he thought they were elves or sprites straight out of Celtic folklore, but eventually he brought them to a local collector, who recognized them for what they were—the most amazing collection of ancient chessmen in existence.²

The "Lewis Chessmen"

The "Lewis chessmen," as these pieces are called, were probably fabricated in Norway around 1200 when the Isle of Lewis was under Norse rule. Originally, there must have been four different sets totaling one hundred and twenty-eight pieces. Today there are ninety-three pieces: eighty-two in the British Museum in London and eleven in the National Museums of Scotland in Edinburgh. They constitute the largest known collection of Western medieval chessmen and one that offers an intriguing entrée into Nordic society.

The majority of the pieces were carved from walrus tusk and a few from whale bone. The kings are all bearded, crowned, enthroned, and hold a half-drawn sword across their knees. The queens, too, are crowned and enthroned, but they have the distinctive feature of pressing a hand against one cheek, as if they were cogitating or worrying. These are thinking-feeling queens, the cerebral-emotive half of a royal pair. Like the viziers who had preceded them, they are counselors to the kings, only more intimately connected to his person. Both the kings and queens wear long garments that leave the tips of their feet visible and cloaks that cover their chests.

The bishops, either seated or standing, hold a crosier in their hands and wear the two-pointed miter that had become fashionable in Europe around the mid-twelfth century. The knights on horseback wear conical helmets with earflaps, nose guards, and short coats of mail, and they carry spears and shields. The rooks

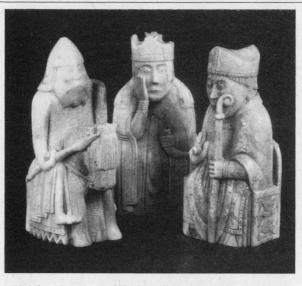

Knight, Queen, and Bishop from the "Lewis Chessmen." Norway, after 1150.

have been anthropomorphized into armed guardians or warders, each standing with helmet, shield, and sword. The pawns, on the other hand, have been deanthropomorphized into inanimate objects resembling milestones.

Like the "Charlemagne" chessmen which were dated between 1075 and 1100 on the basis of the pawns' headgear and shields, the Lewis chessmen are believed to have been made sometime after 1150 on the basis of the bishops' miters. Moreover, the intricate designs on the backs of the kings' and queens' thrones resemble other examples of Nordic scrollwork from this period and, in particular, stone sculpture from churches in Trondheim, Norway. Trondheim, a burgeoning medieval town with a long tradition of professional woodcarvers and bone workers, was probably home to the very workshop in which the Lewis chessmen were carved.³ Many of the walrus tusks used for the chessmen

would have come to Trondheim from Greenland. These unique pieces are all marvels of Romanesque art, representing medieval hierarchy with a rare mix of iconic and realistic detail.

Another Scandinavian queen from around 1200, now housed in Cologne, Germany, may be related to those found on Lewis, judging from the same basket-weave decoration on the back of the throne. She is covered by a cloak with an ornamental border that is gathered up in one of her hands, and wears a crown from which a kerchief falls to her back and shoulders. Hatlike crowns with kerchiefs underneath are characteristic of Scandinavian queens, both off and on the board. Unlike other European crowns, these may have been fashioned to provide protection against the cold northern clime.

Chess probably came to the Nordic countries via England and

Line drawing of chess king made shortly after the . "Lewis Chessmen" were discovered, printed in Massmann's *Geschichte*, 1839.

NORDIC QUEENS, ON AND OFF THE BOARD . 155

Scandinavian chess queen, circa 1200.

France around 1050, but it may also have traveled north from Germany or even from Russia. The earliest Nordic reference to chess concerns a walrus tusk set sent from Greenland to Harald Haardraad of Norway (1040–1067).⁴ The game was mentioned in thirteenth-century Icelandic sagas, which cover the period from the late ninth century, when pagan Norwegian colonists first settled Iceland, until 1262, when Iceland accepted the rule of a Christianized Norway. With a gap of one hundred years or more between the time the events presumably took place and the time the sagas were written, one has to read them with caution.

Chess in Old Norse Sagas

One compendium of Norse sagas, *Morkinskinna*, written between 1200 and 1220, describes a chess match that ostensibly took place around 1130. It concerns the legendary Siguror Slembir, a Norwegian whose travels had taken him as far as Iceland, Rome, and Jerusalem. Here is the chess story told in *Morkinskinna*.

During a winter's stay in Iceland, Siguror watched another Norwegian playing chess with one of their host's farmhands. When the Norwegian asked Siguror for advice because he was losing, Siguror came up with a scheme to help his fellow countryman.

The man who was playing with the Norwegian had a sore foot, with a toe that was swollen and oozing matter. Siguror sat down on a bench and drew a straw along the floor. There were kittens scampering about the floor, and he kept drawing the straw ahead of them until it got to the man's foot. Then the kittens ran up and took ahold of the foot. He jumped up with an exclamation, and the board was upset. They now quarreled about who had won.⁵

NORDIC QUEENS, ON AND OFF THE BOARD • 157

Chess quarrels like this one, some even homicidal, crop up regularly in Old Norse sagas. The great saga writer Snorre Sturlason (1179?–1241) recounted the story of a heated quarrel between Canute, king of Denmark and England, and Earl Ulf, that ended in the latter's death. In the text, "When King Canute and Ulf the Jarl were playing chess, the king made a bad move and the jarl then took a knight from him. The king put his men back and said he should play another move. The jarl grew angry and threw down the chessboard." Generally speaking, when a player asks to take back a hasty move, a true gentleman lets him do just that. But Earl Ulf seems to have been a gentleman in name only.

Insults were exchanged between the king and the earl, whereupon the king became determined to take revenge. First he sent one of his servants to slay the earl, but as he fled to the refuge of a church, the servant came back without having acted. Then Canute sent his bodyguard to the church "and there he struck a sword through the jarl, whereby Ulf the Jarl met his bane."⁶

This bloody deed supposedly occurred in 1028, although chess was probably not known in Denmark at that time, or in England-a country Canute conquered and then ruled conjointly with Queen Emma, the widow of the defeated Saxon king Aethelred II. (She is shown on page 118.) If the legendary quarrel actually did take place, the game in question may have been hneftaff, a board game that had been played in Scandinavia for hundreds of years before the introduction of chess. But by the time of the saga writer Snorre Sturlason, chess had become the pan-European royal game and was considered more fitting for a king than the homegrown variety. Similarly, French and English medieval romances anachronistically attributed chess playing to such legendary kings as Charlemagne, Arthur, and Alexander the Great. Much earlier, the Persian romance Kārnāmak had sought to shed luster on Ardashir, the third-century founder of the Sassanian monarchy, by listing chess as one of his accomplishments.

Chess pieces dating from 1200 onward have been found all over the Nordic region-from Denmark, Sweden, and Norway as far west as Iceland and Greenland. Many of these were discovered in castles and monasteries, attesting to the preponderance of chess players among the nobility and clergy, as elsewhere in Europe. In the Norse lands, unlike much of Europe, there seems to have been little hostility to the game on the part of the Church. Occasionally, however, some of the standard objections cropped up. The King's Mirror (Speculum Regale), a Norwegian treatise on kingship written in the 1250s, associated chess with "the greatest calamities." In a structured dialogue intended to provide a manual of polite behavior, a father says to his son: "There are certain things which you must beware of and shun like the devil himself: these are drinking, chess, harlots, quarreling, and throwing dice for stakes."7 This linkage of chess to vice evokes the atmosphere of an unruly tavern far removed from the stately courts, great houses, and quiet monasteries where the game was initially promoted.

More Scandinavian Chess Queens

Chess arrived in Scandinavia with the queen already on the board, and she has left behind substantial examples of her early presence. First, there are the eight Lewis queens from the twelfth century, plus the related one now in Cologne. Then, from 1200 to 1400, there are at least five other extant queens: one from Sweden, one from Norway, and three from Denmark. All in all, there are more surviving medieval chess queens from Scandinavia than from all the other European countries combined. One wonders if this is just happenstance or a testimony to the positive memories of real queens in Scandinavia.

The single Swedish queen (thirteenth century) now housed in

the Historical Museum of Stockholm sits astride a horse, with wheellike scrollwork on each side. She, too, wears a kerchief covered by a crown. This queen, with her legs on each side of the mount, has a far different feel from the earlier Italian and Spanish pieces, and even from the Lewis queens, who are all enclosed in pavilions or seated on thrones. Here we encounter an outdoors person, perhaps a warrior woman representing one of the historical queens known to have accompanied her troops into battle.

Three Danish pieces preserved in the National Museum in Copenhagen add considerably to the queenly contingent. The earliest (thirteenth century) sits on a high-backed throne, wears an indented crown over a kerchief, and is enveloped in an ample cloak that falls in deep pleats over an undergarment. Her hands are calmly folded in her lap.

The two other Danish queens are on horseback. The first

Swedish chess queen on horseback. Thirteenth century.

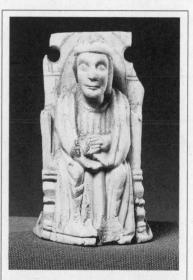

Danish chess queen with folded hands, seated on a throne. Thirteenth century.

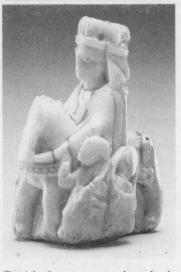

Danish chess queen on horseback, with attendant holding her reins. Fourteenth century.

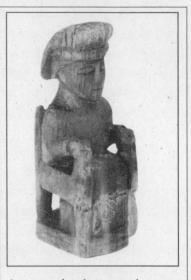

A rare wooden chess queen known as the "Bryggens Madonna, before shrinkage." Norway, fourteenth century.

(thirteenth century) holds her reins in one hand and a celestial globe in the other. She is attended by miniature foot soldiers with helmets and spears (color plate 13). The second (fourteenth century) is flanked by cross-bowmen standing on each side of the horse to hold the reins when she descends. Both queens are sturdy, no-nonsense figures, with all the attributes of regal power, including the mobility that would become the hallmark of the chess queen in the late Middle Ages.

While all the Scandinavian queens discussed so far were made of walrus ivory or whale tooth, a fourteenth-century queen from Norway was made of wood. She and a knight were found in the damp layers of earth in Bergen (Bryggen), which was once an important port for European trade and the administrative center of both monarchy and Church. This queen sits on a chair or throne, her hands firmly placed on the armrests. On her head she wears

Plate 1. *Left:* Rock crystal king in the form of a throne. *Right:* Rock crystal vizier, the ancestor of the chess queen, in the form of an obelisk. Spanish-Arabic, end of the ninth century to beginning of the eleventh century.

Plate 2. Romanesque chess queen packaged within a throne-like structure. Spain, twelfth century.

Plate 3. Queens teaching their children to play chess. Alfonso's Book of Chess, Spain, 1283.

Plate 4. Majestic chess queen, who has replaced the vizier. Southern Italy, early twelfth century.

Plate 5. Margrave Otto IV (of the Arrow) von Brandenburg enjoying the pleasures of court life. Germany, circa 1320.

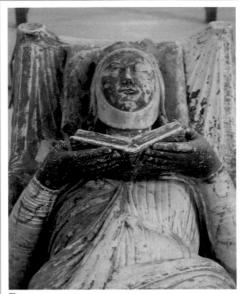

Plate 6. Eleanor of Aquitaine's sepulcher at the Abbaye Royale de Fontevraud. France, early thirteenth century.

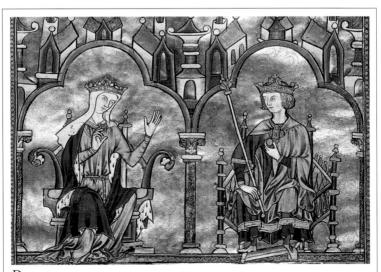

Plate 7. Blanche of Castile instructing her son, King Louis IX of France, circa 1230.

 $P_{\text{late 8. Tristan and Iseut seal their fate with a love potion while they play chess. France, fourteenth century.$

Plate 9. Lancelot sending the magic chessboard to Guinevere. *The Romance of Lancelot of the Lake*, northern France, early fourteenth century.

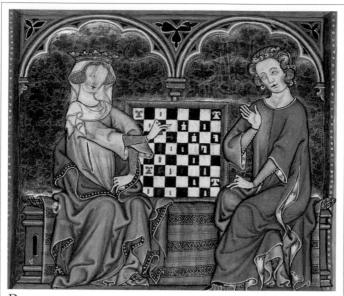

Plate 10. Queen Arabel teaching Willehalm to play chess. The Willehalm Codex, Germany, 1334.

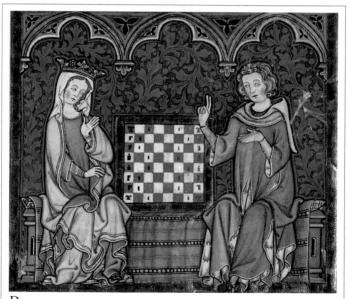

Plate 11. Willehalm teaching Queen Arabel the tenets of Christianity. The Willehalm Codex, Germany, 1334.

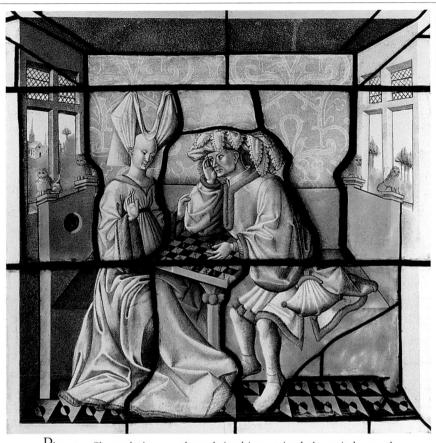

Plate 12. Chess-playing couple enshrined in a stained-glass window at the Hôtel de la Bessée, Villefranche-sur-Saône. France, fifteenth century.

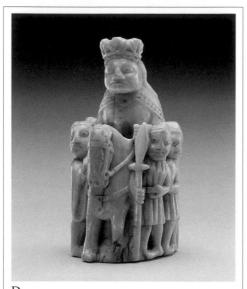

Plate 13. This dour chess queen on horseback is surrounded by pixie-like attendants. Denmark, thirteenth century.

Plate 14. Wooden chess queen known as the "Bryggens Madonna, after shrinkage." Norway, fourteenth century.

NORDIC QUEENS, ON AND OFF THE BOARD . 161

an imposing hat or crown. When she was first exhumed, she exuded such an air of majestic composure that she was baptized the "Bryggens Madonna." Unfortunately, after exposure to the air, she shrunk and is now less impressive than she once was. This can be seen by comparing the black-and-white photo made soon after she was found (page 160) with a more recent color photo (color plate 14).

Nordic Women and Society

What kind of society produced these superb artifacts? Can any of them be linked to an individual queen? What do they suggest about the institution of Scandinavian queenship and about Nordic women in general?

The earliest sagas written in Old Norse focus on Iceland and offer a picture of that outpost before it had come under the Norwegian crown (in 1262). During that period, Iceland was a free state with no central authority; control was in the hands of rival chieftains, who were constantly at war with one another. Although there were no kings and queens in Iceland, chieftains and their wives were at the top of the hierarchy in their communities. The women were expected to oversee the household; to tend to the men's needs; and to provide them with clothing, food, drink, and medical attention, but they also joined the men in presiding over the traditional drinking fests at long wooden tables in the great hall. Originally an exclusively male purview, these feasts were slowly transformed into mixed-gender events, where, according to Snorre Sturlason, men and women drank together, each couple sharing a horn. They also played board games, including chess, the women as well as the men among the upper classes.

In the Icelandic sagas, the most colorful women tend to be strong, independent, and aggressive. They play prominent roles in

their clans mainly by inciting husbands and sons to avenge their family honor, and sometimes by taking revenge into their own hands. But there are other female personalities as well who manifest the dependent and powerless traits that were probably the norm for most women. This was especially true for daughters, generally at the mercy of the males in their families.

In the *Heidarviga Saga*, we see such a powerless creature in the figure of Asdis, the daughter of the fierce chief Styr, and we also get a cameo glimpse of a man and woman playing chess. The young warrior Leiknir courts Asdis by "talking or playing chess." By the time this saga was written, circa 1200, chess was already associated with romance in Scandinavia as in the rest of Europe, although it was probably unknown in Iceland, circa 1000, where the story was set. This bloodcurdling tale describes the backbreaking labor Leiknir performed for his prospective father-in-law in order to marry Asdis. All to no avail, since Styr had the groom killed on his wedding day and later gave Asdis to a more prosperous husband.⁸

Sigrid the Strong-Minded

Beyond Iceland, in Norway, Sweden, and Denmark, where kingdoms were firmly established by the end of the twelfth century, there was a history of strong queens dating from the pre-Christian period. Sigrid the Strong-Minded, for one, left behind a legend of regal marriages and super-cruel revenge. As the widowed mother of the Swedish king Olav, she possessed many great estates in Sweden, and was courted in marriage by several kings. One of them, Harald the Grenlander, a "small king" from Norway, was to learn that pursuing a proud lady could be deadly. According to the colorful (if not always trustworthy) account of Snorre Sturlason: King Harald... made himself ready to ride up into the land and again meet Queen Sigrid. Many of his men counselled him against it, but none the less he went with a great following of men and came to the estates which the queen owned. The same evening another king [from Russia] came thither ... to woo the queen. The kings and all their folk took their seats in a great and ancient hall... Over-much drink there was in the evening and drink so strong that all were drunk and both the chief guard and the night watch were asleep. Then in the night Queen Sigrid bade her men fall on them with fire and weapons. There were burned both the hall and the men who were in it, and they who dragged themselves out were slain. Sigrid said that in this way would she make these small kings loathe coming from other lands to woo her: she was afterwards called Sigrid the Strong-minded.⁹

Woe be it to men of small status who had their eye on this heartless woman!

Then Olav Trygvason, a former Viking chieftain who had established himself as king of Norway in 995, begged for Sigrid's hand. He had already been married to two lesser female sovereigns who had died. The first, Geira, daughter of the king of Vendland, had shared rule over her lands with Olav after their marriage. The second, Gyde, of Irish origin, had ruled the lands of her deceased husband, a mighty earl in England. When widowed, this bold woman lined up all possible suitors and chose Olav Trygvason because he seemed to be the most manly of the lot. Now she, too, had gone to the grave, and Olav was bent upon marrying the powerful Sigrid.

He sent her a big gold ring that seemed to be very costly. But the smiths who examined the ring "said there was a falseness about it" and, after breaking it apart, discovered brass inside. "Then the queen was wroth and said that Olav would even betray in more things than this." Rings carried extraordinary symbolic meaning in

medieval society. They signified that the husband would provide for the bride the same level of comfort she had known in her father's house, so one can well understand Sigrid's wariness.

When Olav arrived in person to pursue the marriage plan, he set as a condition for their union that she become a Christian. Sigrid answered: "I will not go from the faith I have had before, and my kinsmen before me." Olav responded hastily, "Why should I wed thee, thou heathen bitch?' and he struck her in the face with the glove he was holding in his hand." Hardly a Christian act! Sigrid's last words at this meeting were full of foreboding: "This may well be thy death!" She decided to marry the Danish king Swein instead.

The rejected King Olav Trygvason married King Swein's sister, Queen Tyri, who had been married off earlier against her will to the king of Vendland. She had managed to escape from Vendland and threw herself upon the mercy of King Olav, who "saw that she was beautiful... and asked her if she would be wedded to him." She gladly accepted. Yet within the year she was complaining that "she had had such great possessions in Vendland, but in this land she had no goods as beseemed a queen." She encouraged Olav to raise an army and conquer territory in Vendland, even if it meant confronting her hostile brother Swein along the way.

Olav picked up the gauntlet. He, too, was interested in conquest, mainly so that he could bring Christianity to his conquered subjects. He himself had been baptized earlier, probably in England, and since then had been Christianizing Norway with ferocious zeal.

In the meantime, the Danish king Swein was being egged on by his wife Sigrid the Strong-Minded, who had not forgotten the humiliations she had suffered from Olav Trygvason. "Sigrid was King Olav Trygvason's greatest foe, because King Olav had broken his troth with her and smacked her on the face." She also reminded Swein that Olav had wedded Swein's sister without his assent, something his forefathers would never have suffered.

NORDIC QUEENS, ON AND OFF THE BOARD . 165

Early in the spring, King Swein formed a coalition with his kinsman Olav the Swedish king and Éric the jarl to war against Olav Trygvason. Ultimately, the coalition formed by the Danish and Swedish kings and Earl Eric defeated the Norwegian king and his ally, the king of Poland. Olav Trygvason died in battle in the year 1000. The Danish King Swein, the Swedish King Olav, and Earl Eric shared Norway between them. If we can believe the saga, Sigrid the Strong-Minded had reason to rejoice.

Queens, Commoners, and Male Dominance

While some early medieval queens like Sigrid could be as fierce as the men, many others were little more than victims of male supremacy incarnated in their fathers, husbands, or brothers. An incident concerning King Olav Trygvason's sister, Astrid, provides a chilling reminder that most women, even at the royal level, were controlled by men. Olav sent Astrid her hunting hawk, totally defeathered, as a warning of what would happen to her if she did not submit to the marriage he was planning for her.

It was common practice for girls to be married without being consulted, especially when the proposal came from a man of high rank. Princesses forced to cement political alliances through marriage often found themselves in loveless unions, or worse. One of the most unfortunate was the union of Ingeborg of Denmark to Philip Augustus of France. In 1193, one day after the wedding ceremony, he repudiated his wife, but instead of returning her dowry of ten thousand silver marks and sending her home, he locked her up for twenty years and proceeded to live openly with his bigamous favorite, Agnes. Only after Agnes's death did he release Ingeborg and acknowledge their marriage.

Gradually, Scandinavian queens began to acquire greater authority in their own right. Around 1200, they gained a firmer legal position in accordance with the evolution of feudal society and

the development of stronger, richer monarchies. One means of providing queens with property and authority in their own names was through use of the old Germanic "morning gift" offered to the bride after the wedding night. In Denmark, for instance, Valdemar II gave his queen Berengaria a "morning gift" comprising so much land that he had to ask the pope to confirm it. Not only queens, but elite women in general, received dowers in the form of money and/or property from their husbands equal to the dowries the brides brought to the marriage. The dower was to be reserved for the woman in the event of divorce or widowhood.

Another sign that queens were acquiring greater equality with kings was that they were publicly crowned. Margaret Sambiria of Pomerania was crowned at the same time as her husband, the Danish king Christoffer I, in 1252. So was Queen Ingeborg, when she married the Norwegian king Magnus in 1261.

Regency was another mark of Nordic queens' ascent to full royal power. Mårgaret Sambiria was made regent for her son, King Erik V of Denmark, when he was a minor and then again when he died in 1286. His wife, Queen Agnea, was made regent for their young son, King Erik VI, but from 1302 onward, a board of noblemen was appointed to rule. Struggles often arose, here as elsewhere in Europe, between the nobles and a royal widow over the extent of her authority. Sometimes the nobles won out, and sometimes a determined queen had her way.

From the thirteenth century onward, a more sophisticated court culture developed among Scandinavian monarchs under the influence of French, English, and German models. This gave Nordic noblemen and women a proper setting for their various accomplishments, including their mastery of chess. Tales composed by writers attached to the Norwegian court frequently featured mixed-sex matches. The *Karlamagnus Saga*, based on the French Charlemagne cycle and translated into Old Norse during the thirteenth century at the behest of the Norwegian king Hakon IV, described all the trappings of European chess culture for the benefit of the Nordic upper classes. In one episode, the renowned champion Oddgeir (Holger Danske) was shown playing chess with Gloriant, the daughter of King Ammiral.¹⁰

The position of Scandinavian women in general may have improved somewhat during the High Middle Ages. In Norway, the Landslov (laws) of 1274 gave inheritance rights to both sons and daughters, though the former got twice as much as the latter. When she married, a woman officially handed over control of her property to her husband, but, increasingly, joint ownership, or *félag*, became common. Women were able to be more independent in the towns than in the countryside: the Bylov of 1276 gave all women residing in towns the right to make their own legal agreements. Middle- and upper-class urban women sometimes owned their homes and even businesses, such as taverns and bath houses.¹¹

Ingeborg of Norway

In the early fourteenth century, one very young queen insinuated herself into the seat of power in Norway and Sweden. Ingeborg of Norway (1301–61) was the daughter of the Norwegian King Hakon V and was married at the age of eleven to the ambitious Duke Erik, brother to the king of Sweden. In 1318, Erik was killed, and Ingeborg was left with a daughter and a two-year-old son, Magnus, who became king of both Norway and Sweden in 1319.

It was agreed by both countries that during Magnus's minority each kingdom should be governed by a council. The king's mother was not supposed to interfere with these provisional governments, and was to limit herself to family and financial matters. But, aided by her favorite, Knut Porsc, and a group of ambitious noblemen, Ingeborg used her status as widow of the late king and

guardian of her son to gain power. When the Swedish chancellor was dismissed in 1321, she took the state seal by force, and, at the age of twenty, began to rule by herself.

She instituted an expansionist policy with an eye toward conquering the rich Danish province of Skane. To that end, she signed a betrothal agreement between her four-year-old daughter, Eufemia, and the three-year-old Albrekt of Mecklenburg. In effect, this established a defense union among Norway, Sweden, and Mecklenburg against Denmark.

But the Swedish and Norwegian noblemen became increasingly outraged by Ingeborg's high-handed rule. After all, she had seized power by force and relied on the support of advisers who were not even part of the provisional governments. Just before the attack on Skane was to be launched in 1322, the Swedish nobility assembled and agreed that Ingeborg would no longer have any say in government. The following year, the Norwegian notables meeting in Oslo issued a similar decree, condemning Ingeborg's aggressive foreign policy, the consequences of which had caused financial bankruptcy.

Ingeborg was officially stripped of political power, though she continued to command influence over her son until he achieved his majority and became king of the two realms in 1332. Magnus was ultimately undone by renewed struggles with his nobles, which led to an end of the union between Norway and Sweden.

Margaret of Denmark

One medieval Scandinavian queen stands out above all the others: Margaret of Denmark. Daughter of the forceful Danish king Valdemar IV, she was only ten when she was married to the twenty-three-year-old Norwegian king Hakon VI. As in many cases of early royal marriages, the couple waited several years before they lived together as husband and wife. In the interim, Margaret was sent to Sweden to be educated by one of the daughters of Saint Birgitta, the founder of the Birgittinian convents. In 1370, at the age of seventeen, she gave birth to her only son, Olav.

After Margaret's father died in 1375, her son, Olav, was elected king of Denmark by the state council, and she was appointed regent during his minority. Thenceforth all documents from the Danish throne were issued in the joint names of Olav, king of Denmark, and Margaret, queen of Norway. Margaret "Valdemarsdatter" (Valdemar's daughter), as her Danish subjects loved to call her, quickly understood that her father's aggressive manners were not suited to a feminine monarch; she set out to create for herself a quieter, more refined persona, without losing the power incarnated in the crown. For the rest of her life thirty-seven years—she ruled successfully through a combination of determined ambition, unflagging energy, and brilliant political maneuvering.

In 1380, when her husband, King Hakon of Norway, died and the ten-year-old Olav succeeded his father, Margaret effectively became the ruler of Norway as well as Denmark. Though no formal union was established between the two countries, Margaret simply exercised power in both realms with the expectation of passing the dynasty on to her son. It was a tragic and unexpected blow when Olav died in 1387 at the tender age of seventeen.¹²

This, however, did not end Margaret's political influence. Although she had no legal rights to the throne, only one week after Olav's death, she was proclaimed chancellor in Denmark with full royal power. This queen was simply too popular to be replaced. The Letters of Election stated clearly that she was chosen "because she is the daughter of Valdemar, and the mother of Olav; and because we are satisfied with the moderation of her government."¹³ It was understood that she and the council would even-

tually choose a new king. Some months later, she traveled to Norway, where she was elected chancellor for life, and it was decided that the royal succession should proceed from her. This was a remarkable turn of events, given the ancient laws of Norway, which expressly forbade that a woman should occupy the throne.

After adopting her five-year-old grand-nephew, Erik of Pomerania (her eldest sister's grandson), she managed to have him accepted as heir to the two thrones. Then she continued to govern, as regent under Erik's name in Norway, and under her own name in Denmark. Now she was in a good position to accomplish the dream of many a Nordic monarch: to join not just two, but all three Scandinavian kingdoms under one crown.

First it was necessary to eliminate the unpopular king of Sweden, Albrekt of Mecklenburg. Sweden was so eager to get rid of him that it agreed to hand over to Margaret all its main castles. Mecklenburg was eventually captured, imprisoned, and ransomed for the sum of sixty thousand marks. After some years of warfare, Margaret controlled practically all of Sweden, where she was generally received favorably, given the contrast between her wellgoverned kingdoms and the previously disorganized Swedish state of affairs.¹⁴

At the majority of her adopted son Erik in 1396, Margaret called together notables from all three countries to a meeting in Sweden, where Erik was crowned with great ceremony. Afterward, a document was drawn up providing for the permanent union of Denmark, Norway, and Sweden. A treaty written at the castle of Kalmar in southern Sweden in 1397 sealed the union of the three countries. While each country would retain its own name, laws, senate, and customs, they would all be under the rule of one monarch. In turn, the monarch would introduce no new laws without the common consent of the subjects, and would spend the revenue of each country in that country. The monarch was mandated to visit the three kingdoms yearly and spend an equal time in each.

Until her death in 1412, Margaret was the dominating power behind King Erik. A letter written to him while he was traveling to Norway in 1406 provides evidence of her long arm directing policy from afar. It told him which people he could trust and whose advice he should listen to. But above all, he should make no decisions without consulting her, "because we know more of the issues involved than you yourself."¹⁵ There is no evidence that Erik resented this state of affairs.

With an eye to the future stability of her kingdoms, Margaret negotiated Erik's marriage to Princess Philippa, daughter of Henry IV of England. The marriage was celebrated by proxy at Westminster in 1405 and then in Scandinavia, where Philippa was proclaimed queen of Norway, Sweden, and Denmark. The little princess was just twelve years old. The final marriage, together with her coronation, took place in October 1406, in the Cathedral of Lund.

But it was Margaret who continued to rule. One of her most notable achievements was to reduce the power of the contentious lords of Denmark and to transfer back to royal taxation lands held by members of the nobility, and even the Church, that had been illegally taken from the crown. This added considerably to the royal coffers. At the same time, she managed to have very good relations with the papacy through the intermediary of a pliable cardinal in Rome, who helped her reward her supporters with bishoprics and even the right to eat meat on fast days.¹⁶ In deference to her unique position and skill, the Germans called her Frau König ("Madame King.")

After her death in 1412, she was buried in the Cistercian convent of Sorö beside her son, Olav. But the following year, Erik had her remains moved to the high altar in the great cathedral of Roskilde, where a life-sized effigy in marble was erected. Inscribed beneath it is the following legend: "This monument has been raised by Erik, successor of Margaret, to the memory of that Princess, whom Posterity cannot honour beyond her merits."¹⁷

It is possible that the two fourteenth-century chess queens pictured on page 160 were inspired by Margaret of Denmark. Together, they show different aspects of her tenacious power: the composed sovereign sitting majestically on her throne and the mobile horsewoman with attendants at the ready. The reign of Queen Margaret and the reign of the chess queen converged in the late fourteenth century during a felicitous period in the history of Nordic royalty. Margaret's accomplishments stand out even more in contrast to those of her successor, whose progressive political failures eventually led to the breakup of the Scandinavian union.

Bust of Queen Margaret of Denmark. Early fifteenth century.

TEN

Chess and Women in Old Russia

ussians have been playing chess far longer than Scandinavians and other indigenous Europeans. The game called *shakmaté* (a name derived from the words for "checkmate") probably came to Rus-

sia directly from Indian, Persian, and Arabic sources no later than the eighth or ninth centuries. The earliest Arabicstyled pieces found in Russia date from the tenth century, and the earliest chessmen "with little faces," as realistic pieces were called in Old Russia, date from the twelfth century.

The unusual strength of Russian players was already noteworthy several hundred years ago. An Englishman visiting Moscow in 1568 observed: "The common game is chesse, almost the simplest will give both a checke and eke a mate; by praktice comes their skill." A Venetian report of 1656 stated that the ambassador from Moscow and his staff did not go to Mass on holidays, but stayed home to play chess, a game they played "to perfection." A French chronicle of 1685, comparing Frenchmen to the Russian chess-playing diplomats at the court of Louis XIV, admitted: "Our best players are school children compared to them."¹ If, as in Western Europe, the game was originally played mainly by members of the upper classes, it filtered down to commoners quite early and became a widespread staple of social life throughout most of Russia.

Russian Chess Pieces

Russian chessmen have several features that distinguish them from those of other countries. To begin with, all the original names for the pieces are still in use today, except for the king. The king was originally referred to as *tsar*, but has been called *korol* (king) since the seventeenth or eighteenth century. Like the *korol*, most of the other pieces have names that are Slavic in origin: *lad'ia* (rook), *slon* (bishop), *kon* (knight), *peshka* (pawn). Only the queen carries a name with a foreign derivation. She is called *ferz'* a word rooted in the Arabic *firz* or *firzān*, with the meaning of "general" or "vizier." When Eleanor of Aquitaine picked up her *fers* in twelfth-century France and Chaucer poeticized over the *fers* in fourteenth-century England, the Russians would have used virtually the same word for the piece that stood next to the king. But at that time the Russian *ferz*' did not have the same gender as the French and English queen. Instead, it was male, just like its Indian/Persian/Arabic ancestors. A twelfth-century *ferz*' found in excavations at Lukoml has the form of a seated man with his arms crossed and a little cap on his head. He looks like a high official or adviser to the king on the model of the Arabic vizier.²

The Russian *ferz*' remained masculine well into the eighteenth century. Seventeenth- and eighteenth-century walrus ivory chessmen from Kholmogory (a town on the Northern Dwina about 50 miles from Archangel), preserved in the State Historical Museum of Moscow, show the king seated on a throne and the *ferz*' in the guise of a general standing with a spear or sword in his hand. The standing general was probably modeled on Indian sets.³

Yet, from the late seventeenth century onward, the Russian words koroleva (queen) and tsaritsa (the tsar's wife), as well as baba (old woman), began to rival the term ferz', suggesting that the piece was undergoing a sex change. In 1694, Thomas Hyde, the English interpreter of Oriental languages for Charles II, listed koroleva (regina), krala (regina), and tsaritsa (imperatrix) as the Russian terms for the vizier/queen in his Book of Oriental Games (De Ludis orientalibus), which was the first truly scholarly study of chess history. He also listed krôlwa (regina) as the comparable Polish term.⁴ It had taken longer for a woman to appear beside the king on the Russian chessboard than in any other non-Muslim country, including China.

Two other peculiarities of Russian chessmen concerned the bishop and the rook, respectively represented by an elephant and a boat. The elephant and the boat recalled the early origins of the game, since both of these forms had appeared on Indian chessboards, but while the elephant meant nothing to Russians and existed atavistically, so to speak, the boat certainly made sense to a people heavily dependent on their waterways.

In addition to figurative chessmen, abstract sets of the Muslim type have an even longer history in Russia. Although the dominant religion in Russia was (and is) Russian Orthodox, there was (and is)

also a Muslim population obliged to play with chessmen that do not resemble living creatures. Moreover, even if the Koran did not explicitly condemn chess, the appendix to the Koran known as the *Hadith* was adamant in its opposition to the game, and Orthodox Muslims who followed the *Hadith* as rigorously as the Koran would not play chess at all.

Chess and the Russian Orthodox Church

The Eastern Orthodox Church in Byzantium, from which the Russian Orthodox Church derived, became zealous in its condemnation of chess at an early date. The first condemnation appeared in the ninth-century *Nomokanon* of the patriarch Photius, where it was linked with dice.⁵ During the early twelfth century, despite the Byzantine Emperor Alexis Comnenus's enthusiasm for the game, chess was expressly prohibited in the commentaries written by the ascetic monk John Zonares, who had once served as the commander of Comnenus's bodyguard and could not reconcile himself to the emperor's passion for the game. Zonares's commentaries, translated and reworded in the Russian compilations of canon law known as the *Kormchaia*, led to a ban on the game for both clergymen and laymen.

A thirteenth-century Russian "Prelate's Homily to the Newlyordained Priest" exhorted priests not to read forbidden books; not to use charms, magic, or signs; not to watch horse races; and not to play chess or dice. In the early fifteenth century, Russian priests were warned: "If any of the clergy be he monk, priest, or deacon, play chess or dice, he shall be dismissed from his office."⁶ In the sixteenth century, according to ecclesiastic rules, any priest found catching beasts or birds, or keeping hawks, or playing chess, "will be expelled."⁷ As for laypeople, they were habitually asked at confession whether they had sinned by playing chess.

CHESS AND WOMEN IN OLD RUSSIA • 177

In 1649, a Muscovite governor instructed the town commissioner to stop people from playing dice, cards, and chess, as well as from talking in church, getting drunk, listening to traveling entertainers, summoning witches and wizards, making use of fortune tellers, singing devilish songs, dancing, clapping, playing on swings, and several other reprehensible activities.⁸ Practitioners of these vices were to be punished by beating with rods. At least until the eighteenth century, chess was still listed as unacceptable for good Orthodox Russians. But nothing could kill the Russian people's love of the game, and eventually the Church had to give up the fight in Russia, as in Western Europe.

Women Players

Russian women have probably been playing chess as long as the men. They appear as chess players in the Russian heroic epics called *byliny*, which reflect the distant past as far back as the eleventh century, even if the stories were not written down until much later. The descriptions of "chess duels" taking place in medieval Kiev or Novgorod (where many of the earliest Russian chess pieces have been found) sometimes pitted a woman against a man.

In one of these stories, a guest from Chernigov was entertained at a feast in Kiev by the glorious Prince Vladimir. The guest, named Stavr Godinovich, began to brag about his young wife, who was beautiful, intelligent, and played a mean game of chess. Because his boasting angered Prince Vladimir, Stavr was thrown into a cellar. When Stavr's wife, Katerina Ivanovna, heard of her husband's misfortune, she gathered a small army and went to his rescue. Arriving at Vladimir's court and passing herself off as an envoy from a foreign land, she managed to engage the prince in a chess match.

And they sat down at an oak table, The chessboard was brought to them. Vladimir, Prince of the Kiev capital, Moved, but he did not move far enough. He moved again, overstepped himself, And the third time made a fool of himself. And the young guest, the fierce envoy, Beat Prince Vladimir.⁹

In this and other variants of the chess competition between Stavr's wife and Prince Vladimir, her victory led to freedom for her husband.

In another folk epic, Katerina Mikulichna, a merchant's wife, fell in love with a young man named Churilo over a game of chess. After he beat her three times and won from her three hundred rubles, she cried out in distress:

> Ah, young Churilushko, son of Plenko! I do not know whether to play chess with you. I do not know whether to gaze on your beauty, And on your golden curls, And on your gilded rings. And my mind is confused in my stormy head, And my clear eyes have grown dim, Look at yourself, Churilo, at your beauty!¹⁰

In both of these matches, the woman's ability to play chess was intertwined with her romantic interest in a man—husband or potential lover. The authors, presumably male, framed the woman's chess skill within narratives of marital fidelity or adulterous romance, almost as a justification for her prowess. From our vantage point, it simply proves that Russian women played chess in the past and were considered good enough to play with men.

CHESS AND WOMEN IN OLD RUSSIA • 179

Other examples of chess played between men and women can be found in folk songs from the sixteenth and seventeenth centuries. A traditional theme in these songs is the chess match between a "fair maiden" and a "good, brave youth," with the maiden usually winning the victory. One of these songs is set in the Arkhangelsk province, where the renowned Kholmogory chess carvers plied their trade. The maiden "good at playing chess/... beat the brave, young lad." Another song titled "Slender wife, clever wife" portrays a chess-playing couple in their early years. The husband tenderly recalls: "And we lived together, very closely/I learned to read and write with you,/And we played draughts-chess together."¹¹ These songs depict chess as a harmonious, domestic pleasure popular among the common folk.

Chess, Women, and Society

The history of chess in Russia is in many ways a slowmotion version of the history of chess in Western Europe. Most notably, the transformation from the male figure of the vizier or general to that of a female figure took place six or seven hundred years after the chess queen had appeared between 1000 and 1200 in Germany, Italy, Spain, France, England, and Scandinavia. This belated transformation was undoubtedly due to the dominance of Arabic-style chess in Russia, which lasted until Peter the Great (1672–1725) opened the door to European influences. Western-style chess then became popular among the nobility, though Eastern chess rules continued among the lower and middle classes.

Was the absence of a chess queen also related to the slow emancipation of women in Russia? This is a thorny question. On the one hand, it is difficult to deny the decidedly misogynistic character of medieval Russian society. From the twelfth to the sixteenth century,

the Byzantine Church fathers who brought Christianity to Russia, the Mongols who invaded from the East, and the expansionistic autocracy from Moscow combined to keep women "in their place"that is, in a subservient posture to men. The Church proclaimed: "As a prince answers to God, so a man answers to his prince, and a woman to her husband."12 Consonant with Christian teachings on conjugal relations, the Kievan Prince Vladimir Monomakh instructed his sons in the early twelfth century, "Love your wife, but do not give them power over you."13 Popular wisdom declared that a man who was dominated by his wife was not a man. It was common for women to be castigated as evil-tongued and lascivious. when they were supposed to be submissive, chaste, humble, and silent. To keep a wife subservient, a husband had the right to beat her, short of murder. (This was pretty much the case throughout Western Europe as well.) Judicial sources often underlined the intellectual and physical weakness of women and their need to be controlled, chastised, and protected by men.

Still, there is always a gap between ideology and practice, and many women, especially if they belonged to the highest levels of society, did not fit this mold. According to various chronicles, there were princely families in which the wife "ruled the husband" and others where husband and wife lived in mutual harmony. Moreover, medieval laws granted Russian women a certain measure of economic autonomy. The dowry given to a daughter by her family at the time of her marriage, whether in the form of money, livestock, furniture, or property, was conjointly administered by both husband and wife.14 In the city of Novgorod (where many of the earliest Russian chess pieces were excavated), a woman could hold property in her own name, whether she was married or not.¹⁵ The widowed mother of a dead man's children could inherit her husband's estate and administer it, even after her children had become adults; she was legally entitled to be the head of the household until she died. As she grew older, especially if she was widowed, a woman of rank was likely to control considerable land and wealth.¹⁶

Boyar women were known to have commanded large sums of money, as is apparent from the bequests in their wills and from the large donations they gave during their lifetimes to the Church. Like Byzantine, Spanish, French, German, English, Flemish, Polish, Hungarian, and Italian noblewomen, Russian princesses and other female aristocrats founded monasteries, built churches, and kept a high profile as Church donors. Ever since Princess Olga adopted Christianity in the tenth century (she was later canonized as the first Russian saint), Russian women have had a special relationship with the Orthodox Church. While only the affluent could afford to bequeath significant holdings of land or money, others from various stations in life entered monasteries as nuns, and still others, in vast numbers, filled the churches with their fervent prayers.

What is even more remarkable is that some Russian women played an important role in political life. As regent for her son, the saintly Princess Olga governed the principality of Kiev with a skillful hand for almost two decades (945 to 964). Later, from the thirteenth to the sixteenth century, Russian principalities were often directed by women commanding the kind of secular authority that was traditionally accorded only to men.¹⁷

One unusual fifteenth-century Boyar woman, Marfa Boretskaia, became a *posadnitsa* (mayoress) in the Republic of Novgorod. She and her kinsmen struggled to preserve Novgorodian autonomy in the face of Lithuanian and Muscovite expansion. Depending on one's political agenda, historians have seen her either as a crucial historical figure or as an "evil woman" who interfered with Moscow's unification measures. In any event, she was ultimately defeated in 1471 by the grand prince of Moscow, Ivan III, and exiled from her beloved Novgorod.¹⁸

At the peak of the social order, daughters of royalty were known to have exerted influence indirectly through their hus-

bands. Many of these women had been imported as brides from Western Europe. The Kievan grand princes, for example, married the daughters of kings from Sweden, Poland, Norway, France, Hungary, England, Bohemia, Moravia, Byzantium, Georgia, and Lithuania. But, increasingly, during the late Middle Ages, this practice declined, and Russian princes preferred to pick their wives from within their own religion and country. For the most part, the Muscovite tsars, starting with the first one in 1547. steered clear of diplomatic unions with foreign brides and consciously pursued a policy of isolation from Europe, one that was ultimately detrimental to Russia. One historian observed almost wistfully that "The presence at the Russian court of cultivated women from countries whose intellectual, technological, and economic life was in these centuries far richer than Muscovy might have provided a small but regular and unthreatening flow of Western ideas and international understanding, but this opportunity was lost."19 The chess queen was one of those Western ideas lost upon premodern Russians.

Catherine the Great

It is notable that the chess queen—*tsaritsa, boyarina,* or *baba* (old woman or even "broad")—did not definitively edge out the vizier until the period of Catherine II the Great, who reigned from 1762 to 1796. At this time chess was probably the most popular game played throughout Russia, as one English visitor noted in 1772: "Chess is so common in Russia, that during our continuance at Moscow, I scarcely entered into any company where parties were not engaged in that diversion; and I very frequently observed in my passage through the streets, the tradesmen and common people playing it before the doors of their shops or houses. The Russians are esteemed great proficients in Chess."²⁰ Catherine II herself was very fond of the game, though

she played it less frequently than whist, which was the standard after-dinner pastime at her court.

Catherine II has to be included among the most influential rulers of all time, male or female. Yet this formidable woman, the daughter of an obscure German prince serving in the Prussian army and a somewhat more distinguished princess from Holstein-Gottorp, was hardly destined at birth to reign over anything more than a noble Lutheran household. Not even her aspiring mother could have imagined that her daughter would one day become empress of all the Russias. But circumstances peculiar to the Russian Empire, 'coupled with Catherine's great intelligence, ambition, and political acumen, led to her marriage with the grand duke, who became Peter III in 1761, and to the 1762 coup that cost Peter his life and placed Catherine solely on the throne. Suffice it to say that Russia had a unique system of imperial succession: since the death of Peter the Great in 1725, the crown was not automatically inherited by the eldest male of the family, but by a person designated by the emperor (or empress) as the dynastic heir.

Unlike most other European countries, Russia in the eighteenth century was getting used to the rule of female sovereigns chosen in this manner. Peter the Great's half sister Sofia was regent from 1682 to 1689; his widow, Catherine I, reigned from 1725 to 1727; his half niece Anna from 1730 to 1740; and his popular daughter Elizabeth from 1742 to 1761.²¹

Catherine II's immediate predecessor—the capricious and allpowerful Empress Elizabeth—had set the model for the young Catherine. It was Elizabeth who had proclaimed her German nephew, the future Peter III, as her heir and chosen Catherine to be his bride. Like Elizabeth, Catherine became thoroughly Russified: she learned to speak Russian, converted to the Russian Orthodox Church, and embraced the Russian people.

But unlike Elizabeth and unlike Catherine's hapless husband, this German-born, French-educated woman aspired to be an enlightened monarch, one who would bring to Russia the spirit of

Montesquieu, Diderot, D'Alembert, Grimm, Voltaire, and the other philosophes of her age. (The stories of Catherine's personal relations with Diderot and Voltaire rate volumes of their own.) Although she failed, largely, to transform the vast heterogenous Russian territories into a liberal monarchy (for one thing, she maintained the institution of serfdom that had long been abolished in Western Europe), her successes were undeniable. She codified Russia's chaotic laws according to the Great Instruction that she herself had written. She installed a system of absolute central bureaucratic rule that was suited, in her opinion, to Russian circumstances. She both curbed and supported the Russian Orthodox Church. She improved the state of finance and commerce. and extended the borders of her empire. She took a lead in public health, putting down a plague epidemic and submitting herself and her son to the first smallpox inoculations in Russia. Prizing literature and art (but not music, for which she had no taste), she generously supported Diderot's encyclopedia from afar, brought countless works of art to the Hermitage in Saint Petersburg, and patronized the painter Elisabeth Vigée-Lebrun at her court, by then one of the most dazzling in Europe.²²

Her personal life has interested posterity as much as her public persona. There is no doubt that she had many lovers after an initial chaste marriage of several years with the Grand Duke Peter. It is almost certain that her two children were not fathered by her husband. As empress, she granted her lovers the title of adjutantgeneral, a euphemism for the current official favorite, and she was extremely generous to them when they were dismissed. Most were pensioned off with tens of thousands of rubles and thousands of serfs, sometimes with an additional palace of their own. Only Grigori Orlov, who had brought her to power with the aid of his brothers, and, later, her beloved soul mate Potemkin, lasted as long as a decade.

In Russia, she became an excellent horsewoman, following a

CHESS AND WOMEN IN OLD RUSSIA . 185

bent for equestrian pleasures that had begun as a girl when she mounted her pillow at night and rode till she was exhausted (!). Nothing pleased her more than to spend hours on the back of a spirited stallion, preferably riding astride rather than sidesaddle. Had she been represented on a chessboard, it would have been appropriate to depict her mounted on a horse, like the Scandinavian chess queens pictured in the last chapter.

It is difficult to determine exactly when the queen edged out the vizier on Russian chessboards. Eighteenth-century Kholmogory style chessmen, made from walrus or fossilized ivory, still contained a vizier or general. They typically pitted Russians against Orientals and sometimes represented the Russian pawns as Roman soldiers, which may have been a reflection of Catherine the Great's personal bodyguard, who dressed in this manner.²³

Yet by the late eighteenth and throughout the nineteenth century, the *tsaritsa* was a common replacement for the vizier. Was it

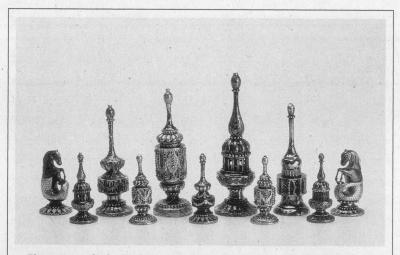

Chess set made for Catherine the Great by Andrian Sukhanov, from the Royal Armory, Tula, 1782.

Finally, in the early nineteenth century, a queen with a woman's face and body stood between the king and bishop on the Russian chessboard.

Catherine's monumental image that shifted weight onto the scale of the chess queen? Surely no female ruler, not even the sainted Princess Olga, was venerated like Catherine the Great—a veneration that may have led to the belated acceptance of the chess queen. After Catherine, the Russian scene was never the same; her influence extended to almost every corner of the empire, even to the miniature representation of society figured on the chessboard. How could Russians deny the chess queen her symbolic power when Catherine had reigned over all the Russians with greater glory than any ruler before her?

It also took longer in Russia for chess to free itself from Church prohibitions. While the Church of Rome effectively gave up its ban on the game in the fourteenth century, the Eastern

CHESS AND WOMEN IN OLD RUSSIA • 187

Orthodox Church continued to prohibit chess well into the eighteenth. But neither the Eastern nor the Western Church succeeded in stamping out the game, not even among the clergy. In Russia, among both aristocrats and commoners, it took root with a tenacity that has continued to this day. Russian dominance of twentieth-century chess is an established fact, but before arriving there, we must backtrack to the fifteenth century for a crucial turning point in chess history.

PART 5

Power to the Queen

ELEVEN

New Chess and Isabella of Castile

t is time to face the second major ques tion raised in this book. How did the chess queen become the powerhouse she is today? Under what circumstances did she emerge as the dreaded "mad

queen," the scourge of all the other pieces on the board? Can we establish a connection between this mighty figure and queenship at a given time and place?

We have seen how the chess queen appeared around the year 1000 as a European replacement for the Arabic vizier, taking over his slow, one-step-at-a-time diagonal

gait. Despite slight regional differences, this is the pace she maintained throughout the Middle Ages. Yet, from the twelfth century onward, she seems to have acquired special value, far beyond her limited mobility on the board. As noted earlier, a Hebrew text from Spain spoke of the chess king and queen as having "no difference between them," when in fact the king was twice as powerful as the queen. (Theoretically, he had the choice of moving to one of eight adjacent squares, whereas she could move to only one of four.) The early-thirteenth-century Carmina Burana chess poem stated categorically that when the king had lost his queen, there was nothing of value left on the board. Similarly, the knight in Chaucer's Book of the Duchess (1369) cried out in despair: "And whan I sawgh my fers awaye,/Allas! I kouthe no lenger playe." (Remember that fers was synonymous with chess queen.) Clearly the authors of these passages were thinking of the chess queen metaphorically, as the ultimate female figure in the feudal hierarchy, and not in terms of her worth in the game. The heightened authority invested in queenship during the course of the Middle Ages spilled over to the little queen on the board and paved the way for her to become the game's mightiest piece. While living queens, like kings, endured the ups and downs associated with the throne, queenship in its various forms (queen consort, queen regent, and queen regnant) developed sturdy roots that became resistant to attacks from even the most misogynistic opponents of female power.

It should not surprise us that the chess queen's official transformation into the strongest piece on the board coincided with the reign of Isabella of Castile (1451–1504.) Isabella's joint rule with her husband, Ferdinand, constituted a high point in Spanish monarchy, comparable in many ways to that of Elizabeth I of England a century later.

The New Queen in "Love Chess"

The first evidence of the chess queen's new preeminence can be found in a Catalan poem titled "Love Chess" ("Seachs d'amor") written sometime between 1470 and 1480. It recorded an actual game played according to the new rules. We even know the names of the two players and an observer— Castellví, Vinyoles, and Fenollar. All three were members of a chess circle in Valencia, a city in King Ferdinand's Aragón, which was home to a lively group of humanists, men of letters, publishers, and booksellers. Many of these were *conversos* (Jews converted to Christianity) or descendants of *converso* families; others, especially the publishers and booksellers, were of German origin.¹

"Love Chess" contained sixty-four stanzas, recalling the sixtyfour squares of the chessboard, and, like earlier chess allegories, it had a romantic theme—in this case, the courtship of Venus by Mars in the presence of Mercury. Mars, representing Castellví, who played with the red (today's white) pieces, tried to obtain the favors of Venus, representing Vinyoles, who played with the green (today's black) pieces, while Mercury, representing Fenollar, looked on.

In the course of the poem, Fenollar provided information about the chess queen that probably reflected the high esteem enjoyed by Queen Isabella. For example, it was officially decreed that a player could not have more than one queen on the board at a time—that is, no pawn could be "queened" until the original queen of its color had been taken. This attempt to preserve the uniqueness of the "one and only true queen" had its precedents as far back as the first mention of the *regina* in the Einsiedeln Poem, circa 1000, thus differing from the earlier Arabic version of the game. The prohibition may have come to the fore once again

under Isabella because of the civil war that pitted her against Queen Juana of Portugal, the illegitimate daughter of Isabella's half brother Enrique IV. Isabella, as we shall see, eliminated Juana as a contender for the throne of Castile and sent her packing into a convent. This would have been an opportune moment for chess theorists to reaffirm the principle of a single queen on the board at any given moment. Yet this restriction did not survive into the game we play today, which allows for a pawn reaching the eighth rank to become a second (or third) queen, even while the first queen is present.

Moreover, Fenollar stated that to lose one's queen was to lose the game. This same sentiment, expressed a century earlier by Chaucer, would be repeated by the earl of Surrey a century later (see chapter twelve). Despite the general sense of despair over losing one's most valuable piece, it is still possible to win a match after one's queen has been lost, as any seasoned player will tell you. In fact, great games won after sacrificing one's queen are legion.

It is noteworthy that this poem referred to the chess queen not as *alferza* (*alfersa* in Catalan)—the name by which she had been previously known in Spain—but by her new name, *dama. Dama* would have had at least three circles of meaning in late fifteenthcentury Spain: "lady" as indicating a superior social status, "lady" in a religious sense as in "Our Lady," and "lady" as referring to the Spanish queen, Isabella of Castile. *Dama* was also coopted as the Spanish name for the game of draughts, probably invented in the period between 1492 and 1495 and, like chess, linked to the prestige of Queen Isabella.²

The New Rules in Lucena's Art of Chess

In addition to the manuscript of "Love Chess," two printed books outlining the chess queen's newly acquired moves also appeared in Spain at the end of the fifteenth century. The first, *The Book of 100 Chess Problems (Libre dels jochs partits dels schachs en nombre de 100*), was published in Valencia in 1495 under the authorship of a certain Francesch Vicent. The second, Luís Ramíriz de Lucena's *Discourse on Love and the Art of Chess with 150 Problems (Repetición de amores e arte de axedres con CL inegos de partido*) was published in 1496 or 1497 in Salamanca. While the book written in Catalan has been lost, Lucena's Spanish text survives in a few rare copies, which reveal how chess mutated into its modern form.

According to the new rules, the queen could advance not only diagonally, but also in a straight line, and as far as she liked, as long as her path was clear. The changes in her technical capacity were so dramatic that Lucena referred to the new game as "lady's chess" or "queen's chess" (*de la dama*) in contrast to "old chess" (*del viejo*) played with the earlier rules. What was and is often referred to as the "game of kings" could henceforth be equally identified as the "queen's game."

The other noteworthy change in new chess concerned the *alfil* (bishop). He, too, could now move to any square, as long as the way was clear, but only on the diagonal. It had taken about five hundred years for the queen and the bishop to arrive at these new levels of strength. These two pieces (originally the vizier and the elephant in the original Indian/Persian/Arabic game) had come into being around 1000 as representatives of European feudal institutions that continued to expand throughout the Middle Ages.

Granting the queen and bishop greater tactical strength on the chessboard was a way of recognizing their awesome positions in real life.

Lucena codified an option for pawns mentioned two hundred years earlier in the Alfonso and Cessolis manuscripts: henceforth, pawns could advance two squares on their first move. He also observed that the transformation of the pawn into a *dama* once it had reached the far side of the board enhanced the overall value of the lowly pawn, since now the queen, and hence the "queened" pawn, was considerably stronger than before. The author confidently suggested that the new rules he followed were better than those of "old chess" still in use elsewhere.³

The moves of the queen, bishop, pawn, knight, and rook described by Lucena are identical with their moves today. The king's basic moves are also the same, with the exception of one possibility: for his first move the king could advance to the third square in front of him, provided he was not in check. This option disappeared slowly in the years following Lucena, and eventually evolved into the possibility of "castling"—that is, the king can move two squares, either to his right or his left, for his first move, while the castle moves to the king's other side, provided, of course, the way has been prepared by the removal of the intervening pieces.

Lucena's book centered around one hundred and fifty chess problems, which were equally divided between old and new chess. Most of these problems were probably taken from Vicent's earlier book of one hundred problems, with fifty more added to complete a "rosary" of one hundred and fifty "beads."⁴ The old chess problems followed the slow rhythms of the Arab-rooted game. Those following the new rules produced a much faster game, since the new queen and bishop could exert greater pressure on their opposing forces and sometimes even effect a checkmate within the first several moves. What do we know about the author of this work? He described himself as the son of a learned doctor, ambassador, and notary, who was a member of the royal council.⁵ His father, Juan de Lucena, was indeed a high official, with personal access to King Ferdinand and Queen Isabella. In one of his letters, he noted that the queen was setting a good example for her people by studying Latin: "When the Queen studies, we become students." The letter also contained an implicit critique of the king: "When the king gambles, we are all gamblers."⁶

Lucena the younger tells us he had studied at the University of Salamanca and traveled to Rome and all of Italy, France, and Spain, where he had recorded the best chess games he had seen. The late Spanish chess historian Ricardo Calvo spent many years tracking Lucena and the circumstances under which he wrote his book. He concluded that Lucena was a student, probably aged twenty to twenty-five, at the prestigious University of Salamanca in 1497. As the son of a distinguished servant of the crown, he would have enjoyed certain privileges, but since he was also known to have come from a converso family, he would have been subject to the social ostracism that conversos experienced from long-term Christians. Among the many conversos at the university during Lucena's years was the playwright Fornando de Rojas, whose masterpiece La Celestina appeared in 1499. Calvo found many points in common between the two authors and their works 7

Although there is no date on the title page of Lucena's book, it is possible to establish a 1496–97 time-frame from the flattering dedication he offered to Prince Juan, Isabella and Ferdinand's only son. Juan would have been nineteen years old, engaged or recently married to Margaret of Austria, daughter of the emperor Maximilian. The wedding ceremony took place in April 1497, and everything augured well for the young couple, but in the autumn, when Prince Juan and his bride went to Salamanca to receive that

university city as his dowry, he succumbed to a mysterious illness and died suddenly on October 4. Lucena, a student at Salamanca and son of a court dignitary, had undoubtedly hoped his book would be noticed by the crown prince. Since the printing press had arrived in Spain barely two decades earlier, in 1478, printed books were still enough of a novelty to attract attention. Lucena's book on chess might have endeared him not only to Prince Juan, but also to Juan's mother and father, who were known to be passionate players. It might even have helped deflect the oppressive attention of the Inquisition, which had its eye on irreverent *conver*-

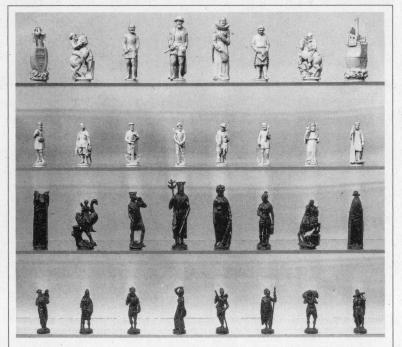

Chess pieces representing the discovery of America, with Ferdinand and Isabella as the White King and Queen, and Native Americans on the other side. Bohemia, late nineteenth century.

sos. Even Lucena's well-placed father had been prosecuted in 1493 and would be investigated again in 1503. But the book fell on deaf ears. In 1497, after the death of her beloved son, Isabella was inconsolable.

Isabella of Castile

Isabella I of Castile remains to this day an ambiguous figure. Certainly she is to be admired for the political strategies that brought her to the throne and sustained her till the end of her life. She was responsible, conjointly with her husband, for uniting all of Spain, including the last Moorish stronghold in Granada. Similarly, she must be credited with financing Columbus's expeditions to the New World. But she was also responsible for instituting the Spanish Inquisition and for the expulsion of Jews in 1492 and Moors in 1502. Hers is a mixed legacy.

Like other European queens in almost every time and place, Isabella was not the obvious heir to the throne. She grew up in the shadow of her half brother, Enrique IV, who had succeeded their father as king of Castile when she was only three and he already thirty. She was last in line for succession after any legitimate children born to Enrique and after her younger brother, Alfonso.

But a series of unexpected deaths placed a crown on her head. At the age of seventeen, two weeks after her brother's youthful demise from natural causes and while Enrique was still alive, she declared herself the "legitimate hereditary successor to these kingdoms of Castile and León," next in line after Enrique. It was a bold move for a seventeen-year-old unmarried infanta.⁸

Marriage became her next vital consideration, one that would strengthen her hand as the future sovereign. Although the aging Enrique pushed hard for a marriage with the king of Portugal, she inclined to her cousin Ferdinand of Aragón, whom she had never

seen but who was reputedly handsome and gallant. She wrote to Enrique that she had made secret inquiry into the person of the Portuguese king and found him wanting, "but all praised and approved the marriage with the Prince of Aragón, King of Sicily."⁹

Aware of Enrique's opposition to the union, Isabella and Ferdinand met for the first time clandestinely in October 1469. They were immediately attracted to each other, and within two weeks were married in Valladolid in the presence of two thousand people. After a day of celebration, the bride and groom retired to their bedchamber. Witnesses stationed at the door entered at a designated moment to carry out the bedsheets and publicly demonstrate the appropriate stains, which proved that the marriage had been consummated.

The marriage inaugurated a union that was to be highly successful on both a personal and a political level. There is no doubt that Isabella and Ferdinand shared a great love for each other, as well as a remarkable sense of trust and common purpose that was to be demonstrated over and over again during their long union. Within a year of their wedding, Isabella gave birth to a girl child, whom they named Isabella. Within five years, Enrique was dead, and Isabella was proclaimed queen of Castile and León.

The proclamation ceremony that took place in Segovia was a majestic triumph, orchestrated by the young queen herself. Magnificently dressed and bejeweled, she stood on a platform in the portal of the church of San Miguel, where she was hailed as queen of Castile and León. Subsequently, members of the clergy, nobility, and city council knelt before her and swore loyalty to Queen Isabella and her husband, King Ferdinand, even though he was absent from the ceremony.

The procession from the church offered a splendid spectacle to the townspeople. Isabella rode on horseback, while the nobles and dignitaries surrounded her and marched behind. At the very head of the procession rode a horseman carrying a naked sword with the point downward, resembling a cross. Isabella chose to revive this ancient symbol of militant faith and justice, although the traditional monarch's symbol in Castile was a scepter. The sword recalled not only the royal conquerors who had wrested Spain from the Moors, but also the feats of the warrior maid Joan of Arc, earlier in the century. As one of Isabella's recent biographers astutely observed, the sword represented power on many levels and made clear to everyone "that the queen and not her consort... was the heir-proper of those Castilian heroes of the reconquest."¹⁰

And where was Ferdinand in all this? Retained in Saragossa for Aragónese affairs, he was stunned to hear that Isabella had proceeded without him. He was shocked at the use of the unsheathed sword, which he considered a symbol of "male privilege" usurped by the queen. Was he to be nothing more than a king consort rather than an equally reigning monarch?¹¹

This was a difference that Isabella settled diplomatically but firmly with the aid of a council of legal experts. At that council convened in Segovia in January 1475 before a large audience of aristocrats, the principle of female inheritance in Castile was reaffirmed; in the event that Ferdinand and Isabella had no male offspring, the crown would pass to their eldest daughter. It was, as another of Isabella's biographers has written, "one of the most extraordinary examinations of female inheritance rights in prefeminist Europe."¹²

In time, Isabella managed to soothe her husband's hurt pride. A new coat of arms, with the royal symbols of Castile and León, Aragón, and Sicily, stood for their joint rule. Their new motto, *"Tanto Monta, Monta Tanto, Fernando como Isabel, Isabel como Fernando"* ("One is equal to the other, Ferdinand as much as Isabella, Isabella as much as Ferdinand") spoke for a union of equals, although she was, by law, the superior partner in Castile and León.

The first years of their reign severely tested their resolve. Upon their accession to the throne, the king of Portugal warred against them, with rights to Castile claimed through his Spanish bride, Juana, the illegitimate daughter of Enrique IV. It was a bitter, divisive war that wrought havoc upon the kingdom. Individual barons and cities took up opposing sides and had to be courted and sometimes subdued by the young monarchs. Not only did Ferdinand ride into battle on behalf of Castile and León; he had battles of his own to fight in the service of the kingdom of Aragón, ruled by his father.

Isabella played an active role in every stage of the turmoil: she encouraged her husband and his soldiers, made personal appearances before their allies, walked barefoot in the street to celebrate a famous victory, presided over the formalities of surrender, and punished or pardoned rebels. She negotiated loans, even from the Church, and instigated financial reform throughout the realm.

One of the intentions of this reform was to undermine the rights of non-Christians: Jewish moneylenders were limited in the amount of interest they could charge, and both Jews and Moors were forbidden from wearing outward signs of luxury, such as gold and silver. These restrictions placed on the non-Christian population would become more severe in the years to come. Isabella and Ferdinand, "the Catholic monarchs," as they became known, set up a strict criminal and administrative system that brought order to their kingdom after the turbulent war years.

Best of all, Isabella produced a male heir—Prince Juan, born June 30, 1478. Six weeks after his birth, she appeared on horseback before the people of Seville, "capering on a white palfrey in a very richly gilt saddle and a harness of gold and silver." In the entourage of aristocratic dignitaries, her son was carried by a nurse riding on a mule "saddled in velvet and pillowed in a colorful brocade." Isabella and Ferdinand not only brought stability to their lands; they believed they had ensured the future of their dynasty.¹³ The following year Isabella gave birth to another child, a daughter named Juana. She was to become, in her adult years, the unfortunate Juana la Loca (Joanna the Mad), but during her early childhood she enjoyed, with her siblings, the privileges of a royal family ruled over by a caring mother. Since Ferdinand was often away on official business in Aragón—often months at a time—it was up to Isabella to preside over their Castilian household.

In fifteenth-century Castile, "home" was where the itinerant court happened to be. It was always a major undertaking to move from place to place with an enormous retinue of servants and all the baggage necessary for a royal residence. In each new setting, Isabella and Ferdinand met with their advisers from six A.M. to ten A.M. during the spring and summer and from nine A.M. to noon in fall and winter, except on Sundays. Theirs was a disciplined life, and they expected their councillors to be no less disciplined.

Chess at the Castilian Court

Still, court life had its many pleasures, among them cards, chess, and other board games. We know that Isabella and Ferdinand were avid chess players. In fact, Hernando del Pulgar, chronicler of their reign, signaled the excessive attention Ferdinand gave to "pelota and chess and backgammon . . . and in this way spent time, more than he should have."¹⁴ Regardless of Pulgar's concern, both monarchs were devoted to chess. On the other hand, Isabella disapproved of gambling and banned it at her court, along with other expressions of wantonness like excessive décolletage or drunkenness.¹⁵

A story has come down to us of how Ferdinand and Isabella's lives were saved by a chess game. During the siege of Málaga in 1487, a certain Muslim named Ibrahim al-Gervi tried to kill the royal couple in their tent. Fortunately for the monarchs, he mis-

took the queen's friend, Beatriz de Bobadilla, and Alvaro de Portugal for the king and queen since they (Beatriz and Alvaro) were in a neighboring tent playing chess.¹⁶ Though severely stabbed, they were saved from death by the arrival of several Spaniards who heard their cries.

Board games were an established part of court life throughout Europe. During the fifteenth century, chess, dice, and backgammon were still highly favored, though they had an upstart rival in cards. Cards, introduced in the last quarter of the fourteenth century, were rapidly becoming as popular as chess, even if chess was still privileged by members of the nobility. Isabella's royal contemporaries in France, Charlotte de Savoie, wife of Louis XI and mother of Charles VIII, and her daughter, the regent queen Anne de Beaujeu, were both dedicated chess players. Charles himself preferred backgammon and dice, but "never chess, where his sister Anne showed too much skill."¹⁷

Had Isabella been a less ambitious person, less convinced of her divine right to wear the crown and her responsibility to unite the peninsula, she might have been content to play more games and rest on her laurels. After all, as of 1481 she was not only queen of Castile and León and the mother of three living children, including the crown prince Juan, but also coregent of Aragón with Ferdinand, who had succeeded his father. Although Aragónese law forbade women from inheriting the crown, Isabella was designated by her husband as an "*otro yo*" ("another I").¹⁸ But Isabella was not content to sit complacently on her throne, especially since she was certain that the time had come to complete the reconquest of Spain.

In 1482, she initiated a war against the kingdom of Granada, the southernmost area of Spain and the only territory still ruled by Muslims. As one anonymous source summed up the events: "By the solicitude of this Queen was begun, and by her diligence was continued, the war against the Moors, until all the kingdom of Granada was won."¹⁹ The war was won at great cost to the lives of Spanish knights and foot soldiers, and great financial expenditure from the populace and the crown. Isabella took personal charge of provisions for the war, from the number of knights required from every city and village to the specific quantities of bread, wine, salt, and animals to be delivered to the camps. While Ferdinand risked his life on the field of battle, nothing could stop his wife from directing the war effort in every other way—not even a difficult pregnancy. She was still at the council table when she went into labor, giving birth to twin girls, one of whom was stillborn.

Despite initial hardships and defeats, the tide of war began to turn in their favor, and Isabella's direct participation brought her renewed respect from her subjects. Indeed, as Pulgar noted: "the Queen was very feared and no one dared to contradict her orders."²⁰ The royal couple led their people in a series of hard-won battles and sieges that eventuated in victory over the Moors. How must the Muslim inhabitants of Córdoba have felt when their mosques were turned into churches and their children forcibly baptized? Like all religious intransigents, the king and queen were certain they had God on their side. On December 15, 1485, as if to punctuate the recent victories, Isabella gave birth to another child, a daughter named Catalina. Six more years of campaigns against the Moors would be necessary before Granada surrendered in January 1492, and the reconquest was complete.

1492. That date is ingrained in the memory of every American schoolchild as the year in which Columbus set sail for the New World, with support from Ferdinand and Isabella. Less commonly known, it was also the year in which the Jews were expelled from Spain. Both of these undertakings had taken years to reach their climax.

As early as 1478, the king and queen had received permission from the pope to appoint inquisitors, with a mandate to root out

heresy. They focused primarily on Jewish and Muslim converts suspected of backsliding from Christianity. The Inquisition in Spain was not initially directed at unbaptized Jews, many of whom provided important financial services to the crown. But in time, the Inquisition took on a life of its own, and like many instruments of fanatical belief, it was driven by boundless hatred for those seen as "other" or "different." Secret denunciations, extreme torture, ghastly executions, and burning at the stake were the fate of thousands of *conversos* deemed to be heretics.

By 1492, Isabella was convinced that Spain needed to be purged of all non-Christians, both Jews and Muslims. In the language of the expulsion decree signed by both Ferdinand and Isabella and made public in April 1492, it was "well known" that damage had been inflicted upon Christians "from their participation, conversation and communication with the Jews." Consequently, Jews who refused baptism were given three months to leave the kingdom and ordered "never to return."²¹

Isabella, Ferdinand, and Columbus

Having disposed of the Jews in this cruel manner, Isabella and Ferdinand turned their attention to other matters, among them the expedition proposed by Columbus. He had first come to the Spanish monarchs for patronage in 1485 or 1486, and then again in 1489. Both times his request was denied, as it was again in December 1491. But after he had left her court and was already on his way to seek funding elsewhere, Isabella had a change of heart. The vision of herself and Ferdinand as magnanimous sponsors of a great exploration that might bring honor and wealth to Spain and future converts to Christianity proved too strong for her to resist.

The story of how chess entered into the decision to sponsor

Columbus has come down to us through letters, presumably written by the warrior Hernando del Pulgar (not the chronicler) early in 1492 to a friend at the court of Ferdinand and Isabella. I say "presumably" because my only source is a French translation found in the October 15, 1845, issue of *Le Palamède*, the first European journal devoted to chess. If these letters can be believed, Columbus would not have received Spanish backing, were it not for a chess match that put King Ferdinand in a receptive mood to the project. In my translation from the French, the letters read in part:

Noble doctor,

King Ferdinand, as you know, delights in playing chess. Like all serious players, he attaches the greatest importance to winning the match. He is malicious, and, if I were not speaking of His Highness, I would say almost perfidious....

Yesterday during the heat of the day, instead of taking his siesta, he retired to the Queen's apartments and began a match with Fonseca, one of his usual victims. Some of us observed the combat as arbiters. The Count of Tendilla, Ponce de León, and Gonsalvo of Córdoba were present. Several maids of honor seated around a frame were finishing a magnificent piece of em-. broidery destined for Our Lady del Pilar [statue of the Virgin standing on a pillar].

The elderly Lady Beatriz Galindez, so learned that she has been renamed "Latina," was seated near the Queen, and both of them were conversing quietly in Latin, while the King, absorbed in the game, was giving poor Fonseca a hard time.

At that moment, the hangings were raised, and a page announced the Queen's confessor. After the holy prelate had presented his respects to the King, he approached the Queen, and asked her what decision she had made regarding the Genoese Cristobal Colón.

The ensuing discussion focused on Columbus's insistence that he be granted the titles of admiral and viceroy—titles that Lady Beatriz and others considered extravagant for an upstart sailor with questionable views about the shape of the earth. The queen, however, took a different view.

"My Lord," she said, "shall we not give this intrepid man the title he is asking for? There is no inconvenience, I think, in granting it to him for the country he intends to discover. If he shows the way to a new world, he will certainly have merited this honor."...

"We'll think about it," said Ferdinand passing his hand across his brow, and, in spite of himself, he no longer gave the game all his attention. Fonseca cleverly profited from the King's distraction, and soon gained the upper hand. "Your Highness's Queen has acted like the rash navigators. She has come too close to the abyss, and the black hand is about to seize her. Your Queen is forced."

"The Devil take the Genoese!" the King exclaimed. "He's going to make me lose a splendid match."...

On the verge of losing his queen, the king became very annoyed, and Fonseca openly rejoiced, considering the game already won. But they had not counted on a strategy seen by the letter writer, Pulgar, which he communicated to Queen Isabella. "If whites don't make any mistakes, Fonseca is dead in four moves."

Isabella drew near the King. She even leaned on his shoulder and held back his arm at the very moment when, after having hesitated for a long time, he raised his hand to place his rook in the fifth square.

"My Lord," she said, "I think you have won."

"I hope so," Ferdinand answered. He stopped and began to

15, 1845.

reflect again.... His eyes searched out mine, and as I indicated with my eyes that he had indeed won, he began to calculate once more. Then a smile crossed his lips and his brow lit up with sublime pleasure.

"Fonseca, you are very sick."

"It seems to me," the Queen said quickly, "that there would be no risk in granting the Genoese the title he wants."

"What do you think about it, Latina?" Ferdinand continued somewhat ironically. "Do you still persist in your opinion?"

"No one is certain of never being wrong," responded Beatriz Galindez....

"After all," Ferdinand added, "no great harm can come from appointing him Admiral of the seas he will navigate."

Then the Queen called one of her pages. "Alonzo, mount your horse, hurry to overtake Cristobal Colón, who is on the road to Palos de Moguer, and tell him that we appoint him Admiral of the Ocean."

Pulgar's letter ends with an appropriately apocryphal comment: "If Cristobal Colón discovers a new world, as I hope he will, it will have been the result of a pawn pushed at the right moment."²²

On April 30, 1492, Ferdinand and Isabella ordered that ships be fitted for Columbus's journey, and on August 3, 1492, he set sail with ninety men in three by-now-famous vessels: the *Niña*, the *Pinta*, and the *Santa María*. Years after that famous first voyage, which discovered what we today call the West Indies, Columbus credited Isabella with his success: "My confidence in God and her Highness, Isabel, enabled me to persevere. . . . I undertook a new voyage to the new heaven and earth, which land, until then, remained concealed."²³ While Columbus did not reach his original destination in the East Indies, nor discover the fabled gold and spices he had hoped for, his voyages to the islands on the Western side of the Atlantic established him as the greatest explorer of his age. They also enhanced the reputation of his Spanish protectors, especially Isabella, whom Columbus considered as his principal support till the time of her death in 1504.

Isabella, the Militant Saint

When the queen died she was mourned extravagantly throughout Spain. Her husband, Ferdinand, who was to survive her by twelve years and take a second wife, gravely announced: "On this day, Our Lord has taken away Her Serene Highness Queen Isabella, my dear and beloved wife . . . she died as a saint and a Catholic, as she had lived her life."²⁴ The archbishop of Toledo was no less laudatory: "A Queen has disappeared who has no equal on earth."²⁵ A queen without equal and an exemplary Catholic—these epithets represented the heights to which Isabella had so earnestly aspired during her reign. In her mind, the religious and the political had always been inextricably intertwined.

Much earlier in her life, when she had given birth to Prince Juan, she had been implicitly compared to the Virgin Mary: like her divine predecessor, Isabella was hailed as a miraculous woman who would usher in a golden age of faith and stability. If that new age had to be accomplished through the sword, she would take on the attributes of the Virgin of Battles (La Virgen de las Batallas).²⁶ There was no perceived contradiction between the twin pictures of the devout mother and the militant victor. Indeed, earlier in the century, Joan of Arc had established an awesome model of piety and militancy, one that Isabella embraced for a great part of her reign.

First there was the war against the Portuguese, then the war against the Muslims in Granada. Off and on for more than two decades, from 1469 to 1492, Isabella and Ferdinand were engaged in combating their enemies. It was during this period that "new chess" featuring the formidable queen came into being. A militant queen more powerful than her husband had arisen in Castile; why not on the chessboard as well?

This may have been the thinking of those players from Valencia who endowed the chess queen with her extended range of motion. Perhaps they even hoped to win favor from the queen by promoting the chess queen. Yet it is just as likely that those Valencian players *unconsciously* redesigned the queen on the model of the all-powerful Isabella. However this came about, the new chess queen was raised to the stature of the living queen, and henceforth the revised game would be called "queen's chess"—an epithet that honored Queen Isabella as well as her symbolic equivalent on the board.

TWELVE

The Rise of "Queen's Chess"

ueen's chess" spread from Spain to other parts of the continent, where it was not always greeted enthusiastically. During the last years of the fifteenth century and the first decades of the six-

teenth, reactions to the chess queen's new power ranged from positive acceptance to frank hostility. One of the earliest reactions, found in a 1493 Italian version of Jacobus de Cessolis's *Book of Chess*, openly questioned the queen's suitability for armed combat. The translator of this work conceded that the queen had acquired the quali-

ties of both the bishop and the rook, but gratuitously added that she was denied those of the knight "because it is uncharacteristic of women to carry arms, on account of their frailty."¹ Thus women were reminded of their feminine weakness, even as the chess queen's increased strength was admitted to the game.

Outside of Spain, the new modality in chess was called both "queen's chess" and "mad queen's chess"—*scacchi de la donna* or *alla rabiosa* in Italian, *eschés de la dame* or *de la dame enragée* in French. The insulting terms evoked a wild, furious, maddened person driven to violent action, as well as the fear one felt in the presence of such a rabid creature.

One French author of a late fifteenth-century allegory titled The Game of Queen's Chess, Moralized (Le Jeu des Eschés de la Dame, moralisé) found it strange that the revised game should be called "mad queen's chess." He was clearly disconcerted by the "very

THE RISE OF "QUEEN'S CHESS" • 215

great privileges" granted to queens and fools (bishops), whereas rooks and knights, whom he characterized as "wise," "prudent," and "discreet," were deemed to have hardly any remaining value. This writer's conservative mentality regarding chess probably paralleled concerns about power shifts in society that he seems to have taken very personally.

A Latin manuscript from around 1500, probably of Spanish authorship though possibly French, dealt exclusively with the new game. This "Göttingen manuscript" (because it is housed in the Göttingen Library in Germany) paid special attention to strategies for the new long-legged queen and bishop. Although the text used Latin terms for the chessmen, the diagrams accompanying the text used initials based on French names: R for *roy* (king), Da for *dame* (queen), r for *roc* (castle), ch for *chevalier* (knight), a for *aufin* or f for *fou* (fool), and p for *pion* (pawn). With its eclectic nomenclature, the Göttingen manuscript appears to have been a

In both of these chess problems from the Göttingen Manuscript, the newly empowered Chess queen enables white to checkmate black. France (?), circa 1500. conscious attempt to spread new chess beyond Spanish borders for French consumption.

Germany lagged behind the Romance countries in adopting the revised game and did not refer to it as "queen's chess" or "mad queen's chess." From at least 1536 onward, it was called *welsches Schachspiel* (Italian chess), indicating that it had come to Germany via Italy.

By mid-century, the new rules were also implanted in England. A poem titled "To the Lady That Scorned Her Lover" written by Henry Howard, earl of Surrey, was based on a game of chess played according to the new rules. The unique value of the queen (*ferse*) was clearly indicated in the following manner: "And when your ferse is had/All all youre warre is donne." Because the chess queen had become so crucial to victory, the player was now obliged to announce "check" not only to the king in danger, but also to the queen—a practice that remained in England, France, Germany, and Iceland well into the nineteenth century, and that still cropped up in the twentieth century.²

How was it that "queen's chess" moved so quickly throughout Christendom? One of the factors was undoubtedly the invention of the printing press. Books like Lucena's could be printed in large numbers and easily circulated from city to city and country to country. This contrasted with the lengthy and costly process of producing handwritten manuscripts, the only previous medium until the second half of the fifteenth century.

Another factor may have been the expulsion of approximately two hundred thousand Jews from Spain in 1492 and their dispersion throughout Europe, Turkey, and the Near East.³ Spanish Jews had often been at the forefront of novelties in chess, as seen by the Hebrew texts discussed earlier, Lucena's book, and the Valencia circle, which included numerous *conversos* or members of *converso* families. Their nonconverted Jewish friends would have taken the new version of chess with them when they left Spain

by chess teachers today, for if the chess queen rushes forth prematurely, the opposing side can concentrate on attacking the queen while moving its pieces into more strategic positions.

Marcus Hieronymus Vida, the Italian-born bishop of Alba, called the chess queen a bellicose virago and an intrepid Amazon in his Latin poem "The Chess Game" ("*Scacchia, Ludus*"). Published in 1527 and widely translated, it pictured the two chess queens fighting against each other to the death:

For the bold Amazons their arms employ With mutual struggles which shall best annoy; Resolve'd alike on neither side to yield, Till one or other stains the purple field With her life's blood, and pours into the skies Loth to depart her angry soul, and dies.⁵

For the rest of the century, "Amazon" cropped up as an alternative term for "chess queen" in various European languages, indicating the fearful respect she now commanded.⁶

Pietro Carrera, a priest and author from Sicily, who recorded many of the new openings and variations developed by sixteenthcentury Italian masters, recognized the queen as "the most worthy and valiant" of the pieces. He warned her, however, to be cautious in her moves, wary of ambush, and "always calculating if the passage could be closed to her upon returning." Yet, "for the safety of her king, she must expose herself to danger and to death . . . providing she bring death to the enemy king, or that there be certain assurance of absolutely winning the game."⁷

Reading between the lines, one senses a certain ambivalence on Carrera's part; he was clearly disconcerted by this "audacious" figure, fearful she would not be circumspect enough in her moves, and willing for her to take risks only when it was a matter of the king's life or death. Carrera's description smacks of anxieties harunder threat of death. Whatever the pathways, new chess became firmly established in Europe during the first half of the sixteenth century, and the virtuoso chess queen became a permanent fixture on the board.

New Chess in Italy

Italians had reason to be proud of their chess tradition. On the heels of the Spaniards and most probably before the Germans, they had been the first Europeans to play the game. Italian artisans had been responsible for creating many of the first chess figures with faces, such as the "Charlemagne" pieces with the two earliest surviving queens. Jacobus de Cessolis's *Book of Chess* became the most widely known chess treatise in Christendom, and Italian players rivaled those from Spain as the best in Europe. Although Italians did not invent the new rules for "queen's chess," they were among the first to play it outside Spain.

The 1493 Italian translation of Jacobus de Cessolis's work indicates that some Italians were grappling with the new game prior to the 1497 publication of Lucena's book. Before Lucena studied at the University of Salamanca, he had traveled widely in Italy and France and recorded the best matches he saw there. There is good reason to believe that some of these were already using the new rules. Then, during the sixteenth century, a number of works intended to teach "queen's chess" or "mad queen's chess" were published by Italians. While focusing heavily on the queen, they clearly did not know what to make of this new force in the game, at once all-powerful, yet feminine.

Francisco Bernardina Calogno's Latin poem "On the Game of Chess" ("*De ludo scachorum*") provided hints for players, including the following: "Do not bring your Queen out too early."⁴ This admonition has proved useful over the centuries and is still repeated

bored not only toward the chess queen, but toward womanhood in general.

Misogynistic Backlash

Whenever women become overtly powerful, there is almost always a backlash. This was true even for the chess queen. In France and Italy, backlash expressed itself in the label "mad queen's chess." A woman who raced about destroying knights, bishops, and even the king struck terror in the hearts of men, some of whom reacted not only by calling the queen "mad," but also by impugning the whole female sex.

The worst example of Renaissance chess misogyny is found in a work published in 1534 by the French poet Gratien du Pont. The insults to women in his *Controversies of the Masculine and Feminine Sexes* reached a new low even by French misogynistic standards.⁸ Gratien had the diabolical idea of amassing nasty words for women on a chessboard, one in each square. The words in the black squares all end in *esse* and thyme with one another, while the words in the white squares end in *ante* or *ente* and form a parallel rhyme. On the black squares, the insults range from *femme abuseresse* (mislcading woman) to *sans fin menteresse* (infinite liar) to *miroir de paresse* (mirror of laziness), and so forth; while on the black squares, woman is characterized as *méchante* (wicked), *puante* (smelly), *mordante* (biting), and other obscenities. Sixty-four squares of abuse! After centuries that had equated chess with romance, the game was coopted by a man who flagrantly hated women.

It is interesting to compare the sometime vicious sixteenthcentury discourse on the chess queen with that of earlier centuries. Before she had acquired her unparalleled powers, the critique of the chess queen was gentle: she was simply advised to stay close to the king. Conflating the chess queen with living

queens, the authors of those earlier chess treatises would also occasionally remind her to remain chaste and behave in a "feminine" manner—attributes that obviously had nothing to do with her moves on the board. But after she had become all-powerful, she was subject to insult from openly misogynistic men, who—like Gratien du Pont—took the opportunity to spread their vitriol to all women.

THE RISE OF "QUEEN'S CHESS" • 221

While misogyny was a fact of life for most women, it did not inhibit all of them. It did not stop the great Spanish mystic, Saint Teresa of Avila (1515-82), from pursuing her religious vocation, from founding many convents, from instituting church reform, from writing some of the greatest works of Catholic literature, or from playing chess. In one of her works, *The Way of Perfection*, she demonstrated her knowledge of the game, even though chess was frowned upon for Carmelite nuns. She even chose the chess queen as her model for humility—a strange choicc, to be sure, but one based on the queen's unflagging commitment to her lord. Teresa established an analogy between the chess queen's stellar performance in battle and "the holy war" that must be waged by each individual against the forces of evil. Because she used the game of chess as a metaphor for moral progress, Saint Teresa was named the patron of Spanish chess in November 1944.

Catherine de' Medici

Saint Teresa's contemporary, Catherine de' Medici (1519–89), the wife of Henry II of France, was known to have been an excellent player. She had probably learned to play in her native Italy, where the game was avidly pursued by both gentlemen and ladies, such as the Marchese Isabella d'Este of Mantua (1474–1539), who owned "a very handsome set" of chessmen made expressly for her by the Milanese craftsman Cleofas Donati.⁹ After Catherine had come to France, she promoted the game at her court, along with other cultural activities that were fashionable in Italy. She even cherished the ambition of playing against the celebrated Italian champion born in Syracuse, Paolo Boi, "but did not have the opportunity," according to Pietro Carrera.¹⁰

Chess echoed the formal dances Catherine introduced to

France. Both entertainments were ordered movements with complicated figurations requiring a high degree of skill. Figured dancing became the dernier cri in Paris after the dancing master Cesare Negri was brought there from Milan in 1554. At one lavish event given in honor of the Polish ambassadors, sixteen ladies of the court danced a ballet, first masked, then unmasked. One might see in the number sixteen an allusion to the sixteen pieces on each side of the chessboard, and a second allusion to all thirty-two chessmen in the repetition of the dance, but a simpler explanation is at hand. The sixteen ladies represented the sixteen provinces of France.¹¹ In any event, both chess and dance provided a set space that served as a microcosm for contemporary society. Each in its own way offered a spectacle intended to contain and entertain Catherine's courtiers.

After she was widowed and named queen regent in 1560, Catherine became a formidable political force behind her three sons—Francis II, Charles IX, and Henry III. She no longer had to suffer the presence of her deceased husband's mistress and acknowledged favorite, Diane de Poitiers, whom she ousted from the splendid château of Chenonceaux. Like many other European queens, Catherine was able to show her true colors only after her consort was dead.

Another devoted player was Anne of Austria, consort of Duke Albrecht V of Bavaria. She thought so much of the game that she commissioned a portrait of herself and her husband engaged in a chess match, intended to serve as the title page for her *Book of Jewels.* The miniature painting shows a thoughtful couple facing each other, surrounded by dignified onlookers, and two dogs, signifying fidelity. While the humans exude an air of composure, the twisted chess pieces lying on their sides next to the board speak for the casualties of combat. THE RISE OF "QUEEN'S CHESS" • 223

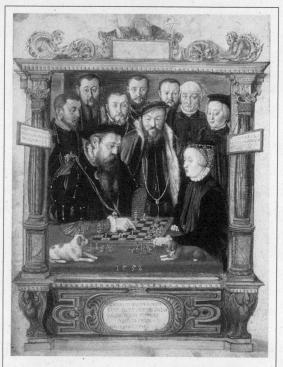

Duke Albrecht V of Bavaria and his consort Anne of Austria playing chess. Title page painted by Hans Muelich for the *Book of Jewels of the Duchess Anne of Bavaria*, 1552.

New Chess in England

During the second half of the sixteenth century, new chess was no less popular in England than on the continent. It was taken up by royalty and commoners, women as well as men, and remained a positive symbol of conjugal interaction. In Shakespeare's *Tempest*, the youthful lovers Miranda and Ferdinand are found playing chess soon after their wondrous wedding.

A fanciful English poem called "The Chesse Play" (1593) by Nicholas Breton described the chess pieces in the following manner. The king is depicted as totally dependent on the other chessmen: "And when he seeth how they fare,/He steps among them now and then." The poor pawns "seldome serve, except by hap" (chance). The strong knight "never makes his walk outright/But leaps and skips, in wilie wise" (in a crafty manner). The bishop has a "wittle brain": "Such straglers when he findes astraie,/He takes them up, and throws awaie." The rooks "keepe the corner houses still,/And warily stand to watch their tides" (to look out for their opportunities). Only the queen has the advantage of such great force that she regularly defeats her enemies.

The Queene is queint, and quick conceit [cunning, with a quick grasp],

Which makes hir walke which way she list [chooses],

And rootes them up, that lie in waite

To work hir treason, ere she wist [as she pleases];

Hir force is such, against her foes;

That whom she meetes, she overthrows.¹²

A living queen, famous for having defeated her most powerful adversary in the battle of the Spanish Armada, and also known to enjoy a spirited game of chess, was then sitting on the throne of England.

Elizabeth I of England

Elizabeth I (1533–1603) played both chess and draughts with her Latin tutor, Roger Ascham, at the beginning of her reign, and with others throughout her lifetime. At least two anecdotes have come down to us concerning Elizabeth and chess. One concerns Elizabeth's arrangement for the marriage of the English lord Henry Steward Darnley to Mary, queen of Scotland. Christopher Hibbert, in his biography *The Virgin Queen*, recounts:

The French Ambassador Paul de Foix, arriving at Court for an audience was shown into her presence as she was playing chess... "This game," he observed, "is an image of the works and deeds of men. If we lose a pawn it seems a small matter, but the loss often brings with it that of the whole game." "I understand you," the Queen replied. "Darnley is only a pawn but he may checkmate me if he is promoted."¹³

Elizabeth feared that Mary of Scotland, in taking Darnley as her husband, might promote him to the rank of consort regnant. In fact, Darnley did become king of Scotland, and his only child with Mary, James VI of Scotland, ultimately became James I of England after Elizabeth's death.

The other anecdote touches upon the career of Sir Charles Blount, afterward Lord Mountjoy. She gave him "a Queen at Chesse of gold richly enameled," after he had distinguished himself at jousting. Subsequently, he wore this little golden chess queen on his arm with a crimson ribbon as a mark of her favor.¹⁴ A similar gift was presented by Elizabeth's great antagonist, Philip II of Spain. He gave the great Spanish chess master Ruy Lopez a necklace of golden chain with a pendant in the form of a rook.¹⁵

What would the little chess queen offered by Queen Elizabeth to Sir Charles Blount have looked like? It may have been a stylized figure with an open crown in contrast to the king's closed crown, following a distinction made in many chess sets. Or it may have been a naturalistic queen sitting squarely on a throne and carrying an orb or scepter in her hand. Or it could even have been a queen mounted on a horse and riding sidesaddle, an equestrian practice brought to England in 1382 by Anne of Bohemia, the wife of

Richard II, that eventually became *de rigueur* for all high-status women.

That this golden queen was an appropriate symbol of her own political power would not have escaped Elizabeth. Indeed, there was no more fitting figure to represent the authority of queenship than the newly empowered chess queen, reborn at the beginning of the Renaissance and infused with the same dynamic spirit that propelled explorers, humanists, scientists, artists, religious revolutionaries, kings, and queens to venture forth into uncharted territories.

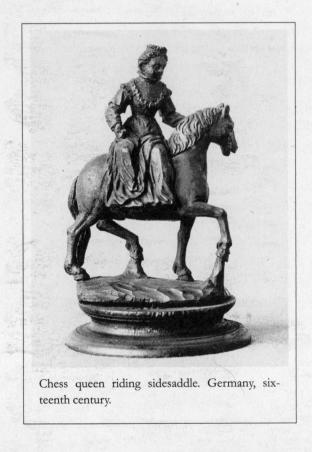

THIRTEEN

The Decline of Women Players

rom the late fifteenth century onward, the simultaneous elevation of queenship and the chess queen should have spelled a renaissance for women players within the great Renaissance. After all,

women had been playing chess since the game was introduced into their Arabian and European homelands. They had been partners with men in making chess a romantic pastime, and, later, in transforming the game into a domestic ritual. With chess ensconced inside conjugal life, with such prominent sovereigns as Isabella and Elizabeth, not

to mention Catherine de' Medici and Anne of Austria, all known for their chess expertise, and with the chess queen at the summit of her tactical strength, it would have made sense for women to continue to play with even greater enthusiasm. Alas, this was not the case.

By the turn of the seventeenth century, it was no longer fashionable for upper-class women to play chess. Narratives and pictures of mixed-gender matches, so numerous in the Middle Ages, became rarer and rarer. The Dutch and Flemish held on longest to domestic chess scenes in their genre paintings, but, in time, even these petered out. Chess became thoroughly masculinized.

One might say that chess had been intrinsically masculine all along. Was it not originally a war game enacting the clash of male opponents? According to this way of thinking, the queen and the bishop were anomalies: their efforts to socialize the warrior class were destined to fail, given the fundamentally military nature of the game. As late as 1694, the Englishman Thomas Hyde, author of the first systematic study of chess, regretted the presence of the queen and the bishop: "They [Europeans] overlook that the game is an image of battle, for which reason the terms Queen and Bishop are inappropriate and ought to be replaced by Supreme General and Elephant-as is the practice among eastern nations who were the founders and inventors of the game." He bemoaned the "absurdity of letting a common soldier [the pawn] become a queen in the course of the game-as though a woman could be made out of a man." Hyde's solution was to "remove the Queen and Bishop from the game at once." 1 Although his criticism had no effect whatsoever on the Western game, post-Renaissance women backed away from "queen's chess." Why?

Ironically enough, it may be that the elevation of the chess queen and the bishop to new levels of strength had something to do with the dwindling number of female participants. Once those two pieces acquired a greater range of mobility, it took fewer

THE DECLINE OF WOMEN PLAYERS • 229

moves, on average, to complete a match. New chess was no longer suited to leisurely encounters between ladies and gentlemen that could last a day or more, with interruptions for eating, drinking, dancing, and singing, or, in more plebian settings, for stirring the pot and nursing the baby. New chess was fast and fierce. A match could be over in a few hours or even a few moves if you didn't pay strict attention. Hands had to be ready to grasp a piece on the board, and not a knee under the table. Chess would no longer tolerate dalliance of any sort.

As chess became less social and more competitive, the professional chess player arrived on the scene. Forget the troubadour chess partner or the attentive lover or even the town Wunderkind who was allowed to take time off after the harvest to play with the local lord. Now there were full-time champions earning their living from arranged matches in princely settings throughout Europe. During the sixteenth century, the Spaniard Ruy Lopez, author of a famous treatise on chess, and the Italian Paulo Boi became international celebrities honored for beating the best players of their day. It would have been unseemly for women to compete publicly in this way. This is just one more instance of the disparity between men, entitled to public activity, and women, consigned to the private sphere, that became increasingly pronounced during the period we call the Renaissance.

The late historian Joan Kelly-Gadol asked some twenty-five years ago whether women had a Renaissance.² It was a revolutionary question. Of course, women had a Renaissance—didn't everyone who lived in those glorious years extending from Isabella to Elizabeth? In time, however, serious students of history came to understand that "everyone" did not necessarily include women. The Renaissance (like Greek democracy or the fledgling American states) was a construct that applied mainly to privileged men. As sixteenth-century humanism inspired by the patriarchal writings of ancient Greece and Rome gradually replaced medieval

courtly culture, and as feudal society gave way to the emerging nation-state, noblewomen were increasingly removed from public activities and limited to the private realm. Here they were expected to manage the household, care for their offspring, and conform to new standards of femininity.

These were articulated in Baldassare Castiglione's highly influential *Book of the Courtier (Libro del Cortegiano*, 1518), in which he called upon ladies to give up certain unladylike activities, such as riding horses and handling weapons. If an upper-class woman continued to ride, she was expected to ride sidesaddle, as in those newly fashionable chess queens portrayed daintily perched atop a horse with their two legs dangling on one side. Playing chess itself seems to have been another casualty in the war against "unfeminine" behavior.

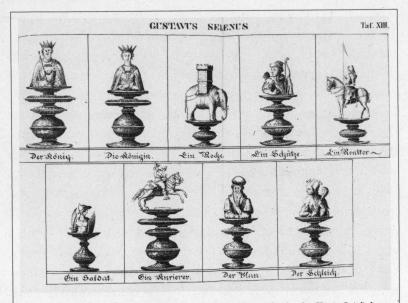

Chessmen from *Chess or the Game of Kings (Das Schach oder König Spiel)* by Gustavus Selenus (Duke of Brunswick), Leipzig, 1616.

THE DECLINE OF WOMEN PLAYERS • 231

During the next few centuries, chess moved from royal courts and private homes into more public domains. First there were the coffee houses that sprang up in eighteenth-century London and Paris, cities that largely supplanted Spain and Italy as the foremost European chess centers. Then, in the early nineteenth century, there were the chess clubs that developed in urban settings throughout Europe and the United States. While a rare woman might set her foot inside a coffee house, chess clubs were for men only. Women did not begin to have their own chess clubs until the turn of the twentieth century.³

Until very recently, the odd woman who played chess risked being called a bluestocking—a derogative label applied to intellectual women with interests beyond the notorious German three K's of *Kinder, Kirche, und Küche* (children, church, and kitchen). A small number of female chess players captured in late nineteenthcentury photos (for example, Gustave Eiffel playing with his daughter, or Lewis Carroll's photo of his chess-playing aunts) found their way into graphic representation precisely because they were exceptions.

One rare Victorian woman, Amalie Paulsen (1831–69), defied the conventions and became a competitive chess player in the United States. Born in Germany, she moved with her husband to New York and attended the first American Chess Congress in 1857. Although she could not officially participate in the tournament, she did play two off-the-record games with male participants, losing one and winning one.⁴

At the turn of the twentieth century, chess clubs for women started to appear in the United States and Europe, for example, the New York Women's Chess Club in 1894. The first Ladies' International Chess Congress was held in London in 1897. In 1898, the Dutch widow Muller-Thijm wrote a newspaper article calling on young ladies to take up the game. Among her arguments, she cited the benefit of "keeping the mind fresh and clear until very

old age." She also fell back on the old notion that chess presented marriage opportunities for a woman in search of a man. The vicar, the doctor, the notary public, or merchant would certainly enjoy the company of a chess-playing wife "in the domestic circle after his strenuous work."⁵ Even if this gendered separation of professions sounds like ancient history today, the push for women in chess is by no means outdated.

During the past hundred years, women have made considerable progress in chess, as they have in most other endeavors. Girls and women now play chess not only in their homes, but also in schools, in chess clubs, and even in public competitions.

The International Chess Federation held its first Women's World Chess Championship in 1927. It was won by the Czech Vera Menchik, who held the title until her death in 1944. After World War II, the Russian Ludmila Rudenko was women's champion from 1950 to 1953, inaugurating a long period of Soviet supremacy in women's chess. In the 1960s, the Georgian Nona Gaprindashvili held the title of women's champion, followed in 1978 by Maya Chiburdanidze, also from Georgia. In 1991, the Chinese Xie Jun won a surprising victory and was champion until she was defeated by the Hungarian Zsuzsa Polgar in 1996. The present women's chess champion is Zhu Chen from China.

The history of the three Polgar sisters, trained from an early age to play chess, raises fascinating questions about women's mastery of the game. Two of the three sisters—Zsuzsa, Zsofia, and Judit—became international grandmasters, whereas Zsofia, the middle sister, is "only" an international master. A book written by their father, Laszlo Polgar, outlined his teaching method and expressed the conviction that every healthy child, boy or girl, can be educated to reach genius levels in a chosen field.⁶ Certainly this was the case for his daughters. But for all his optimism and the Polgar sisters' success, chess is still very much a man's game. As of the year 2000, it has been estimated that only five percent of players worldwide are women. In the United States that number rises to seven percent—still a meager showing. Only Hungary, the Ukraine, and China have practically the same number of male and female chess players.⁷ Women players have a very long way to go if they are ever to attain the common proficiency they enjoyed in the Middle Ages.

Vexing Questions

Will chess ever regain the popularity among women that it once had? My guess is that it will creep into the female domain along with other traditionally masculine endeavors like mathematics, the sciences, aviation, space travel, computers, video games, and the military. Only when women are expected to perform the same functions as men will chess be likely to recapture the female psyche. It is not surprising that chess for women surfaced in the former Soviet Union and more recently in China—countries whose social and political revolutions sought to efface the distinction between "women's" and "men's" work.

Will the best female players ever be able to beat the best male players? That's the question that continues to haunt chess circles. Most male chess players dismiss women competitors outright. Numerous public statements by grandmasters are openly misogynistic. For example, William Lombardy of the United States: "Women play worse because they are more interested in men than in chess." World champion Bobby Fischer boasted that he "could give any woman in the world a piece and a move," and still beat her. Grandmaster Lajos Portish of Hungary, conceding the great talent of the Polgar sisters, asserted that a woman champion of the world would be "against nature."⁸

Perhaps three words uttered by Xie Jun are the most relevant to this debate. When asked to explain women's inferior status in

chess, she replied: "They get married." Women do leave chess for marriage, and even if they remain single, they rarely devote themselves exclusively to the game, whereas star male players do little else than play, practice, think, and dream chess. In that women are generally raised to care for families, interact with friends, and take on multiple tasks that support individual and collective life, such obsessive commitment to a game is usually unthinkable. There are, of course, exceptions-for example, in sports like tennis and competitive ice skating-where a few super-women do show the same kind of single-minded devotion as men. But on the whole, women who have the option or the desire to pursue competitive games, and who are willing or able to accept the personal sacrifices exacted by such activities, are precious few. In our society, according to Jennifer Shahade, American Women's Chess Champion in 2002, we consider it weird for a boy to be totally obsessed with chess, but for a girl, "it's not just weird, it's unacceptable."9

Psychologists and psychiatrists have tried to understand women's relatively poor performance in chess. Some have ascribed it to innate female lacks, such as minimal visual-spatial ability, limited agressivity, or simply not enough brain power. Freudians spoke of women as missing the patricidal impulse necessary to chess, which boys were believed to experience as part of their Oedipal conflict. While many of these theories are no longer considered credible, a few are worth considering. Males have been shown to have higher levels of visual-spatial ability than females, as well as higher levels of aggression. Boys do demonstrate greater overt competition, as compared to the indirect competition evident among girls. Yet even the best research on biological differences between the sexes that might apply to chess is inconclusive, and studies of the social forces that perpetuate male dominance in chess are in their infancy.¹⁰

Why should it matter for girls and women to be able to play chess, and to play it well? The standard arguments have to do with

THE DECLINE OF WOMEN PLAYERS • 235

the intellectual benefits derived from the game: one learns to concentrate, to think ahead, to recognize the consequences of one's acts. These mental gymnastics, like learning Latin, are then supposed to be applicable to other educational experiences. I would add that chess is something more: it is a playing field for life, where one can develop character, sportsmanship, and even grace. People who meet across a chessboard have an opportunity to interact on a very civilized level. They must put aside differences of religion, ethnicity, nationality, language, and sex, and compete solely on the basis of skill. There are few better places for women to expand their intellectual range and interact assertively with men than in chess circles.

Epilogue

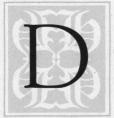

espite their relatively poor performance as players, women can at least take pride in the superiority of the chess queen. No other piece has challenged her primacy since she rose to power

with Queen Isabella five hundred years ago, and no one today foresees a change in the game that would put an end to her preeminence. She continues to dominate the board as a reminder that even a king can't get along without a queen, that even he needs a partner at his side, and a powerful one at that. Perhaps there's more, perhaps the chess queen appeared in the first place because of an unconscious need for a feminine presence on the board: an all-masculine version of society ultimately proved incomplete and unsatisfying.

As for the multiple movements the chess queen acquired in the late fifteenth century, like the miracles attributed to the Virgin Mary, they, too, arose out of a healthy respect for female power. The chess queen came to incarnate unspoken yearnings that are commonly associated with Woman: the desire for her protection and the fear of her retribution or betrayal. Above all, the chess queen is dangerous, awe-inspiring, unpredictable. She often makes the difference between life and death. Each time she moves, her opponent shudders: "Beware, here comes the queen!"

It is true that she has not yet become universal, for the vizier remains steadfast in the Muslim world, as has the elephant, even though they eventually acquired the expanded mobility granted the queen and bishop in new chess. Both the vizier and the elephant, like all the other pieces in sets destined for Muslim players, continue to be represented abstractly. Of Islamic countries, only Turkey regularly produces representative chess sets as well as abstract ones. The Turkish vizier is usually bearded and wears a fez, while the shah, also bearded, is capped by an impressive turban. Yet even in the Middle East, a woman on the chessboard is no longer unthinkable. There has already been a female president of Pakistan, as well as a female prime minister in neighboring India, so why not a chess queen?

The Chess Queen in the Western Imagination

By now, the Western imagination has thoroughly assimilated the chess queen as the ultimate symbol of female power. No one today would cloak her in docility and chastity, as did Jacobus de Cessolis and his medieval confrères. Those men judged the chess queen according to their norms; we fantasize her according to our own.

One of the best-loved classics featuring a chess queen is Lewis

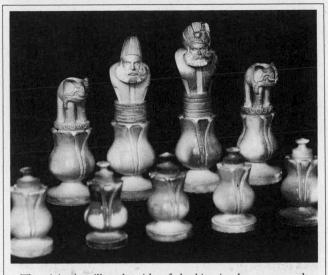

The vizier is still at the side of the king in chess sets made for Muslim players. The original Indian elephants (replaced in Europe by bishops, fools in France, and standard-bearers in Italy) also persist in many Near Eastern and Asian countries. Turkey, twentieth century.

Carroll's *Through the Looking Glass*, the sequel to *Alice's Adventures in Wonderland*. While the first book brought playing cards to life, the second did the same with chess pieces. Once Alice goes through the mirror above the fireplace, she comes upon living chess pieces, most notably the Red and White Queens, Kings, and Knights. The imperious Red Queen criticizes Alice's manners, as if she were her governess, and tells her how to behave, following criteria that make no sense in a rational world, except metaphorically. For example, the queen says one has to run in order to stay in the same place.

As Alice looks over the land in front of her, checkered like a large chessboard, she perceives the analogy between the game of chess and the game of life. She, too, would like to be one of the

living pieces and play on the board: "I wouldn't mind being a Pawn, if only I might join—though of course I should like to be a Queen, best." The Red Queen responds: "That's easily managed. You can be the White Queen's Pawn.... you're in the Second Square to begin with: when you get to the Eighth Square you'll be the Queen." Then the Red Queen and Alice take off at a run with the Queen continually crying, "Faster! Faster!"¹

For all the irrationality expressed by the inhabitants of Looking Glass Country, Alice follows the laws of the game, moving like a pawn across the board, encountering and eliminating various pieces, and reaching the eighth square where she is queened. Ultimately, she checkmates the Red King. In the end, reunited with the Red and White Queens, she tries out her newly acquired authority on them and ends up violently shaking the Red Queen,

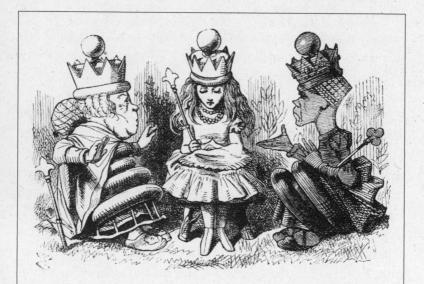

Alice "queened," seated between the White Queen and the Red Queen. Illustration by John Tenniel from Lewis Carroll, *Through the Looking Glass*, New York, 1885. who is reduced to the size and form of Alice's kitten. Only after Alice has become a queen in her own right can she challenge the grotesque Red Queen and turn her into a harmless creature.

Today, with only a few figurehead sovereigns sprinkled throughout Europe, the chess queen evokes a distant era when respect, admiration, and fear were lavished on numerous living queens. Yet the chess queen is still a fitting image for women's place in the world, and not just for royalty. She has entered the academy of gendered icons, alongside the Earth Mother, the Amazon, and the Virgin Mary.

Any woman wishing to follow the chess queen's lead, especially in the public realm, needs to be tactically superior to the men around her, relentless in battle, even cruel when necessary. Whether or not she is called upon to protect her husband (think Hillary Rodham Clinton), she will have to learn to negotiate a treacherous terrain, not unlike the chessboard, if she wants to move forward, both at home and in the workplace. She, and those committed to her well-being, could do worse than take up the chess queen as their personal emblem and silently utter those ritual words: Long live the queen!

Notes

ONE • CHESS BEFORE THE CHESS QUEEN

- 1. H. J. R. Murray, *A History of Chess* (Northampton, Mass.: Benjamin Press, 1986) [1913], p. 149. Murray's 900-page book constitutes the Bible of chess historians. With his knowledge of numerous languages including Latin and Arabic, and his devotion to chess worldwide, H. J. R. Murray was one of those late Victorian giants whose intimidating figure seems to have inhibited further research for the next two generations. But Murray had his own daunting father figure behind him—Sir James Murray, the editor and founder of the Oxford English Dictionary, who recently emerged as a hero in the nonfiction best-seller *The Professor and the Madman*.
- 2. The Shāhnāma of Firdausi, trans. Arthur George Warner and Edmond Warner (London: Kegan Paul, Trench, Trübner & Co., 1915), pp. 386, 393.
- 3. Hans and Siegfried Wichmann, *Chess: The Story of Chesspieces from Antiquity to Modern Times* (New York: Crown Publishers, 1964), p. 12.
- 4. The Koran, trans. N. J. Dawood (London: Penguin Books, 1999), p. 89.
- 5. Victor Keats, Chess in Jewish History and Hebrew Literature (Jerusalem: Magnes Press, 1995), p. 75.
- 6. Al-Mahdi in 780 forbade chess to the inhabitants of Medina, and al-Hākim did the same in 1005 in Egypt, though the former kept a chess master at his court and the latter did not destroy his own sets. Alex Hammond, *The Book of Chessmen* (London: Arthur Barker, 1950), p. 32.

244 • NOTES

- 7. Murray, A History, p. 196.
- 8. Ibid., p. 164.
- 9. This and the following two paragraphs are based on Remke Kruk, "A Lead of Queen, Knight, and Rook," *Dame aan Zet/Queen's Move* (The Hague: Koninklijke Bibliotheek, 2002).
- Remke Kruk, "Warrior Women in Arabic Popular Romance," Part One, Journal of Arabic Literature 24, (1993), pp. 214–230; 25 (1994), pp. 16–33. Part Two—July, pp. 214–16.
- 11. Ricardo Calvo, *Lucena, La Evasión en Ajedrez del Converso Calisto* (Barcelona: Perea Ediciones, 1997), p. 72.
- 12. Roger Collins, "Queens-Dowager and Queens-Regent in Tenth-Century León and Navarre," in *Medieval Queenship*, ed. John Carmi Parsons (New York: St. Martin's Press, 1993), pp. 79–92. This section also draws heavily from Vicenta Márquez de la Plata and Luis Valero de Bernabé, *Reinas Medievales Españolas* (Madrid: Alderaban Ediciones, 2000), pp. 45–61; Gabriel Jackson, *The Making of Medieval Spain* (New York: Harcourt Brace Jovanovich, 1972), pp. 38–40; and Manuel Marquez-Stirling, *Fernán González, First Count of Castile: The Man and the Legend* (University, Mississippi: Romance Monographs, 1980).

TWO • ENTER THE QUEEN!

- 1. Helena M. Gamer, "The Earliest Evidence of Chess in Western Literature: The Einsiedeln Verses," *Speculum* 29 (October 1954): 734-50. This is the most authoritative study of the Einsiedeln Poem.
- 2. Summary of the Einsiedeln Poem from Murray, A History, p. 498.
- 3. Gamer, "Earliest Evidence," p. 747.
- 4. Ernest F. Henderson, *A History of Germany in the Middle Ages* (London and New York: George Bell & Sons, 1894), p. 135.
- 5. Heinrich Fichtenau, *Living in the Tenth Century*, trans. Patrick J. Geary (Chicago and London: University of Chicago Press, 1991), p. 62.
- 6. Pauline Stafford, Queens, Concubines, and Dowagers: The King's Wife in the Early Middle Ages (Athens: University of Georgia Press, 1983), p. 111.
- 7. Janet L. Nelson, "Medieval Queenship," in *Women in Medieval Western European Culture*, ed. Linda E. Mitchell (New York and London: Garland Publishing, 1999), p. 190.
- 8. H. Westermann Angerhausen, "Did Theophano leave her mark on the sumptuary arts?" in *The Empress Theophano: Byzantium and the West at the turn of the first millennium*, ed. Adelbert Davids (Cambridge, England: Cambridge University Press, 1995), p. 252; and Katharina Wilson, *Hrotsvit of*

Gandersheim: A Florilegium of her Works (Cambridge, Eng.: D. S. Brewer, 1998), p. 8.

- 9. Fichtenau, Living, p. 174.
- Ottonian Germany. The "Chronicon" of Thietmar of Merseburg, trans. David A. Warner (Manchester and New York: Manchester University Press, 2001), p. 158.
- 11. Patricia Skinner, *Women in Medieval Italian Society 500–1200* (London, New York, etc.: Longman, 2001), p. 107; and K. Ciggaar, "Theophano: an empress reconsidered," in *The Empress Theophano*, ed. Davids, p. 49.
- 12. Percy Ernst Schramm and Florentine Mütherich, *Denkmale der deutschen Könige und Kaiser* (Munich: Prestel Verlag, 1962), p. 144, plates 73 and 74.
- 13. This information was provided by Father P. Odo Lang, OSB, Librarian of the Einsiedeln Monastery Library.
- 14. Margaret Wade Labarge, A Small Sound of the Trumpet: Women in Medieval Life (Boston: Beacon Press, 1986), p. 14.
- 15. Adolf Hofmeister, "Studien zu Theophano," *Festschrift Edmund E. Stengel* (Munich and Cologne: Böhlau-Verlag, 1952), p. 225.
- 16. Charles K. Wilkinson and Jessie McNab Dennis, *Chess: East and West, Past and Present* (New York: Metropolitan Museum of Art, 1968), p. xx.
- 17. Clifford R. Backman, *The Worlds of Medieval Europe* (Oxford and New York: Oxford University Press, 2003), p. 183.
- 18. Stafford, Queens, p. 141.
- 19. Fichtenau, Living, pp. 31-33.
- 20. Gamer, "Earliest Evidence," p. 747.
- 21. Ruodlieb, trans. C. W. Grocock (Warminster, Wiltshire, Eng.: Aris & Phillips, 1985), p. 61.
- 22. Murray, A History, pp. 408-09.

THREE • THE CHESS QUEEN SHOWS HER FACE

- Michel Pastoureau, L'Echiquier de Charlemagne: un jeu pour ne pas jouer (Paris: Adam Biro, 1990), p. 22.
- Françoise Gasparri, "Introduction," Le XIIe siècle, Cahiers du Léopard d'or, no. 5, p. 14.
- 3. Skinner, *Women*, p. 136. I have relied heavily on Skinner for information about Italian women rulers.
- Das Reich der Sallier 1024–1125, Katalog... des Landes Rhein-Pfalz (Sigmaringen: Jan Thorbecke Verlag, 1992), p. 72.

246 · NOTES

- 5. Mary Taylor Simeti, *Travels with a Medieval Queen* (New York: Farrar, Straus & Giroux, 2001), p. 23. See also pp. 170 and 210.
- 6. Marilyn Yalom, A History of the Wife (New York: HarperCollins, 2001), p. 72.

7. Simeti, Travels, p. 272.

FOUR • CHESS AND QUEENSHIP IN CHRISTIAN SPAIN

1. Murray, A History, p. 406.

2. Ricardo Calvo, Lucena, La Evasión en Ajedrez del Converso Calisto, pp. 87-88.

- 3. Patricia Humphrey, "Ermessenda of Barcelona: The Status of Her Authority," in *Queens, Regents and Potentates*, ed. Theresa M. Vann (Cambridge, Eng.: Academia, 1993), p. 19. See also Donald J. Kagay, "Countess Almodis of Barcelona," pp. 37–47, in the same volume for the story of Ermessenda's equally remarkable granddaughter-by-marriage.
- 4. Bernard F. Reilly, *The Kingdom of Leon-Castilla under Queen Urraca, 1109–1126* (Princeton, N.J.: Princeton University Press, 1982.) This is the essential book on Queen Urraca and I have borrowed heavily from it.
- 5. Keats, Chess in Jewish History, p. 59.
- 6. Eberhard Hermes, ed., *The "Disciplina Clericalis" of Petrus Alfonsi*, trans. P. R. Quarrie (Berkeley and Los Angeles: University of California Press, 1977), p. 115, and Murray, *A History*, p. 408.
- 7. Keats, *Chess in Jewish History*, pp. 67–72. Professor Robert Alter of the University of California at Berkeley also provided help with this poem.
- 8. Keats, Chess in Jewish History, p. 73.
- 9. Ibid., pp. 77-78.
- I am grateful to Kelly Holbert, Assistant Curator in Medieval Art at the Walters Museum of Art, for communicating to me this and other information.
- 11. Murray believed that chess was played more by Jewish women than by Jewish men during the Middle Ages for the very reason that it was an indoors game. *A History*, p. 447.
- 12. Juegos diversos de Axedrez, dados, y tablas con sus explicaçiones ordenado por mandado del Rey don Alfonso el sabio. Edición facsímil del Códice t. I. 6. de la Biblioteca de El Escorial. (Valencia: Ediciónes Poniente y Vincent García Editores, 1987.) In the absence of an English translation of the Alfonsine manuscript, I have also relied in part on the bilingual Spanish-German edition offered by Arnald Steiger, Das Schachzabelbuch König Alfons des Weisen, Romanica Helvetica, vol. 10 (Geneva: Droz, 1941).

- 13. "A Discovery—Prince Edward of England (later Edward I) and his Fiancée Eleanor of Leon and Castile," *Chess Collector* 6, no. 2 (April 1997): cover.
- 14. Nelson, "Medieval Queenship," *Women in Medieval Western Culture*, ed. Mitchell, p. 192.
- 15. Ibid., p. 193.
- 16. Ibid., p. 195.

FIVE • CHESS MORALITIES IN ITALY AND GERMANY

- 1. Citations from *The Book of the Customs of Men* are taken from Jacques de Cessoles, *Le livre du jeu d'échecs*, trans. Jean-Michel Mehl (Paris: Découvertes Gallimard, 1995), pp. 49–83, 210–17 (my translation into English), and those found in Wichmann, *Chess*, pp. 31–36.
- 2. Jenny Adams, "Gender, Play, and Power: The Literary Uses and Cultural Meanings of Medieval Chess in the Thirteenth and Fourteenth Centuries" (doctoral dissertation, University of Chicago, August 2000), p. 6.
- 3. James Magee, *Good Companion, Bonus Socius* (Florence, 1910). Copy of the *Bonus Socius* manuscript in the National Library of Florence (Cleveland, 1893).
- 4. Cited in The "Disciplina Clericalis" of Petrus Alfonsi, ed. Hermes, p. 15.
- 5. The three German citations are from H. F. Massmann, Geschichte des mittelalterlichen Deutschen Schachspieles (Quedlinburg and Leipzig: G. Basse, 1839), p. 12. "Gast unde schâde kumt selten âne haz,/Nu buezet mir des gastes, das iu/Got des schâches bücze" (Walther). "Nun ist ein ander spil,/Des herren pflegen, von dem doch vil/Sunden und scaden komet gerne;/Schâchzabel ich in daz Spil nennen" (Hugo). "Schachzabel solt ir fliehen!" (Anon).
- 6. Summary adapted from Murray, A History, pp. 503–04, and Carmina Burana: Lateinische und deutsche Lieder (Breslau, 1883), pp. 246–48. See also the facsimile edition of Carmina Burana (Munich: Prestel, 1970), ed. Bernhard Bischoff, 2 vol.
- 7. Massmann, Geschichte, p. 164.
- 8. National Geographic (May 1931): 637-52.

SIX • CHESS GOES TO FRANCE AND ENGLAND

- Jean-Michel Mehl, Les jeux au royaume de France du xiiie au début du xvie siècle (Paris: Fayard, 1990), p. 117.
- 2. The Song of Roland, line 112.
- 3. The examples of *Galien le Restorés, Prise la Duchesse, Chanson des Quutre fils Aymond,* where bloodshed ensues from a game of chess, are analyzed by Pierre

Jonin in "La Partie d'Echecs dans l'Epopée Médiévale" in Mélanges de langue et de Litérature du Moyen Age et de la Renaissance, offerts à Jean Frappier (Geneva: Droz, 1970), vol. I, pp. 483–97.

- 4. Jean Markale, La Femme Celte: Mythe et Sociologie (Paris: Payot, 1972), pp. 280-83.
- 5. Chrétien de Troyes, *Perceval: The Story of the Grail,* trans. by Burton Raffel (New Haven, Conn.: Yale University Press, 1999), pp. 186–90.
- 6. Alison Weir, Eleanor of Aquitaine: by the wrath of god, Queen of England (London: Jonathan Cape, 1999), pp. 20–30. Other sources for the life of Eleanor of Aquitaine include D. D. R. Owen, Eleanor of Aquitaine: Queen and Legend (Oxford: Blackwell, 1993); Jean Markale, Aliénor d'Aquitaine (Payot: Paris, 1979); Edmond-René Labande, "Pour une image véridique d'Aliénor d'Aquitaine," in Histoire de l'Europe occidentale XIe-XIVe s. (London: Variorum Reprints, 1973), pp. 175–234; and Amy Kelly, Eleanor of Aquitaine and the Four Kings (Cambridge, Mass.: Harvard University Press, 1952).
- 7. The Pilgrimage of Charlemagne and Aucassin and Nicolette, ed. Glyn S. Burgess and Anne Elizabeth Cobby (New York and London: Garland Publishing, 1988), p. 4.
- 8. Anna Comnena, *The Alexiad of Anna Comnena*, trans. E. R. A. Sewter (Baltimore: Penguin Books, 1969), p. 383.
- 9. Joseph and Frances Gies, *Life in a Medieval Castle* (New York: Harper and Row Perennial, 1979), pp. 120–21.
- 10. Murray, A History, pp. 499, 464.
- 11. Chrétien de Troyes, *Erec and Enide*, trans. Ruth Harwood Cline (Athens: University of Georgia Press, 2000), p. 11.
- 12. The two passages were brought to my attention by Karen Pratt, "The Image of the Queen in Old French Literature," *Queens and Queenship in Medieval Europe*, ed. Anne J. Duggan (Woodbridge, Eng.: Boydell Press, 1997), p. 259.
- 13. Marie de France, The Honey Suckle and the Hazel Tree: Medieval Stories of Men and Women, trans. Patricia Terry (Berkeley: University of California Press, 1995), p. 36.
- 14. Marie de France, Honey Suckle, p. 127.
- 15. Helene Beaulieu, Brève étude historique des noms des pièces de jeu d'échecs (Ann Arbor, Mich.: UMI Dissertation Information Service, 1993), pp. 73–76.
- Geoffrey Chaucer, *The Riverside Chaucer*, ed. Larry D. Benson (Boston: Houghton Mifflin, 1987), "The Book of the Duchess," lines 655–56, p. 338.
- 17. Alexander Neckam, *De naturis rerum,* in *Chronicles and Memorials of Great Britain and Ireland during the Middle Ages,* ed. Th. Wright (London: Longman, Green, Longman, Roberts, and Green, 1863), chap. 184, pp. 324–26.

- 18. Murray, A History, pp. 470-71.
- 19. Neckham, De naturis rerum, p. 324.
- 20. Régine Pernoud, La Reine Blanche (Paris: Albin Michel, 1972), p. 15.
- 21. Ibid., p. 120.
- 22. Mehl, Les jeux, p. 122.
- 23. Labarge, Small Sound, p. 53.
- 24. Jean de Joinville, Vie de Saint Louis (Paris: Classiques Garnier, 1995), p. 225.
- 25. Mehl, *Les jeux*, p. 345. Louis's prohibitions were taken up again a century later in 1364 when Charles V ascended the throne. He outlawed games of chance like dice, backgammon, and skittle, though he spared chess because it was considered a noble intellectual exercise. At the local level, French cities and towns periodically banned chess alongside other board games—the city of Amiens as late as 1417.
- 26. Richard Eales, *Chess* (New York and Oxford: Facts on File Publications, 1985), p. 55.
- 27. Hammond, Book of Chessmen, pp. 39-40.
- 28. Keats, Chess in Jewish History, pp. 145-46.
- 29. Hammond, Book of Chessmen, p. 14, footnote.
- 30. John of Wales, *Summa collationum; sive, Communiloquium* (Cologne, 1470), and Murray, *A History*, pp. 530-32.

SEVEN • CHESS AND THE CULT OF THE VIRGIN MARY

- 1. Richard H. Randall, Jr., The Golden Age of Ivory: Gothic Carvings in North American Collections (New York: Hudson Hills Press, 1993), pp. 41-42.
- Oxford, Corpus Christi College MS 293B fols. 15v-16, printed in Oesten Södergård, "Petit poème allégorique sur les échecs," *Studia Neophilologica*, 23 (1950/51), 133-34.
- 3. Wichmann, Chess, p. 38.
- 4. I thank Stanford Professor Brigitte Cazelles for bringing this work to my attention. The relevant passages are presented in Steven M. Taylor, "God's Queen: Chess Imagery in the Poetry of Gautier de Coinci," *Fifteenth Century Studies* 17 (1990): 403–19. English translations from Taylor, with a few minor changes of my own based on Gautier de Coinci, *Les Miracles de Nostre Dame* (Geneva: Droz, 1955), vol. I.
- 5. Mary Stoll, "Maria Regina: Papal Symbol," Queens and Queenship in Medieval Europe, ed. Duggan, pp. 173–203.
- 6. Marina Warner, Alone of All Her Sex: The Myth and the Cult of the Virgin Mary (New York: Vintage Books, 1983), p. 113.

- 7. This paragraph is based on Diana Webb, "Queen and Patron," *Queens and Queenship in Medieval Europe*, ed. Duggan, pp. 205–21.
- 8. For more on Queen Emma, see Pauline Stafford, "Emma: The Powers of the Queen," *Queens and Queenship in Medieval Europe*, ed. Duggan, pp. 3-26.
- 9. Joachim Petzold argues convincingly for the association between the Virgin Mary and the chess queen in "Wie erklären sich die Bezeichnungen Wesir und Dame in Schach?," Vom Wesir zur Dame: Kulturelle Regeln, ihr Zwang und ihre Brüchigkeit. Über Kulturelle Transformationen am Beispiel des Schachspiels, ed. Ernst Strouhal (Vienna: Internationales Forschungszentrum Kulturwissenschaften, 1995), pp. 67–76.

EIGHT • CHESS AND THE CULT OF LOVE

- 1. Jean-Claude Marol, La Fin' Amor. Chants de troubadours XIIe et XIIe siècles (Paris: Seuil, 1998), p. 72.
- 2. Ibid., p. 24, my translation into English.
- 3. Françoise Guichard Tesson and Bruno Roy, "Les échecs et l'amour," in Evrart de Conty, *Le Livre des Eschez Amoureux Moralisés*, ed. Anne Marie Legaré (Paris: Bibliothèque Nationale, 1991), p. 8.
- 4. Marol, La Fin' Amor, pp. 78-79.
- 5. Andreas Capellanus, *The Art of Courtly Love*, trans. John Jay Parry (N.Y.: Columbia University Press, 1960), pp. 185–86.
- 6. The section on troubadour poetry is heavily indebted to Merritt R. Blakeslee, "Lo dous jocx sotils: La partie d'échecs amoureuse dans la poésie des troubadours," *Cahiers de civilization médiévale* 28 (1985): 213-22.
- Romans de Alexandre. The original reads: "D'eschas, de tables, d'esparvers e d'ostors,/Parler ot dames corteisament d'amors." Cited by Murray, A History, p. 432.
- 8. Galeran de Bretagne, trans. by Jean Dufournet (Paris: Honoré Champion, 1996), p. 99.
- Heinrich von Freiberg, *Tristan*. The original reads: "Den künic und die künegin/gar minneclichen vander/sitzen bî ein ander." Cited by Murray, A *History*, p. 739.
- 10. Richard de Fournival, *La Vieille ou les Dernières Amours d'Ovide*, ed. Hippolyte Cocheris (Paris: Auguste Aubry, 1861), p. 80.
- 11. Histoire de Huon de Bordeaux et Auberon, Roi de Féerie (Paris: Stock, 1983), pp. 202–05.
- 12. Jean Holliday, Illuminating the Epic, the Kassel Willehalm Codex and the Landgrave of Hesse in the Early 14th Century (Seattle and London: College Art Association and University of Washington Press, 1996).

- 13. C. Jean Campbell, "Courting, Harlotry and the Art of Gothic Ivory Carving," *gesta 34* (1995), pp. 11–19. See also Wilkinson and Dennis, *Chess: East and West*, figs. 4 and 5, p. xviii.
- 14. Citations from "Le Roman du Comte d'Anjou," in *Récits d'Amour et de Cheva*lerie, XIIe–XVe Siècle (Paris: Robert Lafont, 2000), pp. 763–67.
- 15. Chiara Frugoni, Books, Banks, and Buttons and Other Inventions from the Middle Ages, trans. William McCuaig (N.Y.: Columbia University Press, 2003), p. 76.
- Stanley L. Galpin, "Les Eschez Amoureux: Λ Complete Synopsis, with Unpublished Extracts," *Romanic Review* 11, no. 4 (October–December 1920): 283–307.
- 17. My English translations are based on Evrart de Conty, *Le Livre des Echecs Amoureux, Moralisés*, ed. Anne-Marie Legaré (Paris: Chêne, 1991) and Evrart de Conty, *Le Livre des Echecs Amoureux, Moralisés*, ed. Françoise Guichard-Tesson and Bruno Roy (Montreal: CERES, 1993).
- 18. Adams, "Gender, play, and power," p. 81.
- 19. Henriëtte Reerink, "Catalogue," Dame aan Zeet/Queen's Move, pp. 85-87.
- 20. Pierre Champion, *Charles d'Orléans, Joueurs d'Echecs* (Geneva: Slatkine Reprints, 1975) [1908], p. 15.
- 21. Dany Sandron, "Le Jeu de l'Amour et des Echecs: une scène courtoise dans le vitrail lyonnais du xve siècle," *Revue du Louvre* (1998): 35.

NINE • NORDIC QUEENS, ON AND OFF THE BOARD

- This chapter relies heavily on the research of Vera Føllesdahl, Ph.D., who has drawn from Michael Linton, *Margret den I. Nordens droning* (Stockholm, 1997) and *Norges Historie* (Oslo, 1977).
- 2. Neil Strattord, *The Lewis Chessmen and the Enigma of the Hoard* (London: British Museum Press, 1997), pp. 4–10.
- 3. A walrus-ivory chess queen of the Lewis type was found in the nineteenth century in a Trondheim church, but she has unfortunately been lost. Christopher McLees and Oystein Ekroll, "A Drawing of a Medieval Ivory Chess Piece from the 12th-Century Church of St. Olav, Trondheim, Norway," *Medieval Archeology* 34 (1990): 151-54, fig. 3.
- 4. Gamer, "Earliest Evidence," p. 739.
- 5. Morkinskinna. The Earliest Icelandic Chronicle of the Norwegian Kings (1030–1157), trans. Theodore M. Andersson and Kari Ellen Gade (Ithaca and London: Cornell University Press, 2000), pp. 369–70.
- 6. Snorre Sturlason, *Heimskringla or the Lives of the Norse Kings*, ed. Erling Monsen and trans. with A. H. Smith (New York: Dover Publications, 1990), pp. 397–98.

252 • NOTES

- The King's Mirror (Speculum Regale—Konungs Skuggsja), trans. Laurence Marcellus Larson (New York: Twayne Publishers, Library of Scandinavian Literature, 1917), vol. 15, p. 83.
- 8. *Heidarviga Saga*, trans. W. Bryant Bachman, Jr. and Gudmundur Erlinssson (Lanham, New York, London: University Press of America, 1995), p. 8. See also Jenny Jochens, *Women in Old Norse Society* (Ithaca and London: Cornell University Press, 1995), pp. 107–08, 103–04.
- Sturlason, *Heimskringla*, pp. 149–50. This and the following paragraphs are based on chapter 7, "The History of Olav Trygvason," especially pp. 130–38, 162–65, 185–86, and 204.
- 10. Willard Fiske, *Chess in Iceland and in Icelandic Literature* (Florence: Florentine Typographical Society, 1905), p. 16.
- Rolf Danielsen et al., Norway: A History from the Vikings to Our Own Times, trans. Michael Drake (Oslo: Scandinavian University Press, 1995), pp. 58-63.
- 12. Ronald G. Popperwell, *Norway* (New York and Washington: Praeger Publishers, 1972), pp. 96–97.
- 13. Mary Hill, *The Reign of Margaret of Denmark* (London: T. Fisher Unwin, 1898), p. 66.
- 14. Helge Seidelin Jacobsen, An Outline History of Denmark (Copenhagen: Host & Son), pp. 31-32.
- 15. Inge Skovgaard-Petersen, in collaboration with Nanna Damsholt, "Queenship in Medieval Denmark," in *Medieval Queenship*, ed. Parsons, p. 37.
- Birgit and Peter Sawyer, Medieval Scandinavia: From Conversion to Reformation, circa 800–1500 (Minneapolis and London: University of Minnesota Press, 1993), p. 75.
- 17. Hill, The Reign, p. 133.

TEN • CHESS AND WOMEN IN OLD RUSSIA

- 1. Isaak Maksovich Linder, *Chess in Old Russia*, trans. Martin Rice (Zurich: M. Kühnle, 1979), p. 149.
- 2. Ibid.
- 3. Ibid., pp. 79-80.
- 4. Thomas Hyde, De Ludis orientalibus (Oxford, 1694), Book II, pp. 74-75.
- 5. W. F. Ryan, *The Bathhouse at Midnight: An Historical Survey of Magic and Divination in Russia* (University Park: Pennsylvania State University Press, 1999), p. 321.
- 6. Linder, Chess, p. 87.

- 7. Ibid., p. 123.
- 8. Ryan, Bathhouse at Midnight, pp. 30-31.
- 9. Linder, Chess, p. 113.
- 10. Ibid., p. 151.
- 11. Ibid., p. 152.
- Russia's Women: Accommodation, Resistance, Transformation, eds. Barbara Evans Clements, Barbara Alpern Engel, and Christine D. Worobed (Berkeley: University of California Press, 1991), p. 37.
- 13. Simon Franklin and Jonathan Shepard, *The Emergence of Russia 750–1200* (London and New York: Longman, 1996), p. 292.
- 14. Stanislaw Roman, "Le Statut de la Femme dans l'Europe Orientale (Pologne et Russie) au Moyen Age et aux Temps Modernes," *La Femme. Recueils de la Société Jean Bodin pour l'Histoire Comparative des Institutions, Deuxième Partie* (Brussels: Editions de la Librairie Encyclopédique, 1962), p. 397.
- 15. Eve Rebecca Levin, *The Role and Status of Women in Medieval Novgorod* (Ann Arbor, Mich.: University Microfilms International, 1988), p. 298.
- Susan Janosik McNally, From Public Person to Private Prisoner: The Changing Place of Women in Medieval Russia (Ann Arbor, Mich.: Xerox University Microfilms, 1976), pp. 28–29.
- 17. Roman, "Le Statut," p. 391.
- 18. Levin, The Role, p. 1.
- 19. McNally, From Public Person, p. 67.
- 20. Richard Twiss, Chess (London, 1787-89), p. 27.
- 21. Peter the Great's wife, Catherine I, was Russia's first crowned woman ruler. Her coronation in May 1724, one of the most elaborate in Europe to date, lent her legitimacy as a coruler and prepared the way for her regency after her husband died. Professor David Goldfrank of Georgetown University, personal communication.
- 22. My main source has been John T. Alexander, *Catherine the Great: Life and Legend* (New York and Oxford: Oxford University Press, 1989).
- 23. Colleen Schafroth, *The Art of Chess* (New York: Harry Abrams, 2002), p. 111.

ELEVEN • NEW CHESS AND ISABELLA OF CASTILE

- 1. Calvo, Lucena, p. 103.
- 2. Govert Westerveld, "Historia de la nueva dama poderosa," in *Homo Ludens:* Der spielende Mensch, IV, 1994, English summary, p. 124.

254 • NOTES

- 3. Murray, A History, p. 785.
- For the latest research on the Vincent/Lucena connection, see D. J. Monte, "Vincent Reconstructed," *Chess Collector* 11, no. 1 (Spring, 2002).
- 5. Murray, A History, p. 784.
- 6. Peggy K. Liss, *Isabel the Queen: Life and Times* (New York and Oxford: Oxford University Press, 1992), p. 254, citing Juan de Lucena, "Carta de ... exhortaría a las letras," in *Opúsculos literarios de los siglos XIV a XVI*, ed. Antonio Paz y Melia (Madrid, 1892), pp. 215–16.
- Ricardo Calvo, "Life, Chess and Literature in Lucena," in Vom Wesir zur Dame, ed. Strouhal, pp. 91–116. This also presents a good summary of Calvo's work for English readers.
- 8. Liss, *Isabel*, p. 68. I have relied heavily on Liss's substantial, carefully researched, biography.
- 9. Ibid., p. 74.
- 10. Ibid., p. 98.
- 11. Nancy Rubin, *Isabella of Castile, The First Renaissance Queen* (New York: St. Martin's Press, 1991), p. 129. Rubin's biography provided another valuable resource.
- 12. Ibid., p. 131.
- 13. Ibid., p. 168.
- 14. Calvo, Lucena, p. 109.
- 15. Rubin, Isabella, p. 182.
- 16. Calvo, "Life, Chess, and Literature," p. 96.
- 17. Yvonne Labande-Mailfert, *Charles VIII et son Milieu (1470–1498) La Jeunesse au Pouvoir* (Paris: Librairie C. Klincksieck, 1975), p. 143.

18. Liss, Isabel, p. 192.

- 19. Ibid., p. 194.
- 20. Ibid.
- 21. Rubin, Isabella, p. 300.
- 22. "Une partie d'échecs en 1492," Le Palamède, October 15, 1845, pp. 459–64. An English translation of Le Palamède's French version of the Spanish letters, made by H. R. Agnel of West Point, N.Y., which differs in many ways from the text I found in that magazine, is included in Edward Lasker, *The Adventure of Chess* (Garden City, N.Y.: Doubleday, 1950), pp. 170–76. It is not clear whether Agnel had access to the original Spanish letters "which form part of a manuscript collection preserved in the archives of Cordova, Spain," according to Lasker, p. 170. It is possible that the French version in Le Palamède was poorly translated in the first place or even doctored: the

words "new world" sound suspicious since Columbus was not hired to find a new world but to find a passage to the East Indies.

- 23. Liss, Isabel, p. 291, citing letter to Juana de Torres (1500).
- 24. Rubin, Isabella, p. 416, citing Luis Suárez Fernández, La España de los Reyes Católicos (Madrid: 1889–90), vol. 2, p. 640.
- 25. Liss, Isabel, p. 354.
- 26. Ibid., p. 157.

TWELVE • THE RISE OF "QUEEN'S CHESS"

- Jacobus de Cessolis, Libro de givocho di scauchi (Firenze, 1493), as cited by Reërink, Dame aan Zet/Queen's Move, p. 95.
- 2. Murray, *A History*, p. 779. My American-born husband, whose father learned chess in a Russian/Polish *shtetl*, remembers his father saying "Queen" to him whenever his queen was in danger.
- 3. Govert Westerveld, De Invloed van de Spaanse Koningin Isabel la Catolica op de Nieuwe Sterke Dame in de Oorsprong van het Dam en Moderne Schaakspel (Amsterdam: Beniel-Spanje, 1997), p. xiv. Westerveld's estimate of 250,000 is higher than more conservative figures ranging from 75,000 to 200,000.
- 4. Murray, A History, p. 793.
- 5. Marco Giralomo Vida, The Game of Chess; A Poem, Tr. from the Scacchia, Ludus, with the Latin Original (Eton: Printed by J. Pote, 1769), p. 41.
- 6. Murray, A History, p. 791, ft. 22.
- 7. Pietro Carrera, *Il gioco de gli scacchi* (N Militello: Per G. de' Rossi, 1617) pp. 115–16. My thanks to Lorraine Macchello for translation.
- 8. Gratien du Pont, Les controversses des sexes masculin et femenin (Toulouse: 1534).
- 9. Hammond, Book of Chessmen, p. 47.
- 10. Carrera, Il gioco, p. 94.
- Stanford professor Janice Ross suggested the analogy between chess and dance. Walter Sorell, *Dance in Its Time: The Emergence of an Art Form* (Garden City, N.Y.: Anchor Press/Doubleday, 1981), p. 75.
- 12. Nicholas Breton, "The Chesse Play," 1593, quoted in *Chess Collector* 11, no. 2 (Summer 2002).
- 13. Christopher Hibbert, *The Virgin Queen* (Reading, Mass.: Addison-Wesley, 1991), p. 156.
- 14. Murray, A History, p. 839, n. 6, citing Sir Robert Naunton, Fragmenta Regalia (1614), p. 33.
- 15. Alexander Cockburn, *Idle Passion: Chess and the Dance of Death* (New York: New American Library, 1974), p. 124.

256 · NOTES

THIRTEEN • THE DECLINE OF WOMEN PLAYERS

- 1. Victor Keats, "Thomas Hyde's Etymology of Chess. A Modern Chess-Historian in the Late 17th Century," *Vom Wesir zur Dame*, ed. Strouhal, pp. 167–68.
- Joan Kelly-Gadol, "Did Women Have a Renaissance?" in *Becoming Visible:* Women in European History, ed. Renate Bridenthal and Claudia Koonz (Boston: Houghton Mifflin, 1977), pp. 137–64.
- 3. Schafroth, Art of Chess, pp. 98-106; and Dame aan Zet/Queen's Move, pp. 62-72.
- 4. Dame aan Zet/Queen's Move, p. 103.
- 5. Ibid., p. 66.
- 6. Laszlo Polgar, Nevelj zsenit! (Budapest, 1989).
- 7. Dame aan Zet/Queen's Move, p. 46.
- 8. Quoted by Cathy Forbes in *The Polgar Sisters: Training or Genius?* (London: B. T. Batsford, 1992), p. 22.
- 9. Paul Hoffman, "Chess Queen," Smithsonian, August 2003, p. 76.
- Norman Reider, "The Natural Inferiority of Women Chess Players," in Chess World I (1964), nr. 3, pp. 12–19; David Spanier, Total Chess (London: E. P. Dutton, 1984); Dennis H. Holding, The Psychology of Chess Skill (Hillsdale: Lawrence Erlbaum, 1985); Ingrid Galitis, "Stalemate: Girls and a Mixed Gender Chess Club," Gender and Education 14, no. 1 (2002): 71–83.

EPILOGUE

1. Lewis Carroll, *The Annotated Alice*, introduction by Martin Gardner (New York: Clarkson N. Potter, 1960), p. 208.

Index

Page numbers in *italics* refer to illustrations.

Abbey of Saint-Denis, 33, 34, 102 Abd al-Rahman III, Caliph, 11-14, 44 Abingdon Monastery, 103 Adam, 99, 109, 111-12 Adelaide (daughter of Empress Theophano), 25 Adelaide, Holy Roman Empress, 19-21, 23-26. adultery, 90, 93, 178 cult of love and, 124, 128-31 Aethelred II, king of England, 26, 118, Afghanistan, chess banned in, 8, 104 "Ager chessmen," 45-47, 46 Agnea, queen of Denmark, 166 Agnes (bigamous partner of Philip Augustus), 165 Ahmad b. al-Amin, 9 Albrecht V of Bavaria, Duke, 222 Albrekt of Mecklenburg, 168 Albrekt of Mecklenburg, king of Sweden, 170 Alexander II, Pope, 29 Alexander the Great, 128, 157

Alexiad (Anna Comnena), 89 Alexis Comnenus, Byzantine Emperor, 89, 176 alfferza, alferza (standard-bearer), 62-63, 95 alficus, 77 al-fil, alfil, 6, 70, 195 Alfonsi, Petrus (Moses Cohen; Moses Sefardi), 52 Alfonso (brother of Enrique IV), 199 Alfonso Enriquez, king of Portugal, 51 Alfonso I, king of Aragón and Navarre (The Battler), 49-50, 51, 52 Alfonso V, king of Portugal, 199-200, Alfonso VI, king of Castile and Léon, 47-50 Alfonso VII, king of Castile and León, 48-51 Alfonso X, king of Castile and León (Alfonso the Wise), 57-66, 102 Book of Chess commissioned by, 44, 57-64, 58-63, 68, 71, 196 al-Hākim, 243n Ali ibn Husayn, 10

Alix (daughter of Eleanor of Aquitaine and Louis VII), 90 al-Mahdi, 243n Alvaro de Portugal, 204 Amalfi, chess pieces carved in, 31-34, 32, 33, 38 Amazon, 218 Amazons, legend of, 89 American Chess Congress (1857), 231 Amin, Caliph, 10 Anna, empress of Russia, 183 Anna Comnena, Princess, 89 Anne de Beaujeu, regent of France, 204 Anne of Austria, 222, 223, 228 Anne of Bohemia, queen of England, 225-26 annulments, 49, 90 Antioch, 89, 90 Aquitaine, 86, 87-88, 90, 98 Arabian Nights, The, 9, 10–11, 131 Arabic, chess terms in, 6, 53, 70, 95, 96, 125, 174 Arabs, 6-14, 173, 195 abstract chess pieces of, xvii, 6-7, 7, 63, 173, 175-76, 179, 238 all-male chess pieces of, xvi chessboard of, 17, 62 Europe invaded by, xvi, xvii-xviii, 6, female chess players, 10-11, 131-34 Russian chess influenced by, 173, 175-76, 179 Aragón, 12, 13, 201, 203, 204 Ardashir, 157 Arthur, King, legends and romances about, 85, 92-93, 130-31, 157 Art of Courtly Love, The (Capellanus), 126 Art of War (Vegetuis), 61 Ascham, Roger, 224 Ashmolean, 99 Astrid (sister of King Olav Trygvason), 165 aufin, 70, 97, 105, 109 Austro-Hungarian Empire, 52 baba (old woman), 175, 182

backgammon, 62, 84, 94, 204, 249*n* in Germany, 76, *76 see also* "nard" Baghdad, 8, 11 Baltimore, Md., Walters Art Gallery in, 55-57, 56, 63 Bari, coronation of Constance in, 39 Beatrice, Marchioness of Tuscany, 35 Beatrice of Lorraine, Duchess, 26 Becket, Thomas à, 90-91 Berengar, Margrave, 19 Berengaria, queen of Denmark, 166 Bernard de Ventadour, 124, 125 Bernart d'Auriac, 127 betting, 103, 104, 203 on chess, 27-28 Bible, 72, 95 Hebrew, xvii, 54, 55 Birgittinian convents, 169 bishops: chess playing of, 29 power of, 18 in social hierarchy, 27 bishops, chess, 75, 214, 239 as calvus, 91, 96 in Carmina Burana, 77, 78 contempt for ancestor of, 77, 78, 91, 96-97, 105 evolution of, xvii, 14, 17-18, 26, 70 in Lewis collection, 152, 153, 153 rules for, 53, 77, 105, 195-96, 215, 228-29, 238 in Russia, 174, 175 social order and, xvii, 68, 70 Blanche of Castile, queen of France, 83, 99-106 cult of the Virgin and, 101-2, 106, 111, 115, 118 death of, 102 marriage of, 99-100 pilgrimage of, 101-2 Blount, Sir Charles (afterward Lord Mountjoy), 225 bluestockings, 231 boats, in chess, 175 Bobadilla, Beatriz de, 204 Bodleian Library, 91, 109-10 Boi, Paolo, 221, 229 Boniface II, Marquis of Tuscany, 35 Book of Chess, The (De ludo scachorum) (The Book of the Customs of Men and the Duties of Nobles; Liber de moribus hominum et officiis nobilium) (Cessolis), 68-72, 69, 71, 110, 196

Italian version of, 213-14, 214, 217 popularity and influence of, 71-72, 72, 73,73 Book of Jewels of the Duchess Anne of Bavaria, 222, 223 Book of Kings (Shāh-nāmeh) (Firdausi), 4-5, Book of 100 Chess Problems, The (Libre dels jochs partits en nombre de 100) (Vincent), 195 Book of Oriental Games (De Ludis orientalibus) (Hyde), 175 Book of the Courtier (Libro del Cortegiano) (Castiglione), 230 Book of the Duchess (Chaucer), 96, 192 Book of the Games of Chess, Dice, and Boards, The (Libro de los Juegos de Ajedrez, Dados, y Tablas) (commissioned by Alfonso X), 44, 57-64, 58-63, 68, 71, 196 game description and rules in, 62-64 gender roles and, 57, 59-61 Book of the Miracles of Saint Foy (Liber miraculorum sancte Fidis), 84 Books of Hours, 118 Boretskaia, Marfa, 181 Borrell, Ramón, 45 Bourges, Coeur residence in, 146 Boyar women, 181 breastfeeding, 39, 116 of Madonnas, 108-9 Breton, Nicholas, 224 Britain, 61 see also England; Scotland; Wales British Museum, 152 "Bryggens Madonna," 160-61, 160 Burgundy, 20 byliny (Russian heroic epics), 177-78 Bylov of 1276, 167 Byzantine Empire, 9, 10, 21-22 chess in, 10, 22, 26, 89, 176 Tegernsee's contacts with, 27

caliphs, 6, 8–9, 11 Calogno, Francisco Bernardina, 217–18 Calvo, Ricardo, 44, 61, 197 *calnus*, 91, 96 canon law, 29, 176 Canute, king of Denmark and England, 118, 157

Capellanus, Andreas, 126 cards, 204 Carmina Burana, 76, 77-78, 77, 192 Carrera, Pietro, 218-19, 221 Carroll, Lewis, 231, 238-41, 240 Castellan of Coucy, The (Roman du Castellan de Couci), 91 Castellví, 193 Castiglione, Baldassare, 230 Castile, 12, 13, 47-52, 98-99, 192, 194, 199-211 chess at the court of, 203-6 castles, in chess, 141-43 see also rooks, chess Catalan: chess terms in, 95 poetry in, 193-95 Catalina, Infanta, 205 Catalonia, 12, 44-47, 46 Catherine de' Medici, queen of France, 221-22, 228 Catherine I, empress of Russia, 183, 253n Catherine II (the Great), empress of Russia, 182-87, 185 Catholics, Catholic Church, 116, 202 names for chess queen and, 119-20 in Spain, 198–99, 202, 204–6, 210–11, 221 see also Church; papacy cavalry, Indian, 3 Caxton, William, 72, 73 Celestina, La (Rojas), 197 Celtic tales, Arthurian legend in, 85 Cessolis, Jacobus de, 68-72, 69 see also Book of Chess, The chariots: in chess, xvi, xvii, 3, 53 in Indian army, 3 Charlemagne, 32, 84, 85, 133, 157 "Charlemagne" chessmen, 32-34, 32, 33, 37, 102, 153, 217 Charles d'Orléans, 144 Charles II, king of England, 175 Charles IX, king of France, 222 Charles V, king of France, 249n Charles VI, king of France, 139, 144 Charles VIII, king of France, 204 Charlotte de Savoie, queen of France, 204 Chartiers, Alain, 144, 145

chastity, 69–70, 220, 238 Chatelaine of Vergy, The (La Chastelaine de Vergy), 138-39 chaturanga ("four members"), 3 Chaucer, Geoffrey, 96, 174, 192, 194 checkmate, 5, 77, 93, 173 cult of love and, 125, 127, 136, 142 cult of the Virgin and, 109, 112-15 chess: Alfonso X's description of, 62-64 bans on, 8, 29, 103-4, 176-77, 186, 2431 in Byzantine Empire, 10, 22, 26, 89, 176 under the caliphs, 8-9 Carmina Burana guide to, 77-78, 77 at the Castilian court, 203-6 before the chess queen, 3-14 Church opposition to, 16, 28-30, 33, 45, 60, 67, 103, 186 cult of love and, 123-47, 128-29, 135, 136, 141, 145, 146 cult of the Virgin and, 107-21, 108, 118, 120 Einsiedeln rules for, 16, 17 Elizabeth I and, 224-28 at German regional courts, 27-28 great reform of (late 15th c.), 119, 191-96; see also "lady's (queen's) chess" ibn Ezra's description of, 53-54, 63 in Muslim theology, 6-8, 7 in nobility's education, 94-95 origin of name for, 4 origins of, xvii, 3, 5 outdoor games of, 92-93 as pastime of kings and courtiers, 66 in Persian literature, 4-5, 6 popularizing of, 70-71 sexual equality and, xx, 147 as symbolic model for social order, 67-71, 75, 86, 97 vice linked to, 158 as war game, xvii, 3, 4, 86, 123, 228 wisdom associated with, 85 see also specific chess pieces chessboards: analogy between course of human life and, 104-5, 109 descriptions of, 5, 17, 62 in early French literature, 84, 85 magic, 130

for new mothers, 39 as religious offerings, 84 chess clubs, 231, 232 chess duels, 85, 177 "Chesse Play, The" (Breton), 224 "Chess Game, The" ("Scacchia, Ludus") (Vida), 218 chess manuals: in Germany, 66, 77-78, 77 in Italy, 66, 68-75, 72, 73, 74 in Spain, 44, 57-64, 58-63 chess matches: Mathilda as prize in, 25 mixed gender, xx, 10-11, 58, 60-61, 61, 75, 126-29, 128, 131-47, 135, 136, 145, 146, 162, 166-67, 177-79, 204, 222, 223, 228 violence and, 85, 97, 103, 157, 203-4 Chess or the Game of Kings (Das Schach oder König Spiel) (Selenus), 230 chess players, professional, 221, 229, 231-34 Chiburdanidze, Maya, 232 childbirth, Virgin Mary as protector during, 116 China, 175, 232, 233 Chinon, tower of, 97 Chrétien de Troyes, 85, 86, 92-94 Christians, Christianity, 10-14 analogy between chessboard and course of human life and, 104-5 conversion to, 11, 52, 164, 180, 181, 193, 197, 198-99, 206, 216 monogamy and, xvi, 18, 64, 69 in Spain, 11-14, 43-53, 84, 202, 204-6, 210-11, 221 Christoffer I, king of Denmark, 166 Church, 26-30, 158 chess as symbolic social model for, 67-71 chess opposed by, 16, 28-30, 33, 45, 60, 67, 103, 186 chess pieces left to, 44, 45 Holy Roman Empire vs., 35, 40, 67 laws of consanguinity and, 49, 90 Urraca's relations with, 49, 51 see also Catholics, Catholic Church; papacy; specific popes "Cleric's Tale" (Gautier de Coinci), 114-15 Cligès (Chrétien de Troyes), 93

Clinton, Hillary Rodham, 241 Coeur, Jacques, 146 coffee houses, 231 Cohen, Moses, see Alfonsi, Petrus Cologne chess queen, 154, 155, 158 Columbus, Christopher, xviii, 199, 205-10, 2551 comes or curvus, 17, 91, 96 Conan de Bethune, 125 confraternities, 117 conjunx, 77, 78 Conques, St. Foy's sanctuary at, 84 consanguinity, annulments and, 49, 90 Constance of Hauteville, Holy Roman Empress, 38-40 Constantinople, 21, 88-89 Controversies of the Masculine and Feminine Sexes, The (Les controversses des sexes masculin et femenin) (Gratien du Pont), 219, 220 Conty, Evrart de, 139-43, 141 convents, 20, 117-18, 169, 171, 194 Saint Giles, 44, 45, 84 conversos, 193, 197, 198-99, 206, 216 Copenhagen, National Museum in, 159 Córdoba, 11, 13, 14, 22, 44, 205 Council of Ephesus (431), 116 counts or aged ones, in chess, 17-18, 26, 91 courtesy, xx, 123 courtly love, see love, cult of crowns, hatlike, 154, 155, 159, 159 Crusades, xx, 33-34, 84, 88-90, 98, 102, 103

dama, 194 dame, 96, 119 Damiani, Petrus, 29, 97 Darnley, Henry Steward, 225 Davizzi, Tommaso, 139 Deborah, 54 Deeds of the Romans (Gesta Romanorum), 73-74, 110 degli Alberti, Caterina, 139 De Naturis Rerum (Neckham), 96 Denmark, 157-60, 166, 168-71 chess queen in, 159-60, 159, 160 Devil, 109, 111-12, 114 Diane de Poitiers, 222 Díaz de Bivar, Rodrigo (the Cid), 47 dice, 62, 84, 94, 204

in chess, 28-29 lower-class image of, 66, 126 prohibition of, 103, 176, 177, 249n Diderot, Denis, 184 Die, Comtesse de, 125-26 Disciplina Clericalis (Alfonsi), 52 Discourse on Love and the Art of Chess with 150 Problems, The (Repetición de amores et arte de Axedres con CL Juegos de Partido) (Lucena), xviii, 195-96, 216, 217 domna (beloved woman), celebration of, 86 Donati, Cleofas, 221 Donizo, 36 dowers, 21, 166 dowries, 21, 87, 165, 166, 180, 198 draughts, 194, 224 Dutch paintings, chess scenes in, 22 Eastern Orthodox Church, 176, 186 Edinburgh, museums in, 152 education: chess instruction as part of, 79, 94-95 of nobility, 94-95 Edward (the Confessor), pre-Norman king of England, 118, 118 Edward I, king of England, 61, 61, 102 Egypt, chess ban in, 243n Eiffel, Gustave, 231

Einsiedeln Monastery, 15–18, *16*, 24, 27 Einsiedeln Poem ("Verses on Chess"; "Versus de scachis"), 15–19, *16*, 24,

25, 26, 72, 91, 193 Eleanor, queen of Castile, 98-99 Eleanor of Aquitaine, 83, 86-94, 96-99, 105, 126, 174 annulment of first marriage of, 90 court education of, 87-88 court of, 88, 91-92, 105 cult of love and, 86, 88, 92, 105, 106, 124 death of, 99 imprisonment of, 97-98 pregnancies and childbirths of, 87, 88, 90 on Second Crusade, 88-90 Eleanor of Castile, queen of England, 61,61 elephants: in chess, xvi, xvii, xviii, 3, 6, 17, 53, 70,

175, 195, 228, 238, 239

elephants (cont.) in Indian army, 3 "Eliduc" (Marie de France), 94 Elizabeth, empress of Russia, 183 Elizabeth I, queen of England, 192, 224-28 Elvira, Infanta, 51 Emma, queen of Denmark and England, 118, 118, 157 Emma, queen regent of France, 26 England, 61, 90-99, 157, 164, 166, 174 chess banned in, 103 chess playing by royal prisoners in, 98 chess queen in, 38, 83, 91, 95-96, 99, 179, 216, 225-26 cult of love in, 92, 105, 124 daughter's inheritance of throne in, xvii queen regent in, 26 "queen's chess" in, 216, 223-26 spread of chess in, 87, 91, 105 English, chess terms in, 4, 70, 96 Enrique IV, king of Castile, 194, 199-200, eques, 17, 77, 91 Eracle (Gautier d'Arras), 93 Eric, Earl, 165 Eric and Enide (Chrétien de Troyes), 92-93 Erik, Duke, 167 Erik of Pomerania, king of Denmark, Norway, and Sweden, 170-71 Erik V, king of Denmark, 166 Erik VI, king of Denmark, 166 Ermengaud of Urgel, Count, 44, 45, 84 Ermessenda, Countess, 45-46 Escorial Monastery Library, 57-58 Europe, Arab invasion of, xvi, xvii-xviii, 6, 11 see also specific places Eve, 99, 111-12 Ezzo, Count of Palatine, 25

father-daughter incest, 137–38 filag (joint ownership of property), 167 femina, 77, 78 Fenollar, 193–94 Ferdinand, king of Castile and Aragón, 192, 193, 197, 198, 199–211 attempted murder of, 203–4 chess playing of, 203, 207–9, 209 in civil war, 202 Columbus's voyage and, 206–10 Inquisition and, 205–6

Isabella's separations from, 200, 203 marriage of, 199-200 in reconquest, 205 Fernandus Petri, 51 fers, 95-96, 105, 174 ferz', 174-75 ferzia, 91 feudal structure, xvii, xx, 27, 195 fierce, fierge, 95, 96, 112, 114, 119, 140 Firdausi, 4-5, 6 First Crusade (1095), xx, 33-34, 84 firz, firzan, ferz (royal adviser or counselor), 6, 53, 95, 174 Fischer, Bobby, 233 Flemish paintings, chess scenes in, 228 Floovant (French narrative), 131 Florence, 73, 99, 139 Florence, Bishop of, 29 Fogg Museum, 39 Fonseca (King Ferdinand's chess partner), 207-9,209 fools, in chess, 70, 239 foot soldiers: in chess, xvii, 34, 53, 160 Norman, 32, 34 Four Hundred Songs of Holy Mary (Cántigas de María) (written or collected by Alfonso X), 116 Foy, Saint, 84 France, xx, 83-106, 156, 166, 174, 204, 217 Catherine de' Medici in, 221-22 chess banned in, 103, 104, 249n chess in early history and literature of, 84-86 chess queen in, 32-34, 32, 38, 83, 95-96, 99, 102, 179, 214-15, 219 cult of love in, xx, 86, 88, 92, 105, 124-47, 128-29, 135, 136, 141 cult of the Virgin in, 101-2, 115, 116, 118 fools or jesters in, xvii, 70, 239 queen regent in, 26, 204 "queen's chess" in, 214-16, 215, 219 Franciscans, 104-5 Francis II, king of France, 222 Frederick II, Holy Roman Emperor, 39, 40, 102 French, chess terms in, 4, 70, 95, 96, 112, 119, 215 French National Library, "Charlemagne" chessmen in, 32-34, 32, 33

French Revolution, 34, 102 Freudians, 234 Frugoni, Chiara, 139

Galeron of Brittany (chivalric romance), 128 Galicia, 12, 48-51 Galindez, Lady Beatriz, 207, 208 Game and playe of the chesse (English translation of Cessolis's Book of Chess), 73 Game of Queen's Chess, Moralized, The (Le Jeu des Eschés de la Dame, moralisé), 214-15 games of chance, religious opposition to, 16-17, 28 Gandersheim Abbey, 24-25 Gaprindashvili, Nona, 232 García Sánchez, king of Navarre, 12-13 "Garden of Love with Chess Players" (German engraving), 146 Garin of Montglane, 85 Gautier d'Arras, 93 Gautier de Coinci, 111-15 Gauvain, in Arthurian legend, 85 Gav, s Geira, Queen of Vendland, 163 Gelmirez, Bishop, 50, 51 general, in chess, 3, 6, 175, 179, 185, 228 German, chess terms in, 4 Germany, 18-29, 156, 166, 216 backgammon in, 76, 76 chess in regional courts of, 27-28, 75 chess manual in, 66, 77-78, 77 chess playing peasants in, 76, 78-79 chess queen in, 38, 77-78, 83, 179 cult of love in, 124, 129, 133-34, 146 Jewish conversions in, 52 lack of enthusiasm for chess in, 75-76 Ottonian dynasty in, 18–27 popularity of chess in, 75, 76-79, 76, 77, 83 "queen's chess" in, 216 rook in, 28, 77 Gervi, Ibrahim al-, 203-4 Geschichte des mittelalterlichen Deutschen Schachspieles (Massmann), 72 Gesta Ottonis (Hrotsvitha); 25 gifts: chess sets as, 38, 100, 103, 130 "morning," 166 Glazner, Gary, vii Gloriant (daughter of King Ammiral), 167 God, 111, 112 in chessboard analogy for the world, 109,110 goddesses, pre-Christian, 31 Godfrey IV the Bearded of Lorraine, 35 Godfrey V the Hunchback of Lorraine, González, Count Fernán, 13 González, Count Pedro, 51 Good Companion, The (Bonus Socius), 72-73, 74 Göttingen manuscript, 215-16, 215 Granada, 199, 204-5, 211 Gratien du Pont, 219, 220, 229 Great Instruction, 184 Greeks, ancient, 95 Greenland, 154, 156, 158 Gregory VII, Pope, 35 Groitzsch, Wipecht von, 38 Guillaume (William) (son of Eleanor of Aquitaine and Henry II), 90 Guinevere, Queen, romances about, 92-93 Gui of Nanteuil (epic poem), 94-95, 127-28 Guiscard, Robert, 34 Guiscard, Roger, 34 Gungelin, Count of, 78 Gyde, 163 Haardraad, Harald, 156

Hadith, 176 Hakon IV, king of Norway, 166-67 Hakon V, king of Norway, 167 Hakon VI, king of Norway, 168-69 hand gestures, 36, 36, 37, 37 Harald the Grenlander, king of Norway, 162-63 baram, 8 Harûn al-Rashîd, 8-9, 22 Harvard University, Fogg Museum at, 39 Hasdai ibn Shaprut, 14 Heidarviga Saga, 162 Heinrich II, landgrave of Hesse, 134 Heinrich von Freiburg, 129 Henry I, king of England, 98 Henry II, Holy Roman Emperor, 78 Henry II, king of England, 87, 90, 92-94 death of, 98 sons' revolt against, 97 Henry II, king of France, 221

Henry III, king of France, 222 Henry IV, Holy Roman Emperor, 35 Henry IV, king of England, 171 Henry of Portugal, Count, 50 Henry VI (Henry of Hohenstaufen), Holy Roman Emperor, 38-40 Hermitage, 184 Hibbert, Christopher, 225 hneftafl (Scandinavian board game), 157 Holy Grail, quest for, 85 Holy Land, 84, 88, 102 Holy Roman Empire, 18-27, 29 Church vs., 35, 40, 67 horseback, chess queens on, 159-60, 159, 160, 225-26, 226, 230 horses, 13 in chess, xvi, xvii, 6, 14, 44, 53 Hôtel de la Bessèe, 145-46 Hrotsvitha, 24-25 humanism, 229-30 Hungary, 232, 233 Huon of Bordeaux, 85, 131-33 Hyde, Thomas, 175, 228 hymns, Virgin Mary exalted in, 115-16

ibn Ezra, Abraham, 53-54, 55, 63 ibn Yehia, Bonsenior, 54-55 Iceland, 156, 158, 161-62, 216 Icelandic sagas, 156, 161-62 illegitimate children, 93, 184, 194, 202 Urraca's recognition of, 51 incest, 137-38 India, 3-7, 173, 175, 195, 238 all-male chess pieces in, xvi naturalistic chess pieces in, xvi, xvii origins of chess in, xvii, 3, 5 Ingeborg, queen of Norway, 166 Ingeborg of Denmark, queen of France, 165 Ingeborg of Norway, queen of Norway and Sweden, 167-68 inheritance rights, xvii, 167, 180, 201, 204 Inquisition, Spanish, 198-99, 205-6 International Chess Federation, 232 Iran, chess banned in, 8 Irene, Byzantine Empress, 9, 10, 22, 89 Isabella, Infanta, 200 Isabella, queen of Castile, 64, 192-94, 197-211, 227-28, 237 attempted murder of, 203-4

chess queen and, xviii-xix, 192-94 in civil war, 194, 202, 211 death of, 210-11 discovery of New World and, xviii, 198, 199, 206-10 Inquisition and, 199, 205-6 marriage of, 199-200 pregnancies and childbirths of, 200, 202-3, 205, 211 proclamation ceremony of, 200-201 Isabella d'Este, Marchese, 221 Isabella Stewart Gardner Museum, xv, 107-9, 108, 120-21, 120 Islam, see Muslims, Islam Isle of Lewis, 151-52 Italian, chess terms in, 4, 70, 95 Italy, 29, 31-40, 66-75, 221 chess manuals in, 66, 68-75, 72, 73, 74 chess opposed in, 29 chess queen in, 18, 31-34, 32, 36-38, 37, 68, 71, 73-75, 83, 159, 179, 213-14, 213, 217-19 cult of love in, 138-39 cult of the Virgin in, 116, 117 expansion of chess playing in, 40 living models for chess queens in, 35-37 Ottonian dynasty in, 18, 19, 21, 22 "queen's chess" in, 213-14, 213, 217-19 standard bearer in, xvii, 239 Theophano's role in, 22 Virgin as "surrogate monarch" in, 117 Ivan III, tsar of Russia, 181

James I, king of England, 225 Jean II, king of France, 98 jesters, in chess, xvii, 75, 141-42 Jesus, xx in chessboard analogy for world, 109-10 nursing of, 108, 108 Virgin Mary as bride of, 116–17 Virgin Mary as mother of, xv, xx, 108-9, 108, 116 Jews, Judaism: chess banned by, 104 Christian conversion of, 52, 193, 197, 198-99 as conversos, 193, 197, 198-99, 206, 216 graven images prohibited by, xvii, 53

as scholars, 65 in Spain, 11, 14, 43, 44, 47, 52-55, 65, 193, 197, 198-99, 202, 205, 206, 216 Spain's expulsion of, 199, 205, 206, 216-17 in spread of "queen's chess," 216-17 women in, 54 Joan of Arc, 201, 211 John, king of England, 98 John of Wales, 104-5 John Tzimiskes, Byzantine emperor, 21 John XII, Pope, 19 Joinville, Jean de, 103 Juan, Prince, 197-99, 202, 204, 211 Juana la Loca (Joanna the Mad), 203 Juana of Portugal, queen of Castile, 194, judges, in chess, 70

Kalmar treaty (1397), 170 Karlamagnus Saga, 166-67 Kārnāmak (Persian romance), 4, 157 Kelly-Gadol, Joan, 229 Kholmogory, 179 chessmen of, 175, 185 Khomeini, Ayatollah, 8 Khusrau I, 6 kibitzing, during chess playing, 28 Kiev, 177, 181 kings: queen's relationship with, xvi-xvii, xix, 91 in social order, 26-27, 68-69, 105 kings, chess, xviii, 3, 99, 109, 141-42 in abstract chess sets, 7, 14 in Carmina Burana, 77, 78 in Cessoli's Book of Chess, 68, 71, 72 "Charlemagne," 32, 33, 33, 37 chess queen's protection of, xvi, 91 in Lewis collection, 152, 153, 153, 154 in Muslim chess, 6, 7 rules for, 17, 77, 105, 192 size of, 27 social order and, xvii, 68 in Spain, 46, 47 King's Mirror, The (Speculum Regale) (Norwegian treatise on kingship), 158 knights, xx, 95 as chess tutors, 94

cult of love and, 124, 127-28, 131-34, 138-39 skills required by, xx, 52, 127-28 in social order, 27, 70, 105 knights, chess, xviii, 17, 75, 99, 109, 141-43, 152, 174, 214, 215 in Carmina Burana, 77, 78 rules for, 53, 77, 105 social order and, xvii, 68, 70, 97 kon (knight), 174 Königen, 119 koral (king), 174 Koran, xvii, 6-7, 104, 176 Kormchaia, 176 koroleva (queen), 175 krala, 175 królwa, 175

lad'ia (rook), 174 Lady of the Chess Château, 85 "lady's (queen's) chess" (axedrez de la dama), 195, 211, 213-35 decline of women players and, 227-35 as "mad queen's chess," 214-17, 219 misogyny and, 219-21, 220, 233 rise of, 213-26 Lancelot and Guinevere, legend of, 130-31 Landslov (laws) of 1274, 167 Latin, chess terms in, 4, 17, 91, 95 Lay of the Shadow, The (chivalric romance), 127-28 León, 12, 13–14, 47–51, 199–202 Lerida (Lleida), diocesan muscum in, 46 Levita, Ramón; 44 "Lewis chessmen," 38, 151-54, 153-55, 158, 159 discovery of, 151-52 Little Office of the Blessed Virgin Mary (Hours of the Virgin), 118 Liudolf, 20 Livre des Echecs Amoureux Moralisés, Le (The Edifying Book of Erotic Chess) (Conty), 139-43, 141 Lombardy, 20, 40 Lombardy, William, 233 London, 231 British Museum in, 152 Lopez, Ruy, 229 Lothar, 19

Louis (son of Marguerite of Provence and Louis IX), 102

Louis V, king of France, 26 Louis VI, king of France, 97, 126 Louis VII, king of France, 87-90, 102 Louis VIII, king of France, 99-101 Louis IX, king of France (St. Louis), 99-104, 118 aversion to games of, 102-3, 249n Crusade of, 102, 103 Louis XI, king of France, 204 Louis XIV, king of France, 174 Louis d'Orléans, 144 Louvre, 99, 134-35, 135 love, cult of, 119, 123-47 adultery and, 124, 128-31 Arab women champions and, 131-34 chess as courting ritual and, xx, 126-47, 128-29, 135, 136, 141, 145, 146, 162 Eleanor of Aquitaine and, 86, 88, 92, 105, 106, 124 love as combat in, 127, 140 romance literature and, 127-34, 128-29 sex and incest and, 134-39, 135, 136 troubadours and, xx, 86, 88, 92, 105, 124-27 "Love Chess" ("Scachs d'amor"), 193-95 "love courts," 92 love poems, 86, 88 Lucena, Luis Ramiriz de, xviii, 195-99, 216, 217 Lukoml ferz', 175 lying-in period, chess playing during, 39

Madonna and Child, Gardner, as "chess queen," xv, 107-9, 108, 120-21, 121 "mad queen's chess," 214–17, 219 Magnus, King of Norway, 166 Magnus, King of Norway and Sweden, 167-68 Málaga, siege of (1487), 203-4 Mālik, 8 Ma'mûn, Caliph, 10 Manesse manuscript, 75 Margaret of Austria, 197 Margaret of Denmark, queen of Norway, 168-72, 172 Margaret Sambiria, queen of Denmark, 166 Marguerite of Provence, queen of France, IOI-2 Marie de Champagne, 88, 90, 92, 126

Marie de Clèves, 144 Marie de France, 94-95 Mariolatry, see Virgin Mary, cult of marriage: annulment of, 49, 90 chess vs., 234 courtly love and, 124-25 forced, 165 Mary, queen of Scotland, 225 Massmann, H.F., 72, 79 māt, 125 Mathilda (daughter of Adelaide of Burgundy and Otto I), 20 Mathilda (daughter of Empress Theophano), 25 Matilda, Marchioness of Tuscany, 35-36 Matilda, queen of England, 98. matriarchy, 14 matz, 127 Mâwardî, 10 Maximilian, Holy Roman Emperor, 197 Mecklenburg, 168 Medina, chess ban in, 243n Menchik, Vera, 232 Midsummer Night's Dream, A (Shakespeare), 132 minnesingers, 124 Miracles of Our Lady, The (Les Miracles de Nostre Dame) (Gautier de Coinci), 111-15 Mir de Tost, Arnau, 46 Mir de Tost, Arsenda, 46 misogyny, 54, 95, 105, 119 "queen's chess" and, 219-21, 220, 233 monasteries, 20, 50, 117-18, 158, 181 Einsiedeln, 15-18, 16, 24, 27 English, 103 of Saint Salvator Maggiore, 23 Tegernsee, 27 monogamy, xvi, 18, 64, 69 Morkinskinna (compendium of Norse sagas), 156-57 "morning gifts," 166 Moscow State Historical Society, 175 mothers, new, chessboards for, 39 Muhammad, xvii, 6 "Mule and the Fox, The" (Alfonsi), 52 Muller-Thijm (Dutch widow), 231-32 murder, 203-4 chess matches and, 85, 103 Murray, H. J. R., 243n

Murray, Sir James, 243n music, 77, 87, 179 Virgin Mary exalted in, 115-16 Muslims, Islam, 6-14, 103, 238, 239 abstract chess pieces of, xvii, 6-7, 7, 46, 47, 52, 63, 175-76 chess banned by, 8, 104, 176 chess in theology of, 6-8, 7 Christian conflict with, 84 polygamy and, xvi Shi'ite vs. Sunni, 7 in Spain, 6, 11, 13, 43, 44, 46, 47, 52, 53, 59-60, 62, 84, 199, 201, 202, 204-5,211 women champions in western literature, 131-34

"nard" (predecessor of backgammon), National Geographic, 79 National Library of Florence, 73 National Museum of Florence, 99 National Museums of Scotland, 152 Native Americans, 198 Navarre, 12-14, 22 Neckham, Alexander, 96-97 Neckham, Hodierna, 96 Negri, Cesare, 222 new chess, see "lady's (queen's) chess" New World, discovery of, xviii, 198, 199, 205-10 Nicephorus, Byzantine Emperor, 9, 22 Nishapur, 7 nobility, xx education of, 94-95 in Scandinavia, 166-68, 171 Nomokanon, 176 Normandy, 90, 91, 98 Norman foot soldiers, 32, 34 Norse sagas: chess in, 156-58 women in, 161-62 Norway, 156, 158, 162-71 chess queen in, 160-61, 160 Christianizing of, 164 "Lewis chessmen" linked with, 152-54, 153 queens in, 166, 167-68 Notre Dame, 101, 115 Noval, Peire Bremon Ricas, 127 Novgorod, 177, 180-81

chess playing of, 59, 60, 221 Oddgeir (Holger Danske), 167 Ogier the Dane (Ogier le Danois), 85, 86 Olav, king of Denmark and Norway, 169 Olav, king of Sweden, 162, 165 Olav Trygvason, king of Norway, 163-65 Old (Anglo-Norman) French, 94, 96, 109 "old chess" (uxedrez del viejo), 195 "Old Man of the Mountain, The," 103 Old Testament, 54 Olga, Princess, 181, 186 Omari, Caliph, 6 Omar Khayyam, 104 Omayyid caliphs, 11 "On the Game of Chess" ("De ludo scachorum") (Calogno), 217-18 Orff, Carl, 77 Orlov, Grigori, 184 Oslo, 168 Otto I (Otto the Great), Holy Roman Emperor, 19-20, 23, 24, 25 Otto II, Holy Roman Emperor, 19-23, 25, 27 ivory plaque of, 23, 37 Otto III, Holy Roman Emperor, 21-26 Otto IV of Brandenburg, Margrave, 75 Ottonian dynasty, 18-27 Einsiedeln's ties to, 18, 24, 27 Ottonian Renaissance, 20, 21, 25 Ovid, 130 Oxford, 99 Bodleian Library at, 91, 109-10 paintings, 117, 118 cult of love and, 138-39 of mixed gender chess matches, 222, 223, 228 Pakistan, 238 Palamède, 207, 209, 2541-551 Palermo, 38, 39

nuns, 118, 181

Paris, 33, 88, 99, 222, 231 church construction in, 101 Louvre in, 99, 134–35, *135* Notre Dame in, 101, 115 Paulsen, Amalie, 231

papacy, 166, 171

paraz, 53

pawns, chess, 6, 14, 17, 141, 142, 174

Holy Roman empire vs., 35, 40

pawns, chess (cont.) "Charlemagne," 32, 33, 34 donation of, 44 in Lewis collection, 153 promotion of, 8-9, 18, 53, 58, 73, 97, 105, 193, 196 rules for, 53, 77, 105, 193, 196 social order and, xvii, 68, 70-71, 105 peasants, 68, 70-71, 105 chess playing of, 76, 78-79 Peckham, Archbishop, 103 pedes, 17, 77, 91 Pennell, Mike, 61 Perceval (Chrétien de Troyes), 85, 86-Perez, Count Fernando, 51 Persia, xvi, xvii, 4-7, 173, 195 chess in literature of, 4-5, 6 Muslim, 6-7, 7 Persian, chess terms in, 4, 6 peshka (pawn), 174 Peter III, tsar of Russia, 183, 184 Peter the Great, tsar of Russia, 179, 183, 2531 Petzold, Joachim, 119-20 Philip Augustus, king of France, 100, 165 Philip II, king of Spain, 225 Philippa, queen of Norway, Sweden, and Denmark, 171 "Philomena" (Marie de France), 94 Photius, 176 Pilgrimage of Charlemagne, The, 88-89 pilgrimages, 101-2 plastic arts, chess as courting ritual in, 127, 129, 134-35, 135, 136, 138-39, 144-46, 145, 146 playing tables, 84, 94 Poem of the Cid, The (Alfonso VI), 47 Poems (Poèmes) (Chartier), 144, 145 poetry, 87, 94-95, 109-10 love, 86, 88 Poitiers, 91 Poitiers, Battle of (1356), 98 Poitou, 90 Polgar, Judit, 232, 233 Polgar, Laszlo, 232 Polgar, Zsofia, 232, 233 Polgar, Zsuzsa, 232, 233 Polish, chess terms in, 175 polygamy, xvi Porse, Knut, 167 Portish, Lajos, 233

Portugal, 50, 51, 199-200, 211 Potemkin, Grigori Aleksandrovich, 184 pravers: invocation to the Virgin in, 115 Little Office of the Blessed Virgin Mary (Hours of the Virgin), 118 pregnancy, Virgin Mary as protector during, 116 "Prelate's homily to the Newly-ordained Priest," 176 printing press, 72, 144, 198 Prodigal Son, 135, 136 property: inheritance of, 167, 180 joint ownership (félag) of, 167 prostitutes, playing chess with, 135, 136 Protestant Reformation, names for chess queen and, 119 Provençal language, 86, 127 Proverbs 31, 55 Pulgar, Hernando del (chronicler), 203, 205 Pulgar, Hernando del (warrior), 207-10 "queened," 9, 53, 58, 73, 97, 193, 196 queens, xvi-xix chastity of, 69-70 cult of the Virgin and, 101-2, 106, 111, 115-21 greed of, 105 role of, xvi-xvii, xix, 12, 69-70, 93 Scandinavian, 162-72, 172 in Seven Divisions, 64 in social hierarchy, 26-27, 69-70 in Spain, xviii–xix, 12–14, 48–52, 64-66, 192-94, 197-211 viziers compared with, xvi, xix queens, chess, 237-41 in Carmina Burana, 77, 78

in Catholic vs. Protestant countries, 119–20 in Cessoli's *Book of Chess*, 68, 71, 72 "Charlemagne," 32, 32, 33

chess king protected by, xvi, 91 in cult of love, 126–27, 129–30, 142 early, with faces, 32, 32, 38, 55–57, *56* in Einsiedeln Poem, 15–18, *76* in England, 38, 83, 91, 95–96, 99, 179, 216, 225–26

in France, 32–34, *32*, 38, 83, 95–96, 99, 102, 179, 214–15, 219 in Germany, 38, 77–78, 83, 179

Hebrew evidence of, 52-55, 192 on horseback, 159-60, 159, 160, 225-26, 226, 230 as icon of female power, xv-xxi in Italy, 18, 31-34, 32, 36-38, 37, 68, 71, 73-75, 83, 159, 179, 213-14, 213, 217-19 in Lewis collection, 38, 152, 153, 153, 155, 158, 159 living models for, 18-24, 35-37, 48-51, 83, 86-94, 96-106, 162-72, 172, 192-94, 197-211, 219-20, 224-26 Madonna and Child as, xv, 107-9, 108, 120-21, 120 male anxiety about, 74-75 as metaphor for best wifely behavior, 69-70,93 naming of, 95-96, 119-20 origins of, xvi-xviii, 19-26 rules for, xvi, xviii, 77, 78, 105, 113, 191-96, 228-29, 238 in Russia, 38, 174-75, 179-80, 182, 185-86, 186 size of, 27 social currents coinciding with birth of, xix-xx social order and, xvii, 68 as soul, 73-74 in Spain, 14, 38, 46 47 transformation of, xviii-xix, 191-211; see also "lady's (queen's) chess" Virgin Mary as, xv, 107-15, 108, 120-21, 120, 129 viziers compared with, 37, 53-54, 63, 152, 174-75 vizier's rivalry with, 29-30, 36, 37, 52-53, 87, 95, 179, 185-86, 191-92, 238 as weakest piece, xviii, 17 in western imagination, 238-41 "queen's chess," see "lady's (queen's) chess" queens consort, xix, 192 queens regent, xix, 20-26, 100-101, 166-69, 192, 204, 222 queens regnant, xix-xx, 48-51, 192 Raoul of Cambrai (chivalric romance), 127-28

Ravenna charter (990), 22

Raymond of Burgundy, king of Galicia, 48 Raymond of Poitiers, 90 regina, 16, 17, 77, 78, 91, 95, 175, 193 Reims Cathedral, coronations at, 100, 101 reina, reyna, reine, 95, 96, 112, 119 Renaissance, 226-30 rex, 17, 77, 91 Richard I (Richard the Lion-Hearted), King of England, 96 Richard II, King of England, 226 rings, 163-64 Robert, duke of Normandy, 98 Rocamadour, as pilgrimage site, 101-2 rochus, 17, 77, 91 rock crystal chess pieces, 45-47, 46 Rojas, Fernando de, 197 romance literature: Arthurian legend in, 92-93 cult of love and, 127-34, 128-29 Romance of Lancelot of the lake, The, 130 "Romance of the Count of Anjou, The" (1316), 136-38 Romance of the Rose, The, 139 Romanesque chess queen, 55-56 Rome, 116, 171 rooks, chess, 6, 14, 17, 28, 53, 99, 109, 214, 215 in Carmina Burana, 77 in Lewis collection, 152 53 rules for, 97 in Russia, 174, 175 social order and, xvii, 68, 70, 97 Roskilde Cathedral, 171 royal prisoners, chess partners for, 98 Rudel, Jaufre, 124 Rudenko, Ludmila, 232 Ruodlieb (Latin epic), 27-28 Russia, 156, 163, 173-87 abstract chess pieces in, 173, 175-76, 179 chess pieces in, 173-77, 179, 180, 185-86, 185 chess queen in, 38, 174-75, 179-80, 182, 185-86, 186 spread of Christianity to, 180, 181 status of women in, 179-82 strength of players in, 174, 182, 187 women chess players in, 177-79 Russian, chess terms in, 174-75 Russian Orthodox Church, 175-77, 180, 181, 184

Sainte Chapelle, 101 Saint Giles, 44, 45, 84 Saint Jean d'Acre, Louis IX's campaign at, 103 Saint Salvator Maggiore Monastery, 23 Salamanca, 195, 197-98 Salamanca, University of, 197, 198, 217 Salerno, 31-35 chess pieces carved in, 31-34, 32, 33 Norman invasion of, 34 "Salve Regind" (hymn), 116 Sancha, Infanta, 48 Sáncho I, king of León, 13-14 Sancho I (Sancho Garcés), king of Navarre, 12 Sancho II, king of Navarre, 44 San Julian de Bar, 44 San Millán de la Cogolla, 44 San Pere of Ager, 45-46, 46 Sassanian monarchy, 157 Saxony, 21 Scandinavia, 151-73 arrival of chess in, 154, 156, 158 court culture in, 166-67 cult of love in, 162 queens in, 162-72, 172 Scandinavian chess queens, 158-61, 179 Cologne, 154, 155, 158 Gardner Museum Madonna as, 107-9, 108, 120-21, 120 hatlike crowns of, 154, 155, 159, 159, 160-61, 160 in Lewis collection, 38, 152, 153, 153, 155, 158, 159 Scotland, 61 Second Crusade (1146), 34, 88–90, 102 Sefardi, Moses, see Alfonsi, Petrus Segovia: council in (1475), 201 Isabella's proclamation ceremony in, 200-201 Selenus, Gustavus, 230 senex (old man), 96 Seven Divisions (Siete Partidas) (commissioned by Alfonso X), 64-66 sex, sexuality: chess and, 134-39, 135, 136 Church's view of, 69-70 shah (king), 4, 6 Shahade, Jennifer, 234 shah mat (check mate), 5

Shakespeare, William, 132, 223 Sicily, xvii, 31, 34, 38-40 Sigrid the Strong-Minded, queen of Sweden, 162-65 Siguror Slembir, legend of, 156 Sikelgaita, Princess, 34, 35 Simeti, Mary Taylor, 38-39 Siofredo, 44 Sissa ibn Dahir, 5 Skane, 168 slaves, chess-playing, 9, 10 slon (bishop), 174 Snorre Sturlason, 157, 161, 162-63 social order, chess as reflection of, 67-71, 75, 86, 97 Sofia, Regent of Russia, 183 Song of Roland, The (Chanson de Roland), 84-85,86 Song of Songs, 55 Sophia (daughter of Empress Theophano), 25 Soviet women, as chess players, 232, 233 Spain, 29, 43-66, 192-211 abstract chessman in, 14, 46, 47, 52, 63 Arab invasion of, xvii, 6, 11 caliber of chess playing in, 40 chess manual in, 44, 57-64, 58-63 chess queen in, xviii-xix, 14, 38, 46-47, 52-57, 56, 63, 83, 159, 179, 192-96, 211, 221 chess viziers in, 46, 47, 53, 87 Christian sovereigns in, 12-14, 47-52, 57-66 conversion of Jews in, 52 cult of the Virgin in, 116 daughter's inheritance of throne in, xvii, 201 Hebrew evidence of chess queen in, 52-55 Inquisition in, 198-99, 205-6 Jews expelled from, 199, 205, 206, 216-17 Jews in, 11, 14, 43, 44, 47, 52-55, 65, 193, 197, 198-99, 202, 205, 206, 216 Muslims in, 6, 11, 13, 43, 44, 46, 47, 52, 53, 59-60, 62, 84, 199, 201, 202, 204-5, 211 printing press in, 198 "queen's chess" in, 195, 211, 213 queens in, xviii-xix, 12-14, 48-52, 64-66, 192-94, 197-211

reconquest in, 204-5, 211 Spanish, chess terms in, 70, 95, 119 standard bearers, in chess, xvii, 62-63, 70, Stockholm Historical Museum, 159 Ströbeck, chess playing in, 78-79 Suger, Abbot, 34, 88 Sukhanov, Andrian, 185 Sûlî, 10 Surrey, Henry Howard, earl of, 216 Sweden, 158, 162-65, 168-71 chess queen in, 158-59, 159 Swein, king of Denmark, 164-65 Switzerland, 19 Einsiedeln Monastery in, 15-18, 16 table manners, 20 Talhand, 5 Taliban, 8, 104 Tegernsee Monastery, 27 Tempest (Shakespeare), 223 Tenniel, John, 240 Teresa, queen of Navarre, 13 Teresa of Avila, Saint, 221 Teresa of Portugal, 48, 51 Theodora, Byzantine empress, 116 Theophano, Holy Roman Empress, 19-27 as consors regni, 23 daughters of, 22, 25 death of, 22-23, 25 dowry of, 21 as imperator augustus, 22, 26 ivory plaque of, 23, 37 Thiermar of Merseburg, 22 Third Crusade, 98 Through the Looking Glass (Carroll), 239-41, 240 Toda Asnárez, queen of Navarre, 12–14, 22,44 Toledo, 48 "To the Lady That Scorned Her Lover" (Howard), 216 Travels with a Medieval Queen (Simeti), 38-39 Trimborg, Hugo von, 76 Tristan (Heinrich von Freiburg), 129 Tristan and Iseut, legend of, 128-29, 128-29 trobairitz (women troubadours), 125-26

Trondheim, 153–54

troubadours, xx, 86, 87-88, 92, 105,

124-27

chess vocabulary used by, 125, 127 women as, 125-26 trouvères, 124 Troves, court in, 92 tsar, 174 tsaritsa, 175, 182, 185-86 Turkey, 238, 239 Tuscany, 35-36, 39 Ukraine, 233 Ulf, Earl, 157 Urban II, Pope, 35 Urgel, 44 Urraca, queen of León and Castile, xix, 48-52 Valdemar II, king of Denmark, 166 Valdemar IV, king of Denmark, 168, 169 Valencia, 193, 195, 211, 216 Valladolid, 200

Vatican Library, 39 Vegetuis, 61 Vendland, 163, 164

"Verses on Chess," see Einsiedeln Poem "Verses on the Game of Chess" (ibn Ezra), 53-54 Vetula (La Vielle) (Ovid pretender), 130 Vicent, Francesch, 195, 196 Vida, Marcus Hieronymus, 218 Vigée-Lebrun, Elisabeth, 184 Villefranche. Hôtel de la Bessèe in, 145-46 Vinyòles, 193 Violante of Aragón, queen consort of Castile and León, 64-66 violence, chess matches and, 85, 97, 103 Virgin Mary, 31 as Bride of Christ, xx, 116 as chess queen, xv, 107-15, 108, 120-21, 120, 129 coronation of, 116-17 as courtly "lady," 119 cult of, xx, 101-2, 106-21 feasts of, 117 Isabelle of Castile compared with, 211 in Miracles of Our Lady, 111-15 as Mother, xv, xx, 108-9, 108, 116 as queen (Maria Regina), xx, 116-18 secular queens and, 113-21

women valorized by, 119 Virgin Queen, The (Hibbert), 225

Visconti, Valentine, 144 viziers, 18 queens compared with, xvi, xix viziers, chess, xvi-xix, 6, 7, 14, 17, 37, 195, chess queen compared with, 37, 53-54, 63, 152, 174-75 chess queen's rivalry with, 29-30, 36, 37, 52-53, 87, 95, 179, 185-86, 191-92, 238 pawns promoted to rank of, 8-9, 14 in Russia, 174-75, 185 in Spain, 46, 47, 53, 87 Vladimir Monomakh, Prince, 180 Vogelweide, Walther von der, 75 Voltaire, 184 "Waking Piece" (Glazner), vii Wales, 61

walcs, 61
walcs, 61
walrus tusk, chess pieces carved from, 152, 153-54, 156
Walters Art Gallery, 55-57, 56, 63
war: chess as game of, xvii, 3, 4, 86, 123, 228 in medieval life, 86 *Way of Perfection, The* (Teresa of Avila), 221
wedding gifts, chess set as, 38
Welf V of Bavaria, 35
William IX of Aquitaine, Duke, 86, 88, 92
William of Orange (William of Toulouse; William of Aquitaine), 133-34
William the Conqueror, 91, 94, 98
William X of Aquitaine, Duke, 87
wills, chess sets and pieces in, 44-45, 84

Winchester Poem, 91, 96-97 wisdom, chess associated with, 85 Wolfram von Eschenbach, 134 women: board games recommended for, 57 chastity of, 69-70, 220 cult of love in elevation of, 124 cult of the Virgin in valorizing of, 119 new medieval importance of, xvi-xvii, 85, 86, 94, 167 Nordic, society and, 161-67 in Russia, 179-82 as troubadours, 125-26 women, as chess players, 221-22, 223 in Arabian Nights, 10–11 in Book of Chess, 58-63, 59-61. decline of, 227-35 foreign wives, 38 Muslim, 10, 59-60, 62, 131-34 new mothers, 39 psychological views on, 234 questions about revival of, 233-35 in Russia, 177–79 Women's World Chess Championship (1927), 232

Xie Jun, 232, 233–34

Zaida (extra-legal partner of Alfonso VI), 48 Zhu Chen, 232 Ziriab, 11 Zonares, John, 176 Zubaidah, 9

PHOTOGRAPHIC CREDITS (COLOR)

Rock crystal king and vizier. [2 photos] Museu de Lleida Diocesà i Comarcal. Spanish Romanesque chess queen. Walters Art Museum, Baltimore.

Queens teaching children to play chess. Patrimonio Nacional, Madrid.

Twelfth-century Italian chess queen. Staatliche Museen zu Berlin-Preussischer Kulturbesitz, Skulpturensammlung.

Margrave Otto IV. Universitätsbibliothek, Heidelberg.

Eleanor of Aquitaine. Abbaye Royale de Fontevraud.

Blanche of Castile and Louis IX. The Pierpoint Morgan Library/Art Resource, NY.

Tristan and Iseut in boat. Bibliothèque Nationale, Paris/Bridgeman Art Library, London.

Lancelot and Guinevere. The Pierpont Morgan Library/Art Resource, NY.

Queen Arabel teaching Willehalm. Landesbibliothek, Kassel.

Willehalm teaching Queen Arabel. Landesbibliothek, Kassel.

Stained-glass window. Musée du Moyen Age (Cluny), Paris. Réunion des Musées Nationaux/Art Resource, NY. Photo Gérard Blot.

Danish chess queen on horseback. National Museum, Copenhagen.

"Bryggens Madonna." Bergen Museum, Bergen, Norway.

PHOTOGRAPHIC CREDITS (BLACK AND WHITE)

page

- 6 From *Shāh-nāmeh*. Metropolitan Museum of Art, New York, Purchase, 1934, Joseph Pulitzer Bequest. (34.24.1)
- 7 Islamic chessmen. Metropolitan Museum of Art, New York, Pfeiffer Fund, 1971. (1971.193a-ff)
- 16 From Einsiedeln Poem. Einsiedeln Monastery, Switzerland.
- 23 Otto II and Theophano. Musée du Moyen Age/Cluny, Paris. Réunion des Musées Nationaux/Art Resource.
- 28 German rook. Staatliche Museen zu Berlin-Preussischer Kulturbesitz, Skulpturensammlung.
- 32 "Charlemagne" chess queen carrying a globe. Bibliothèque Nationale de France, Paris.
- 32 "Charlemagne" chess queen holding belt buckle. Bibliothèque Nationale de France, Paris.
- 33 "Charlemagne" chess king. Bibliothèque Nationale de France, Paris.
- 33 "Charlemagne" pawn. Bibliothèque Nationale de France, Paris.
- 36 Twelfth-century Italian chess queen. Staatliche Museen zu Berlin-Preussischer Kulturbesitz, Skulpturensammlung.
- 37 Twelfth-century Italian vizier. Bibliothèque Nationale de France, Paris.
- 46 Ager chessmen. Museu de Lleida Diocesà i Comarcal, Lleida, Spain.
- 16 Spanish chess queen. Walters Art Museum, Baltimore.
- 58 Alfonso X and unidentified woman. Patrimonio Nacional, Madrid.

276 • CREDITS AND PERMISSIONS

- 59 Ladies with high hats. Patrimonio Nacional, Madrid.
- 60 Nuns. Patrimonio Nacional, Madrid.
- 61 Edward I of England and fiancée. Patrimonio Nacional, Madrid.
- 62 Moorish women. Patrimonio Nacional, Madrid.
- 63 Young ladies playing chess. Patrimonio Nacional, Madrid.
- 69 Jacobus de Cessolis. Cleveland Public Library.
- 72 German translation of Cessolis. Cleveland Public Library.
- 73 From Game and playe of the chesse. Cleveland Public Library.
- 74 From The Good Companion. Cleveland Public Library.
- 76 Backgammon players. Bayerische Staatsbibliothek, Munich.
- 77 Chess players. Bayerische Staatsbibliothek, Munich.
- 108 Madonna and Child. Isabella Stewart Gardner Museum, Boston.
- 118 Queen Emma. By permission of the British Library, London.
- 120 Madonna and Child (back). Isabella Stewart Gardner Museum, Boston.
- 128 Tristan and Iseut. Louvre, photo by Kathleen Cohen.
- 135 Ivory mirror case. Cleveland Museum of Art, J. H. Wade Fund. Acc. No. 1940.1200.
- 136 Prodigal Son. Metropolitan Museum of Art, Gift of George Blumenthal, 1941. (41.100.159)
- 141 From *The Edifying Book of Erotic Chess.* Bibliothèque Nationale de France, Paris.
- 145 Chartier's Poèmes. Royal Library, The Hague.
- 146 "Garden of Love with Chess Players." Kupferstichkabinett Staatliche Museen Preussischer Kulturbesitz, Berlin.
- 153 "Lewis" chessmen. British Museum.
- 154 Line drawing of "Lewis" king. Cleveland Public Library.
- 155 Line drawing of "Lewis" queen. Cleveland Public Library.
- 155 Scandinavian chess queen, circa 1200. Kunstgewerbemuseum der Stadt, Cologne.
- 159 Swedish chess queen. Antikvarisk-topografiska arkivet, the National Heritage Board, Stockholm.
- 159 Danish chess queen seated on throne. National Museum, Copenhagen.
- 159 Danish chess queen on horseback. National Museum, Copenhagen.
- 159 "Bryggens Madonna." Bergen Museum, Bergen, Norway.
- 172 Queen Margaret of Denmark. Museum für Kunst und Kulturgeschichte, Lübeck.

- 185 Catherine the Great's chess set. Hermitage Museum, St. Petersburg/ Bridgeman Art Library, London.
- 186 Nineteenth-century Russian chessmen. Long Island Chess Museum. Courtesy of Floyd and Bernice Sarisohn.
- 198 Ferdinand and Isabella as chess pieces. Metropolitan Museum of Art, New York. Gift of Gustavus A. Pfeiffer, 1948. (48.174.149)
- 209 Chessboard from Le Palamède. Cleveland Public Library.
- 214 First edition in Italian of Cessolis. Royal Library, The Hague.
- 215 From Göttingen Manuscript. Göttingen Library, Germany.
- 220 Misogynist chessboard. Royal Library, The Hague.
- 223 Duke Albrecht V of Bavaria and Consort. Bayerische Staatsbibliothek, Munich.
- 226 Chess queen riding sidesaddle. Bayerisches Nationalmuseum, Munich.
- 230 From Chess or the Game of Kings. Cleveland Public Library.
- 239 Turkish chessmen. Cleveland Public Library.
- 240 From *Through the Looking Glass.* Department of Special Collections, Stanford University Libraries.

BOOKS BY MARILYN YALOM

BIRTH OF THE CHESS QUEEN A History

ISBN 0-06-009065-0 (paperback)

Illustrated with beautiful art throughout, this book takes a fresh look at the politics and culture of medieval Europe, the institution of queenship, and the reflections of royal power in the figure of the chess queen.

"An enticing portal into the past.... Yalom writes passionately and accessibly about this esoteric topic." A HISTORY OF THE WIFE

ISBN 0-06-093156-6 (paperback)

story of the

For any woman who is, has been, or ever will be married, this intellectually vigorous and gripping historical analysis of marriage sheds new light on an institution most people take for granted, and that may, in fact, be experiencing its most convulsive upheaval since the Reformation.

"A delectably readable volume." —People

-Los Angeles Times Book Review

Don't miss the next book by your favorite author. Sign up for AuthorTracker by visiting www.AuthorTracker.com.

Available wherever books are sold, or call 1-800-331-3761 to order.